The
Interior Designer's
DRAPERY
BEDSPREAD
& CANOPY
Sketchfile

The
Interior Designer's
DRAPERY
BEDSPREAD
& CANOPY
Sketchfile

Edited by
MARJORIE BORRADAILE HELSEL
ASID

WHITNEY LIBRARY OF DESIGN
An imprint of Watson-Guptill Publications
New York

The Interior Designer's Drapery, Bedspread, and Canopy Sketchfile is a compilation of the following books: *The Interior Designer's Drapery Sketchfile* © 1969 by Marjorie Borradaile Helsel and *The Interior Designer's Bedspread and Canopy Sketchfile* © 1975 by Marjorie Borradaile Helsel.

Preface Copyright © 1990 by Marjorie Borradaile Helsel

First published in 1990 by Whitney Library of Design,
an imprint of Watson-Guptill Publications,
a division of BPI Communications, Inc.,
1515 Broadway, New York, N.Y. 10036

LIBRARY OF CONGRESS CATALOGING-IN-PUBLICATION DATA

Helsel, Marjorie Borradaile.
 The interior designer's drapery, bedspread, and canopy sketchfile
 / Marjorie Borradaile Helsel.
 p. cm.
 Republished from the author's previous editions: The interior
 designer's drapery sketchfile, 1969 and the interior designer's
 bedspread and canopy sketchfile, 1975.
 Includes index.
 ISBN 0-8230-2546-2
 1. Drapery—Themes, motives. 2. Coverlets—Themes, motives.
I. Helsel, Marjorie Borradaile. Interior designer's drapery
sketchfile. II. Helsel, Marjorie Borradaile. Interior designer's
bedspread and canopy sketchfile. III. Title.
NK3197.H43 1990
747'.5—dc20 90-12901
 CIP

Distributed in the United Kingdom by Phaidon Press Ltd.,
Musterlin House, Jordan Hill Road, Oxford OX2 8DP

Printed in U.S.A.

First printing, 1990

1 2 3 4 5 6 7 8/96 95 94 93 92 91 90

Contents

Preface

The *Interior Designer's Drapery, Bedspread & Canopy Sketchfile* begins at the precise point where ready-made treatments for windows and beds end. Its realm is the world of the *custom-made*—an inspired domain born on the interior designer's drawing board and developed in the professional workroom.

My principal motivation in assembling this comprehensive collection of drawings of window and bed solutions is the almost daily need for this design tool in my own office. Firstly, its sketches may be copied *per se* to supplement workroom orders and instruct workroom personnel. Thus, in its role as a design tool, *The Sketchfile* can provide the actual drawings from which custom-made draperies, valances, bedspreads, skirts, etc., may be produced. Others of its designs may be quickly adapted to fit the requirements of a current job or an immediate problem, short of executing completely new sketches for the occasion.

It is easily conceivable that *The Sketchfile* may, too, prove to be a much-needed "catalog" in the catalog-less custom-made field. With it, the designer can show a client a substantial selection of solutions without investing the time to draw dozens of speculative or preliminary designs.

This volume is intended, of course, as an idea source, expanding the professional's library in an area which has a serious vacuum of available illustrative material. Just thumbing through *The Sketchfile* may well trigger an idea that leads to a fresh and original creation, or an ingenious solution to an old problem. It sums up and draws together an impressive array of drapery and valance designs and the diverse personalities of the bed, with all of its multifarious trappings.

I have observed that the efficiency of a reference volume is directly related to how retrievable its information really is. The designer should find *The Sketchfile*'s index invaluable in this regard, as each design reappears there in miniature, and is page-

referenced for quick retrieval. In the body of the work itself, three major sub-divisions separate the drawings in both the window and bed sections: period, formal, and casual designs. The period designs dovetail with the traditional breakdowns of furniture styles and offer an authentic reference resource for restoration projects and design students.

Secondary sub-divisions include the very brief headings, which illustrate the various types of drapery pleating: valances, the change of which can create a completely new drapery concept; tie-backs, which concentrate on the imaginative employment of materials to hold back draperies rather than the methods, for there are, after all, only a handful of ways to physically tie a drapery back; headboards and daybeds, which I have indexed together as the distinction between the two is seldom more than the number of ends; and skirts not included in the previous bedspread sections.

While every attempt has been made in this book to take into account such diverse factors as the sizes and types of windows, the styles of interiors and even the ages and sexes of their occupants, the designer will know whether a drapery design will scale up for a hotel lobby or belongs in a man's private study. And that the very nature of bed coverings begs for individualizing with appliqués, quilting, braids, ruffles, and bows, a myriad of which is already available or can be executed in a professional workroom.

Thus, very little explanation has seemed necessary—you will know best how to achieve the results you want—and intrusive copy has been almost entirely omitted from this reference work. Drawings are annotated only where it seems desirable to supplement the meaning of a sketch or to suggest a certain material. It is hoped that the 371 different designs which appear in *The Interior Designer's Drapery, Bedspread & Canopy Sketchfile* will speak for themselves and that this definitive collection will be as welcomed to your desk as it to mine.

MARJORIE BORRADAILE HELSEL, ASID

DRAPERIES

Period Designs

RENAISSANCE

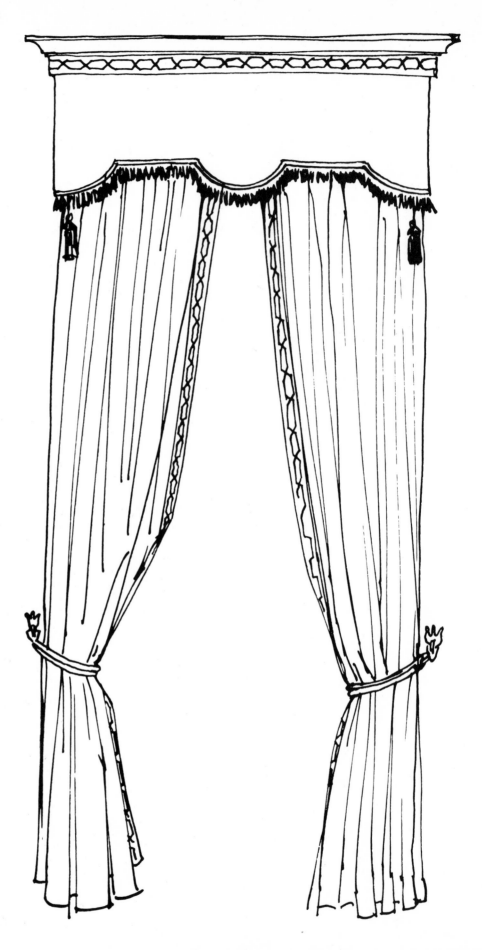

1

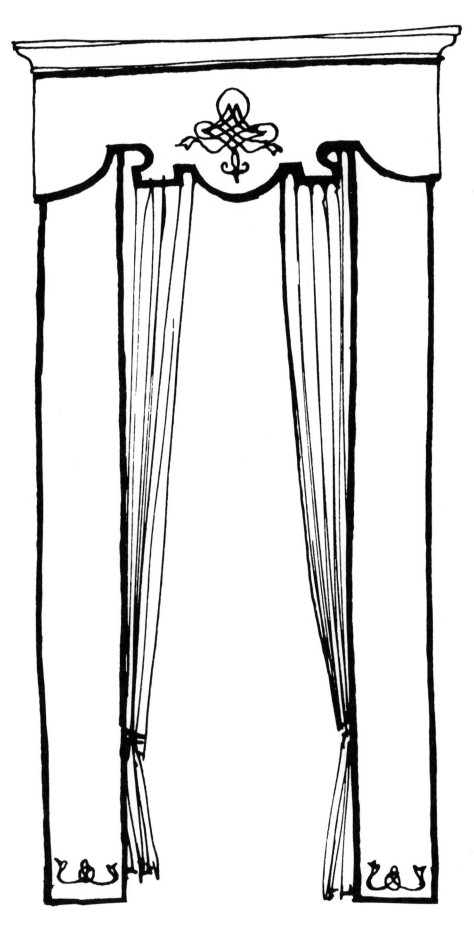

*flat fabric panels
with embroidery*

2

RENAISSANCE

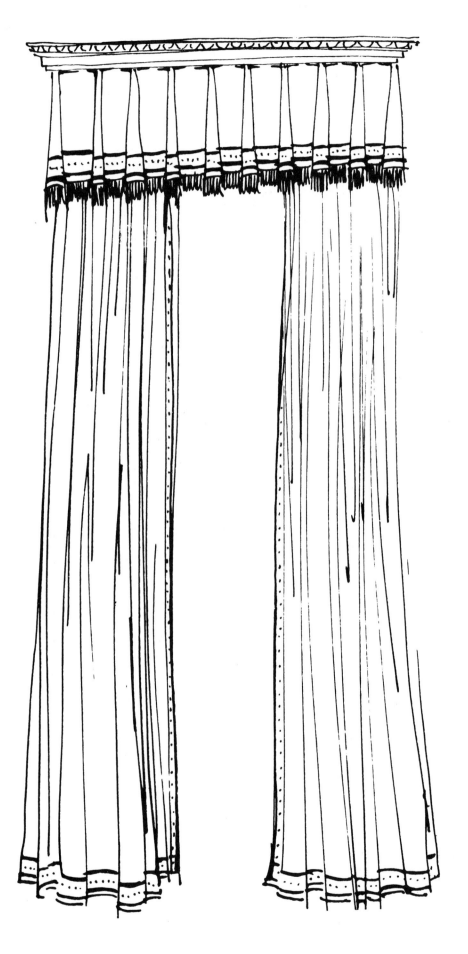

3

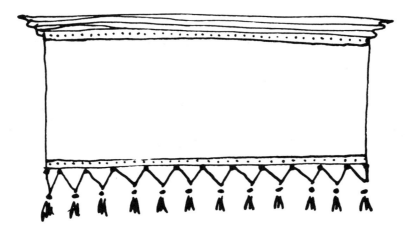

4

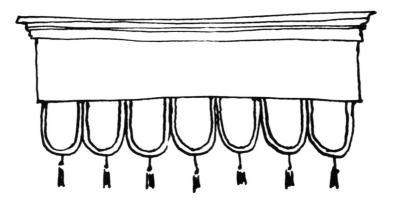

5

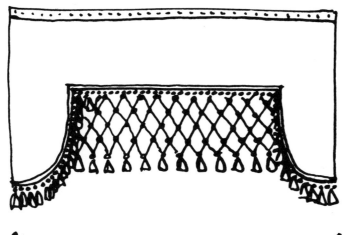

6

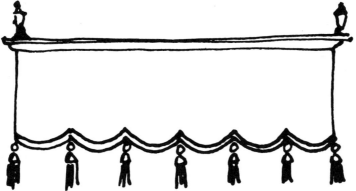

7

LOUIS XIII

flame stitch

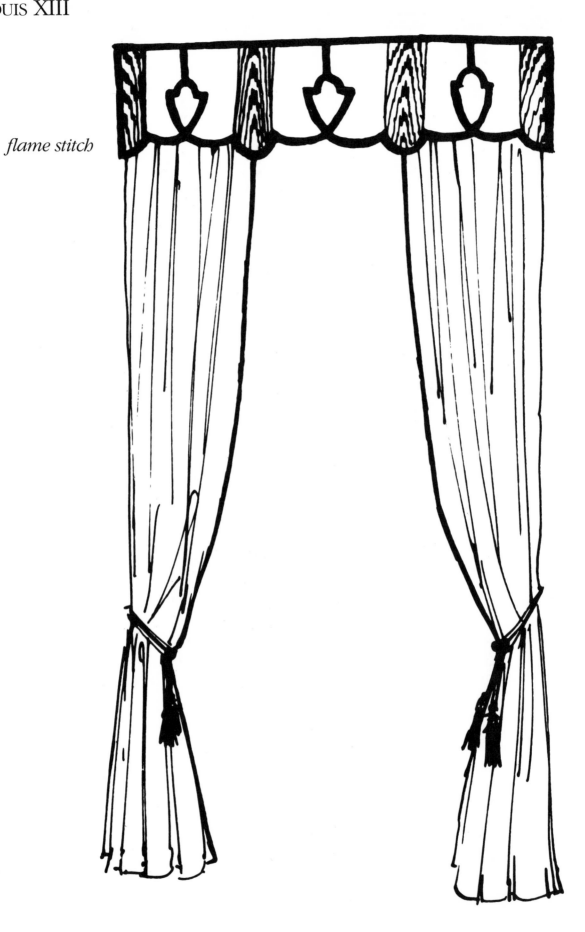

8

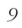

9

10

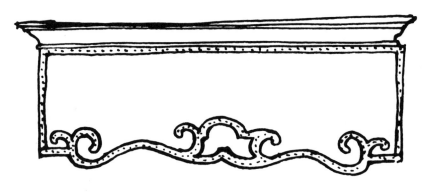

11

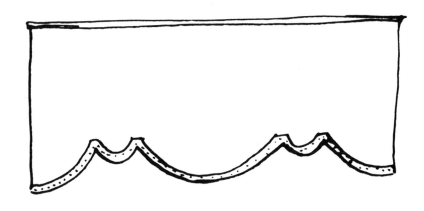

12

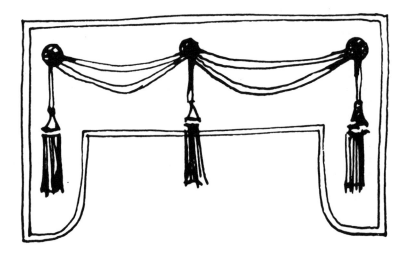

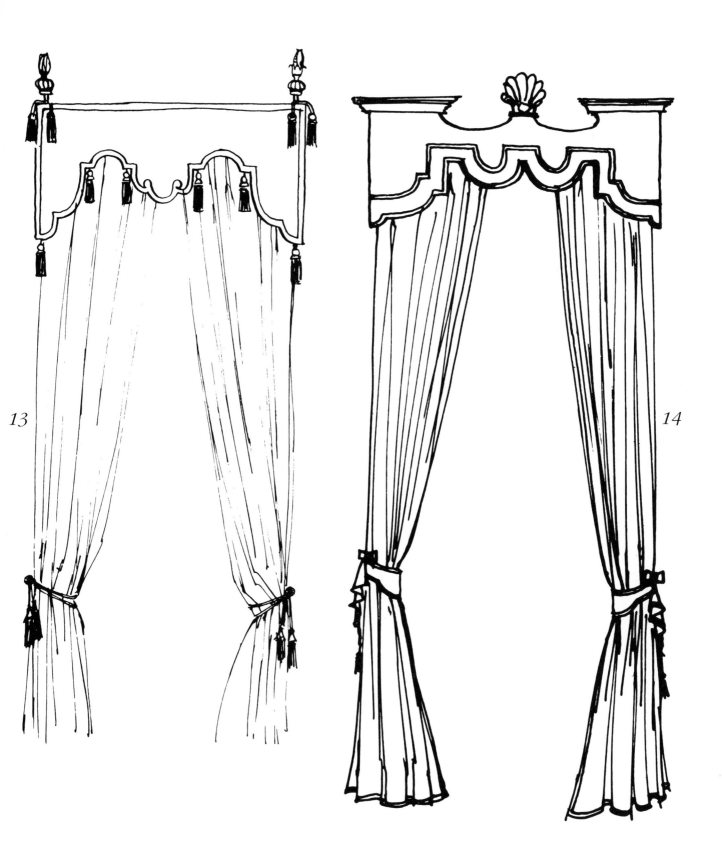

13

14

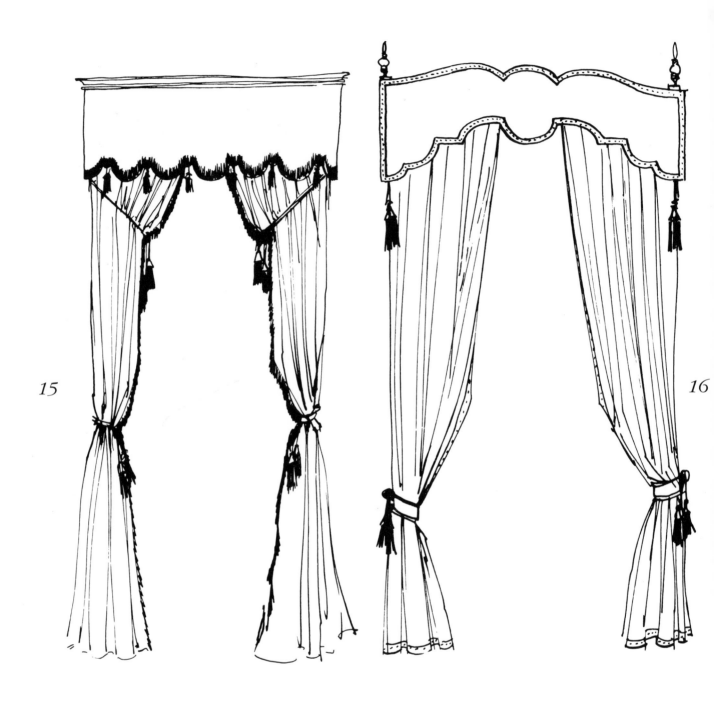

15

16

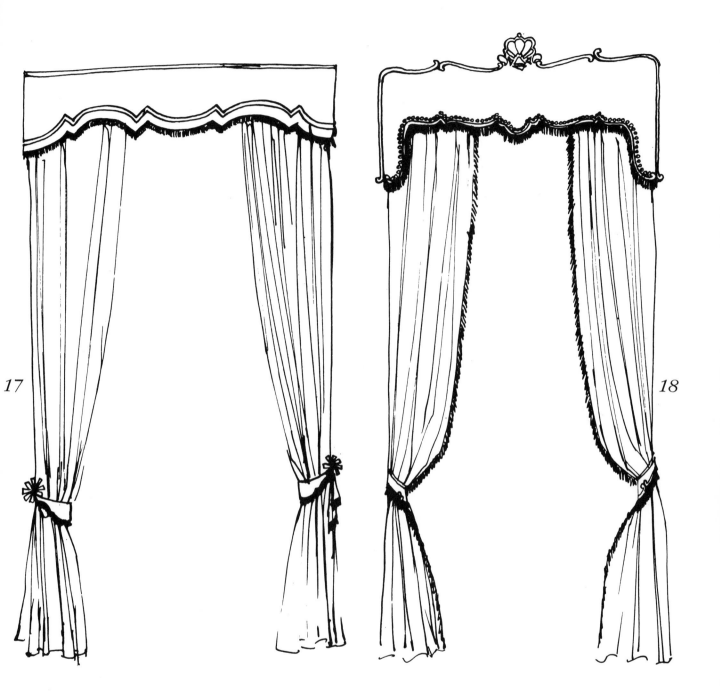

17

18

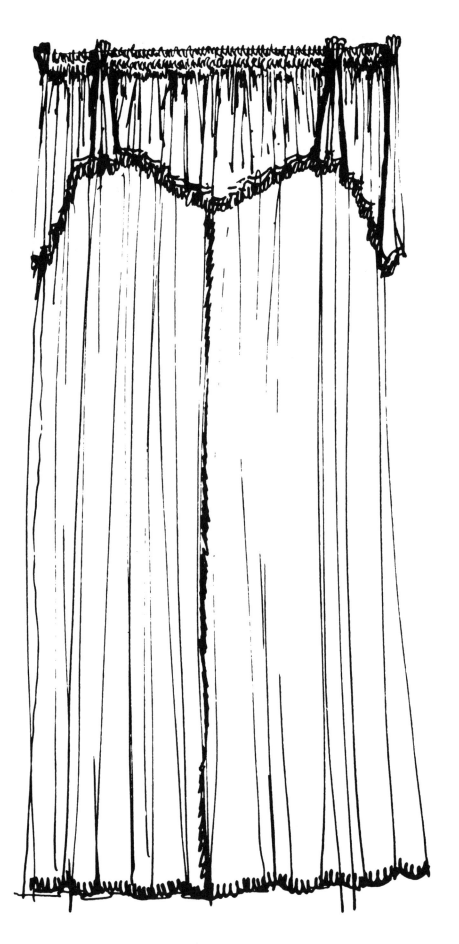

19

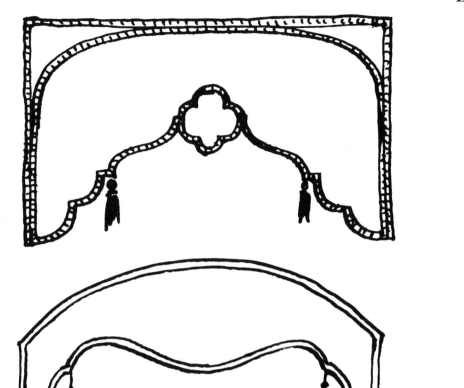

20

21

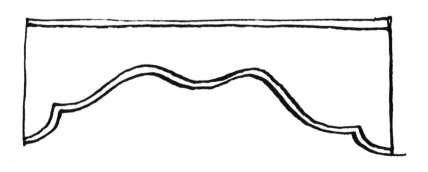

22

23

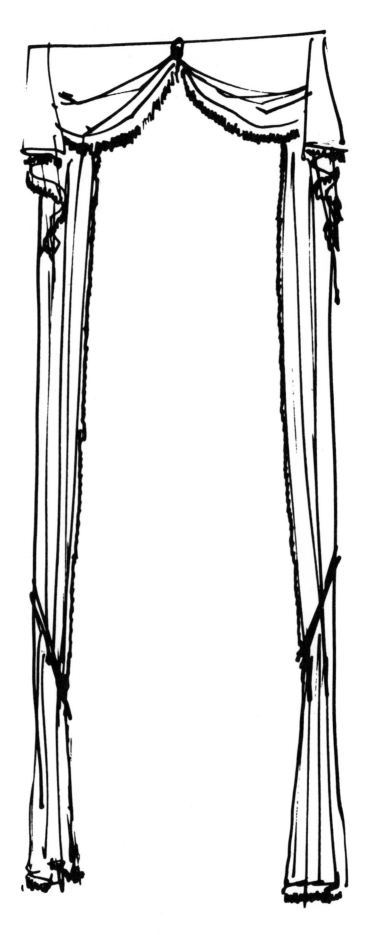

24

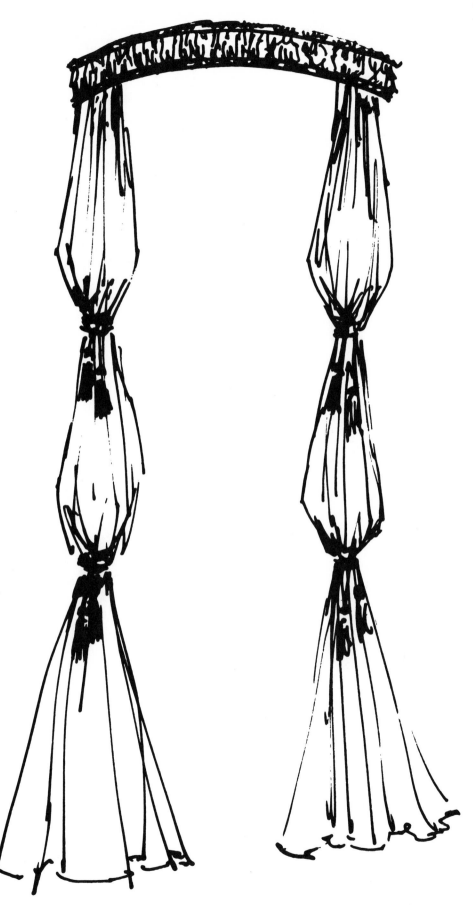

26 *first fabric*
 second fabric

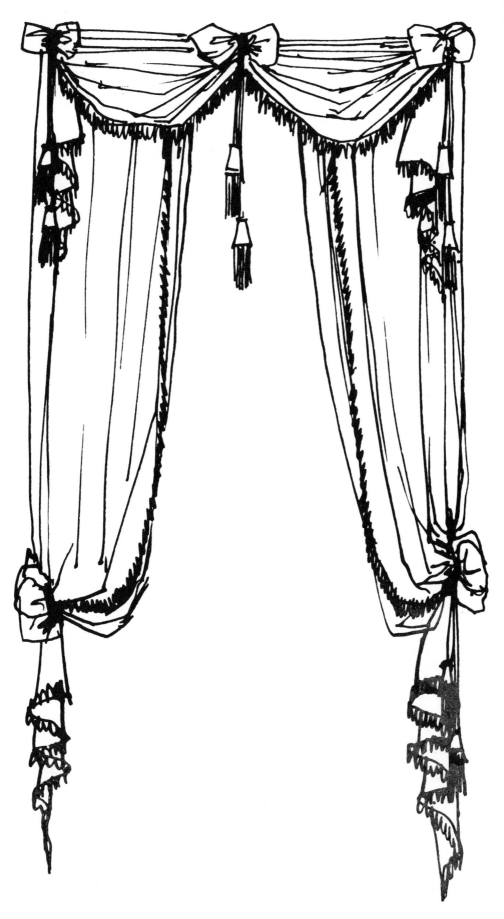

28

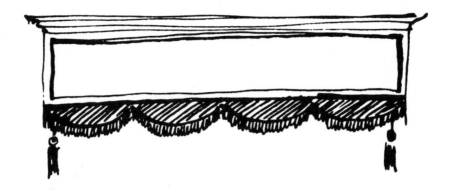

29

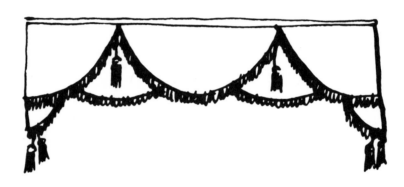

30

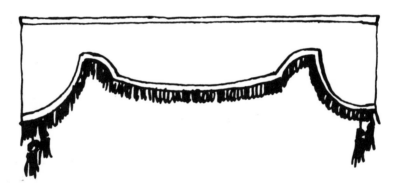

31

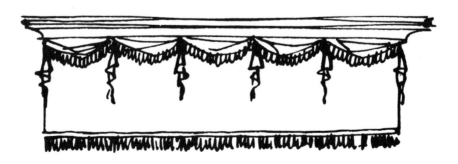

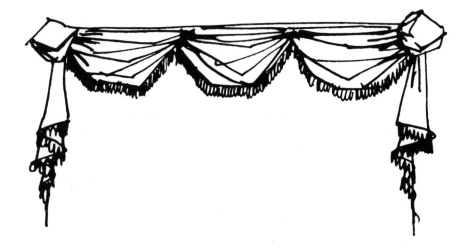

32

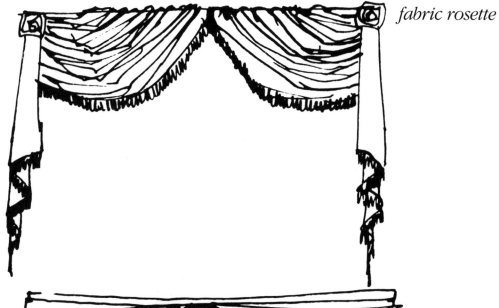

fabric rosette

33

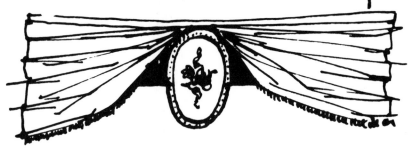

34

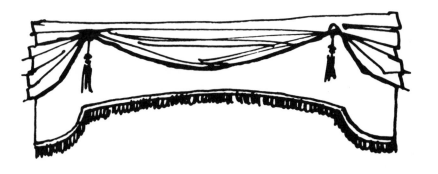

35

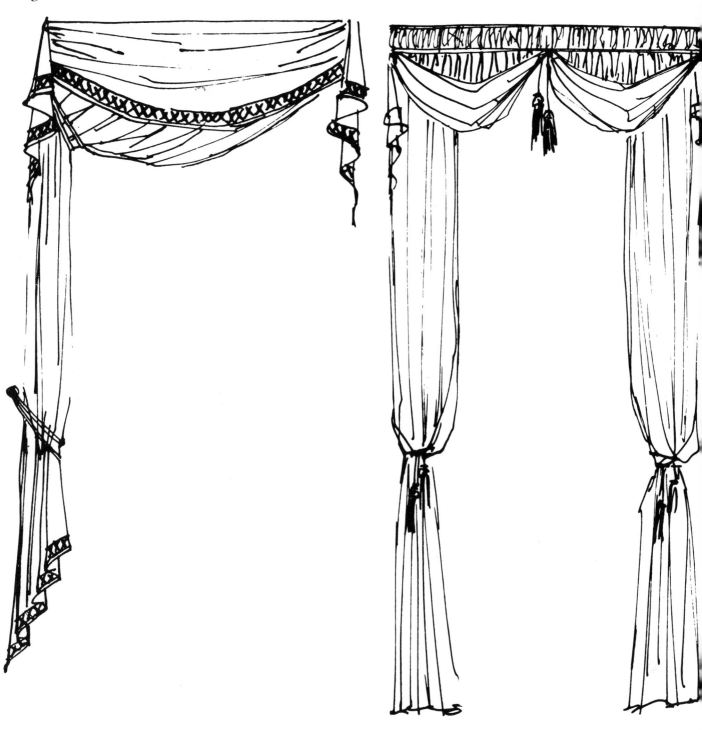

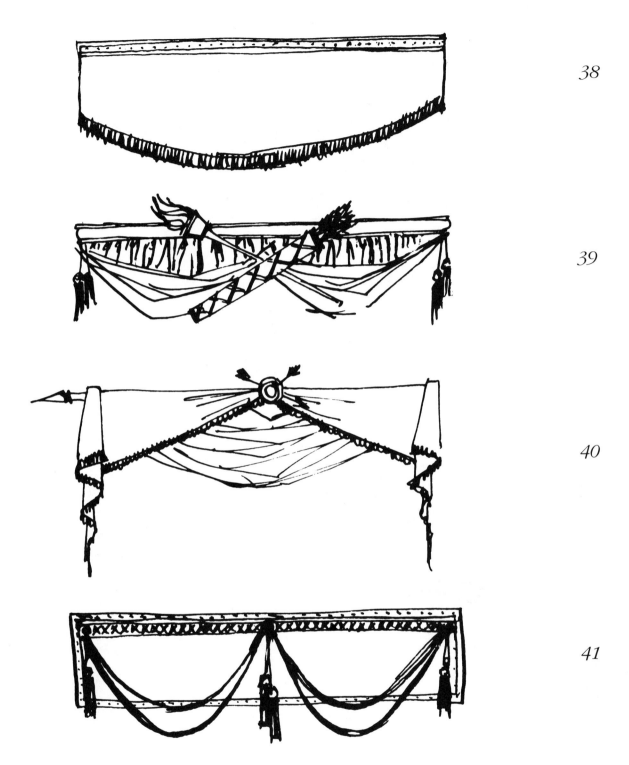

38

39

40

41

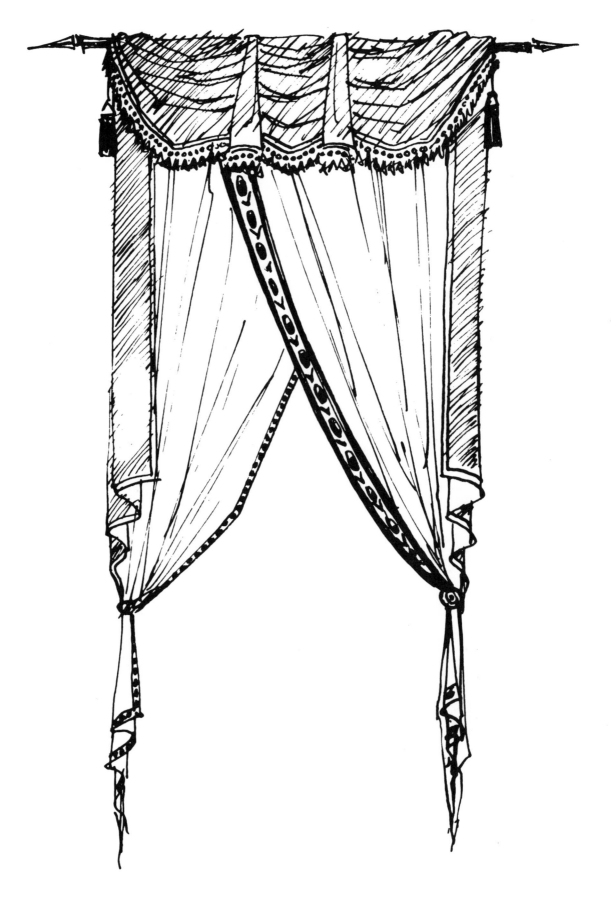

42

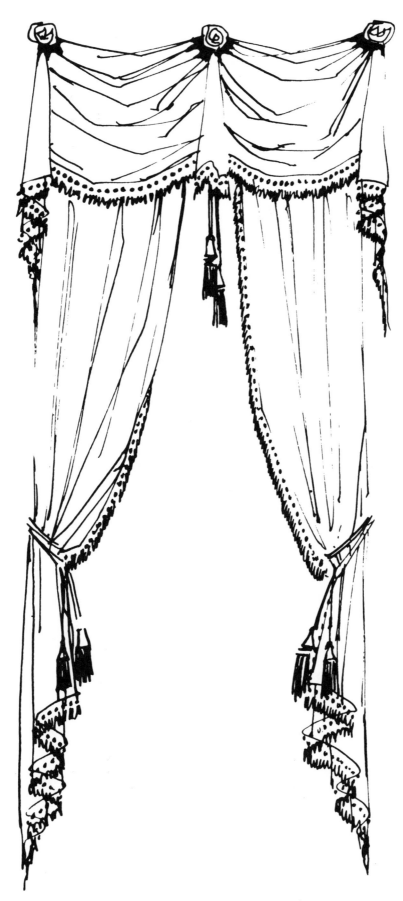

43

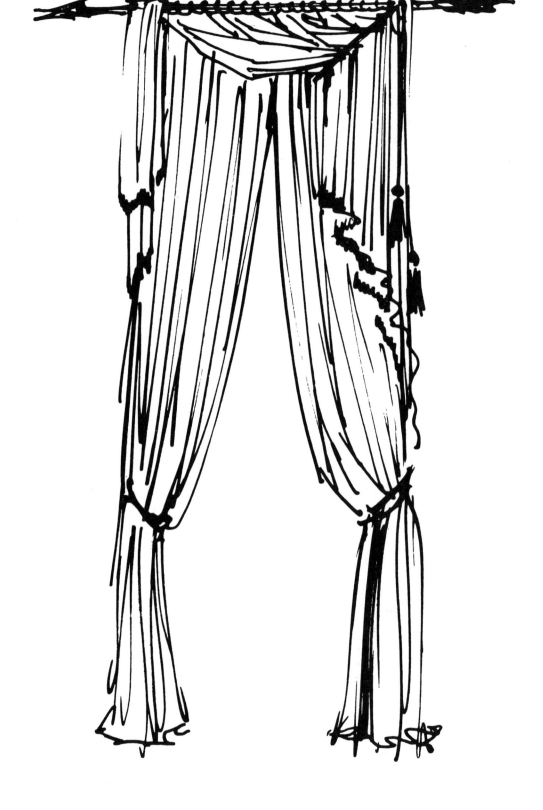

44

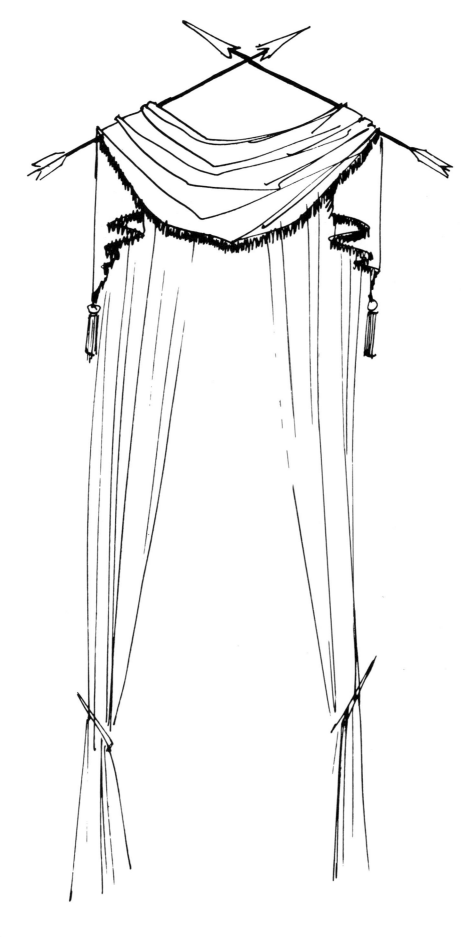

45

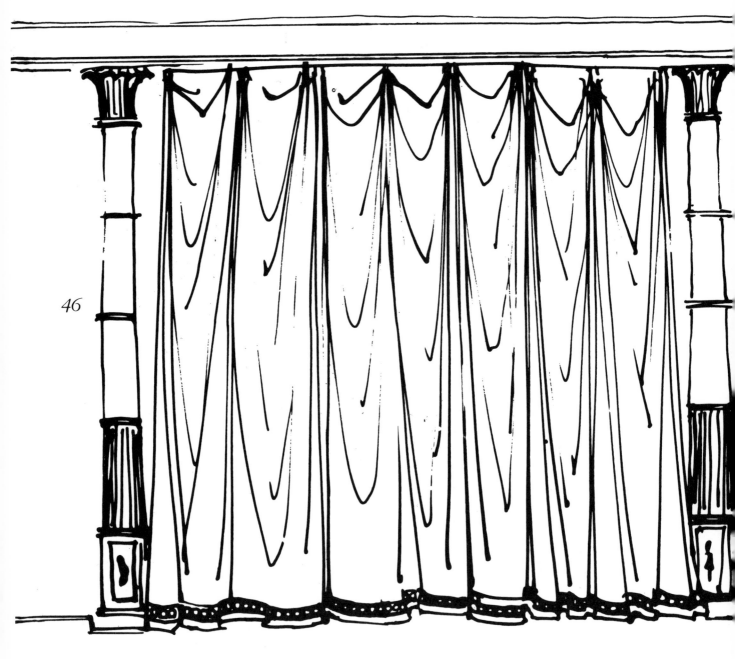

46

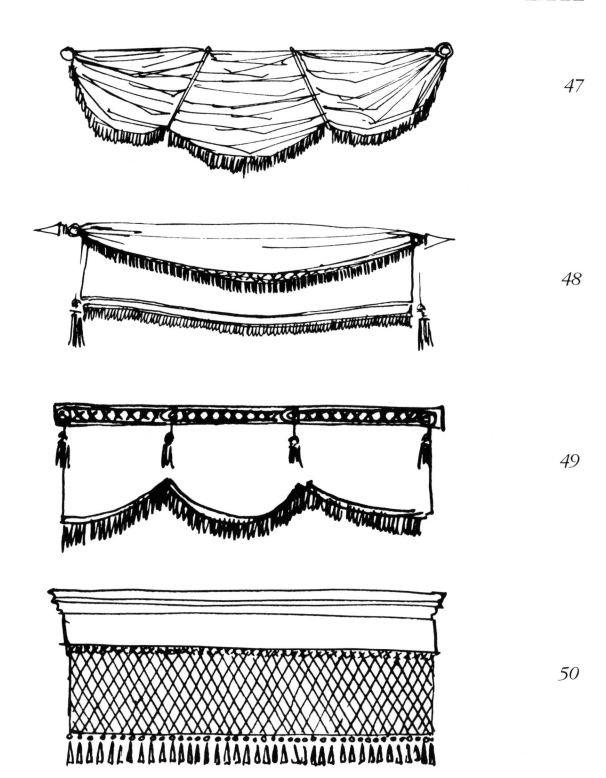

47

48

49

50

51

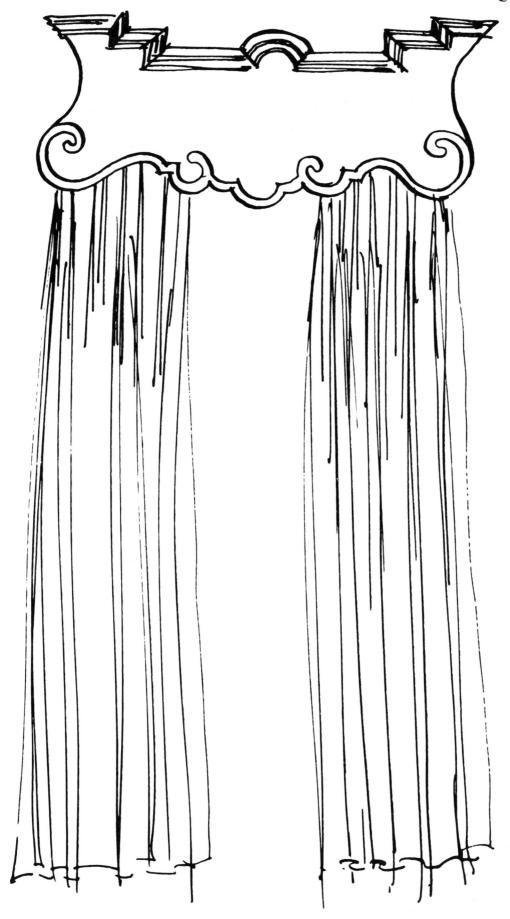

52

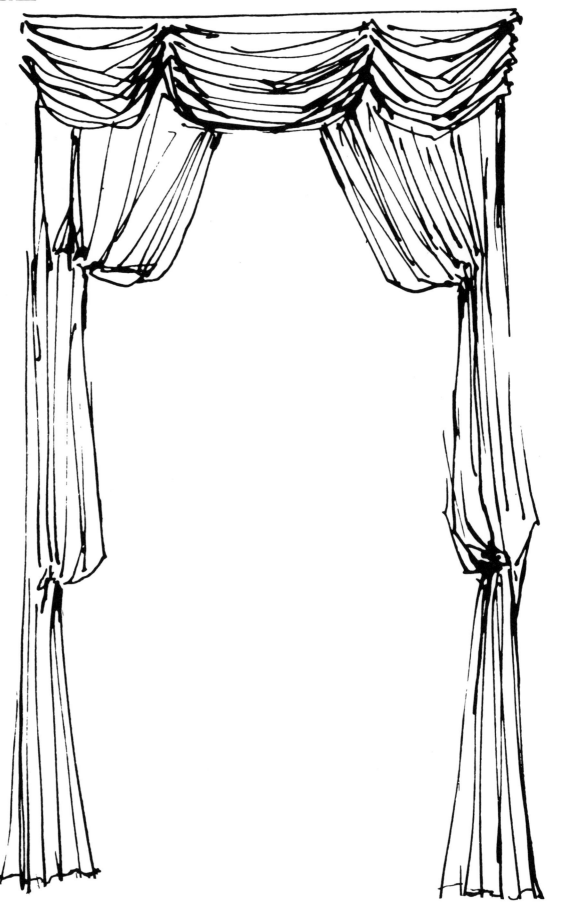

53

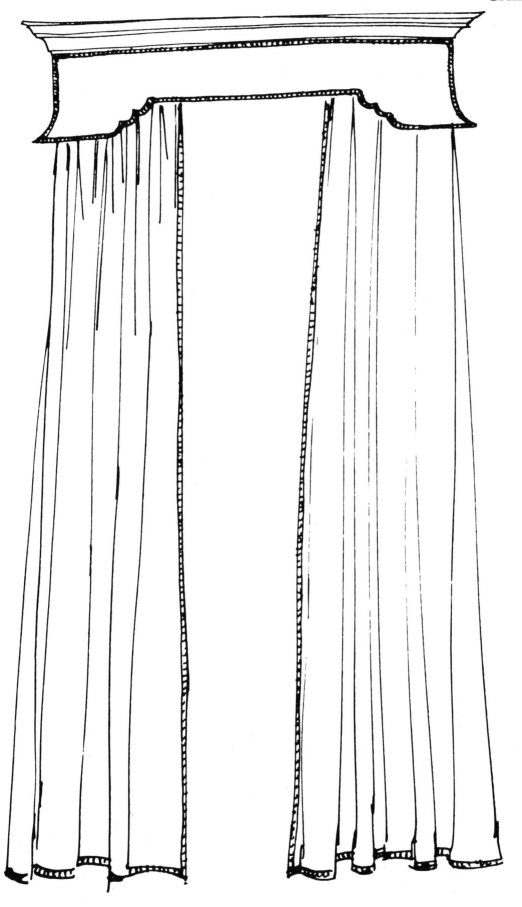

54

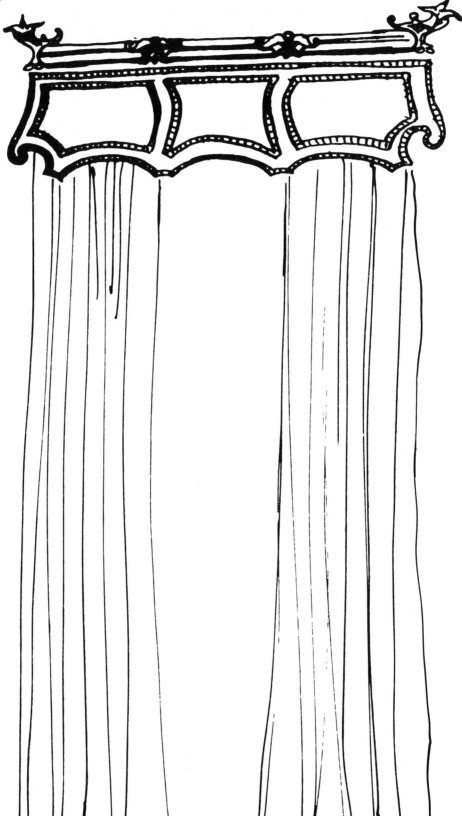

55

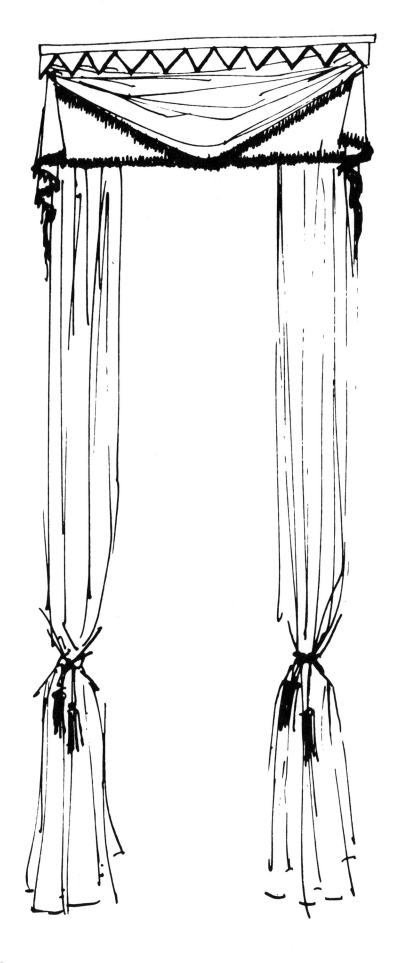

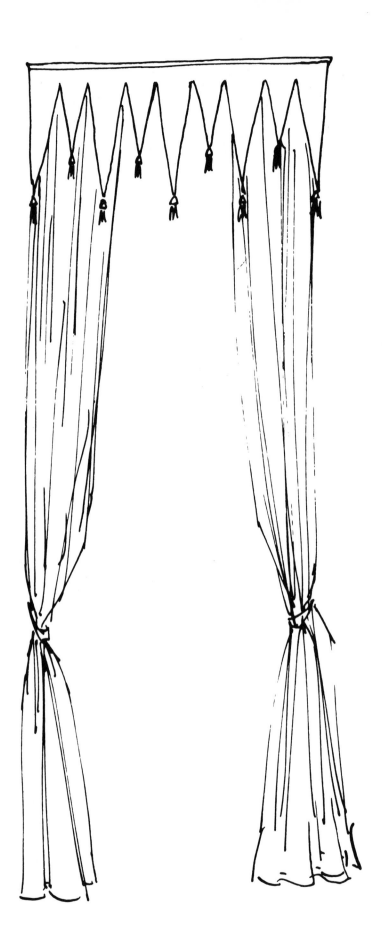

57

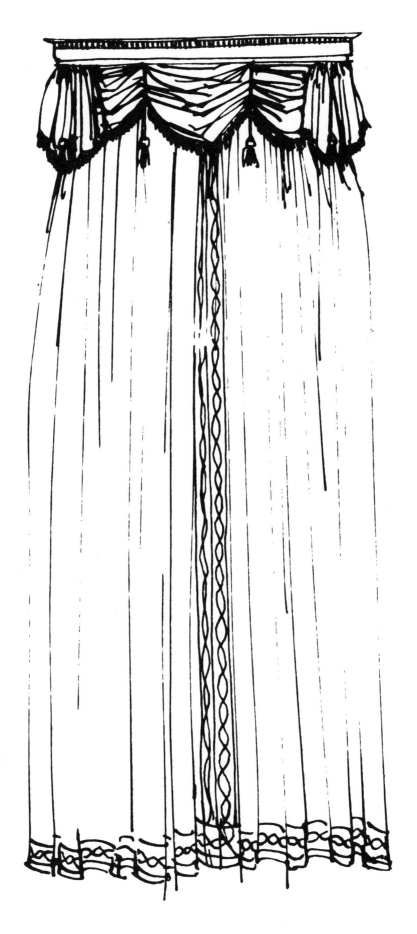

58

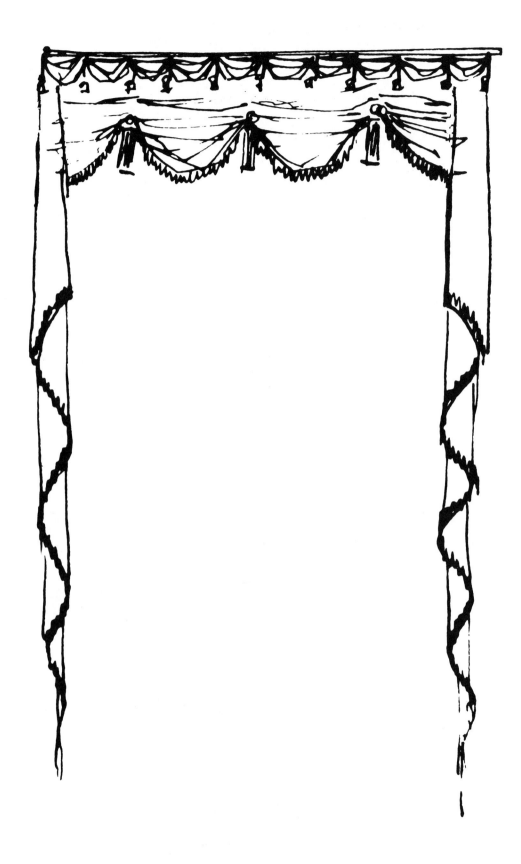

59

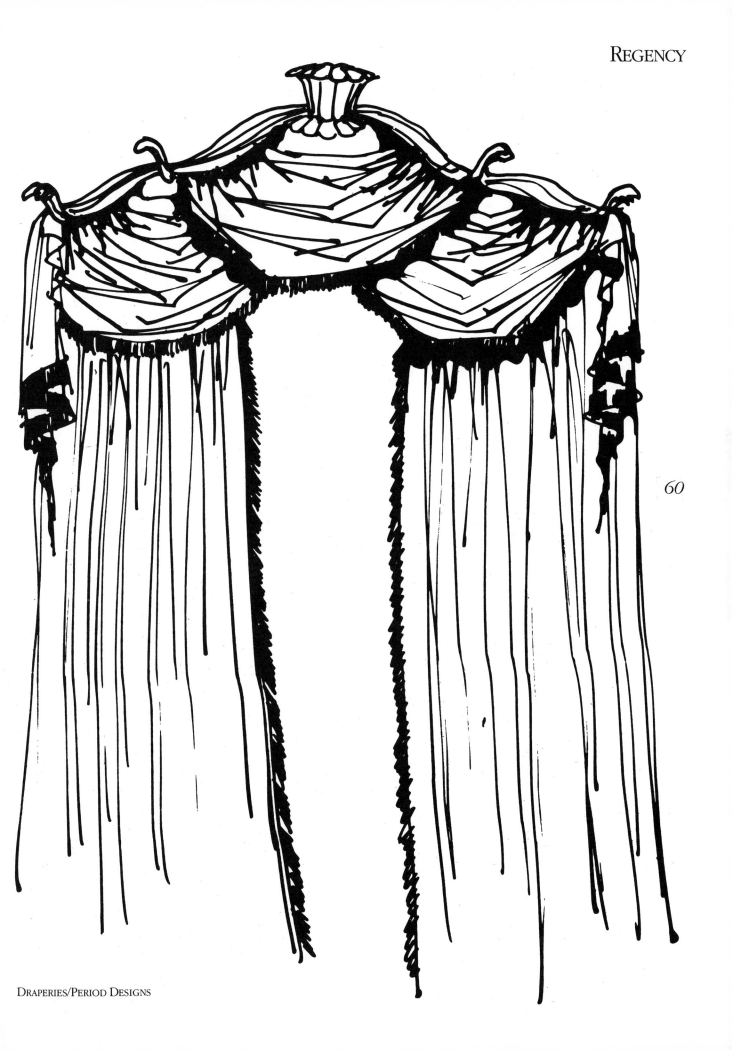

60

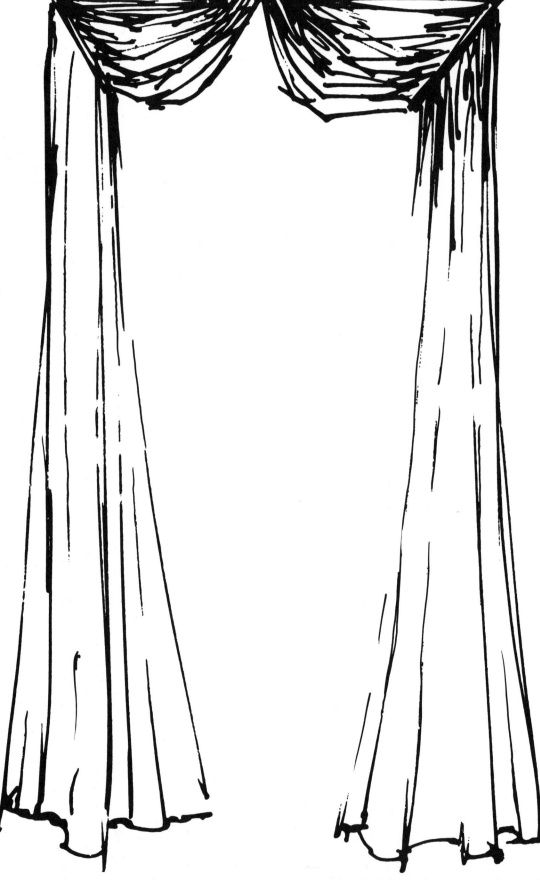

61

Formal Designs

metal medallions

62

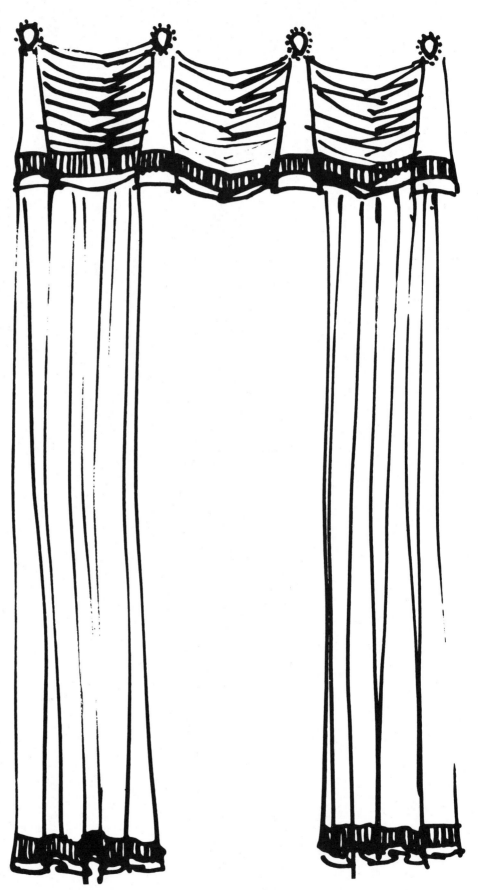

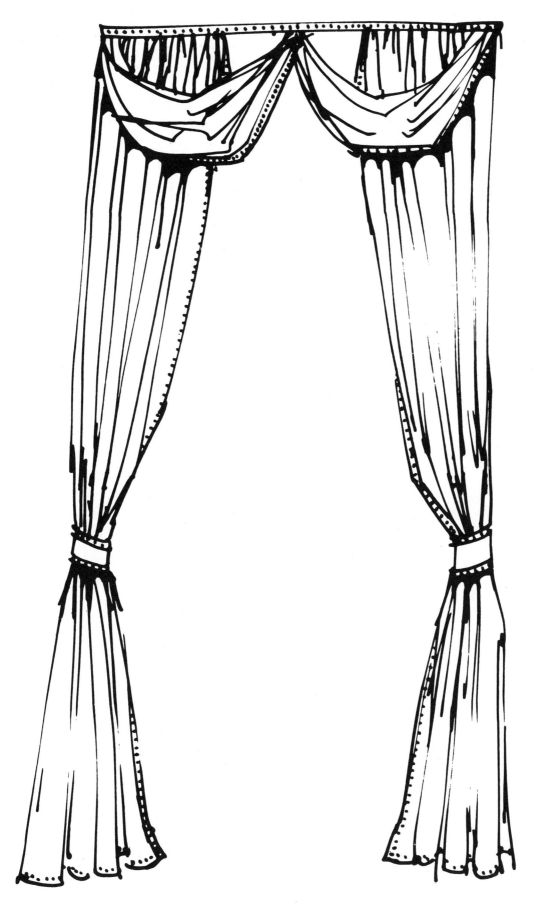

63

64

65

66

67

68

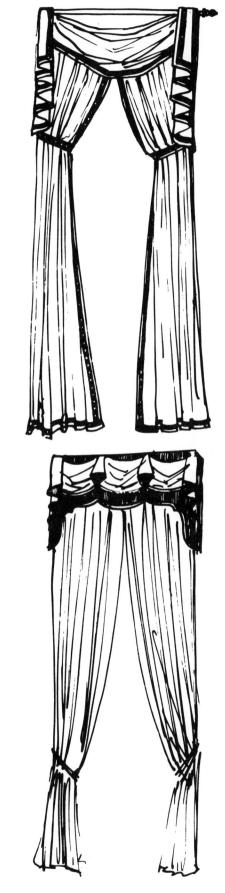

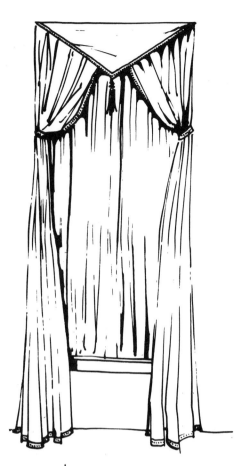69

70

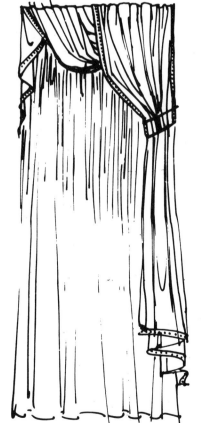71

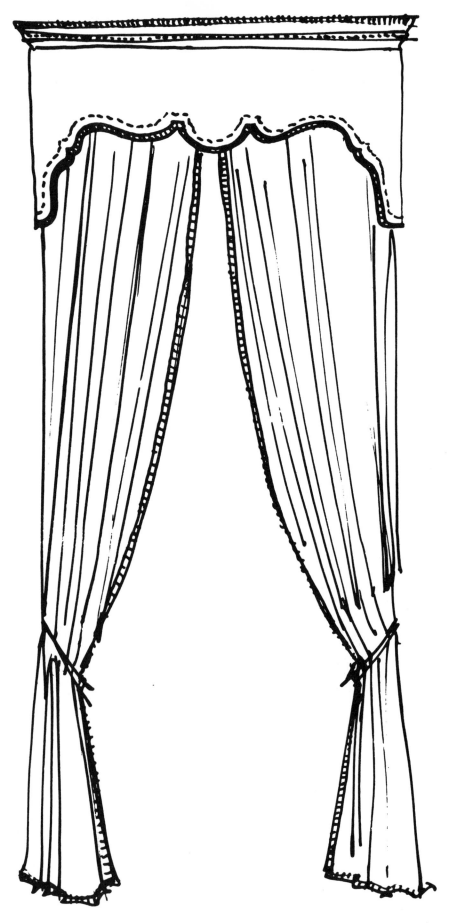

72

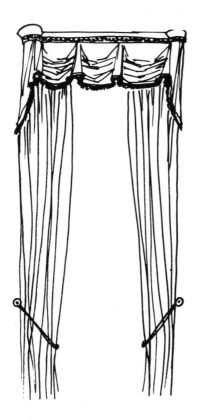

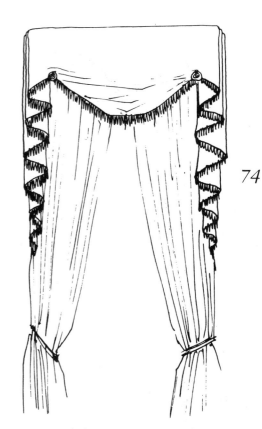

*valance and curtain
seem to be one piece
drawn up with loops
and drawstring*

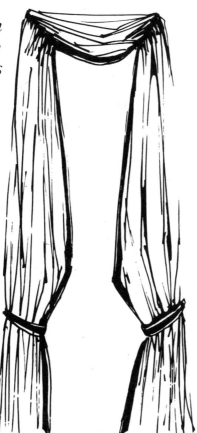

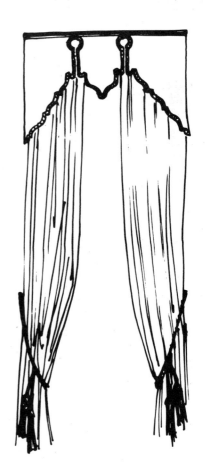

sheer curtains with
over panels heavier fabric

77

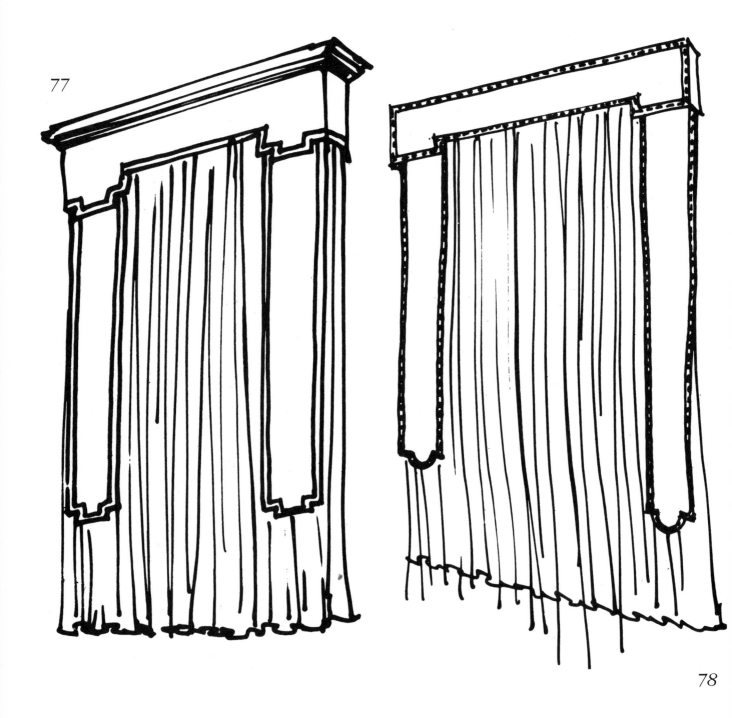

78

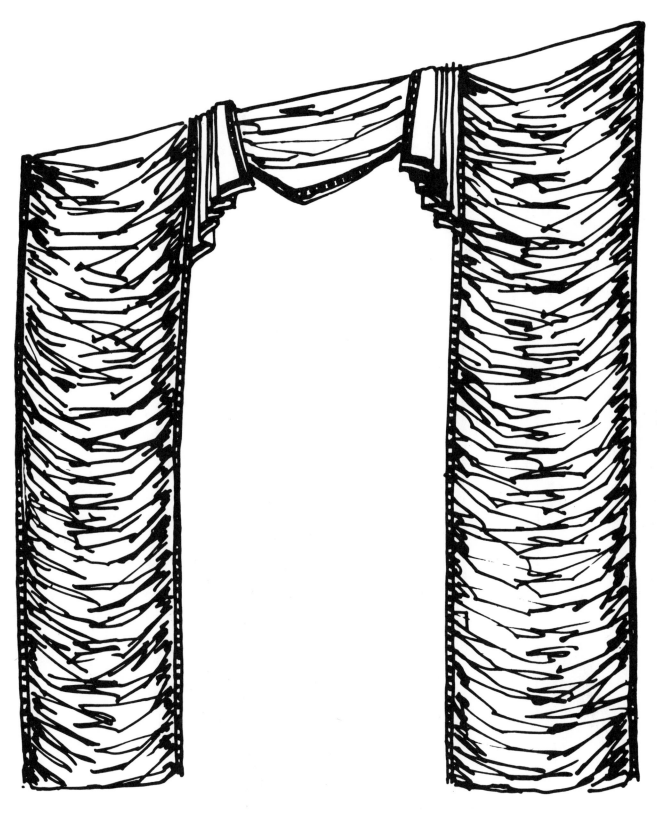

79

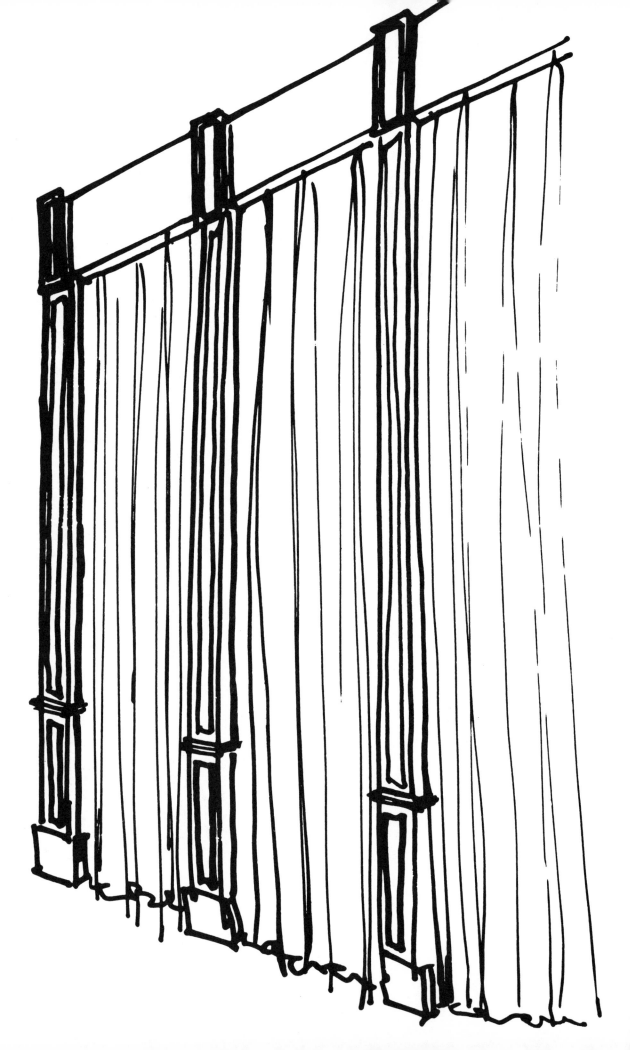

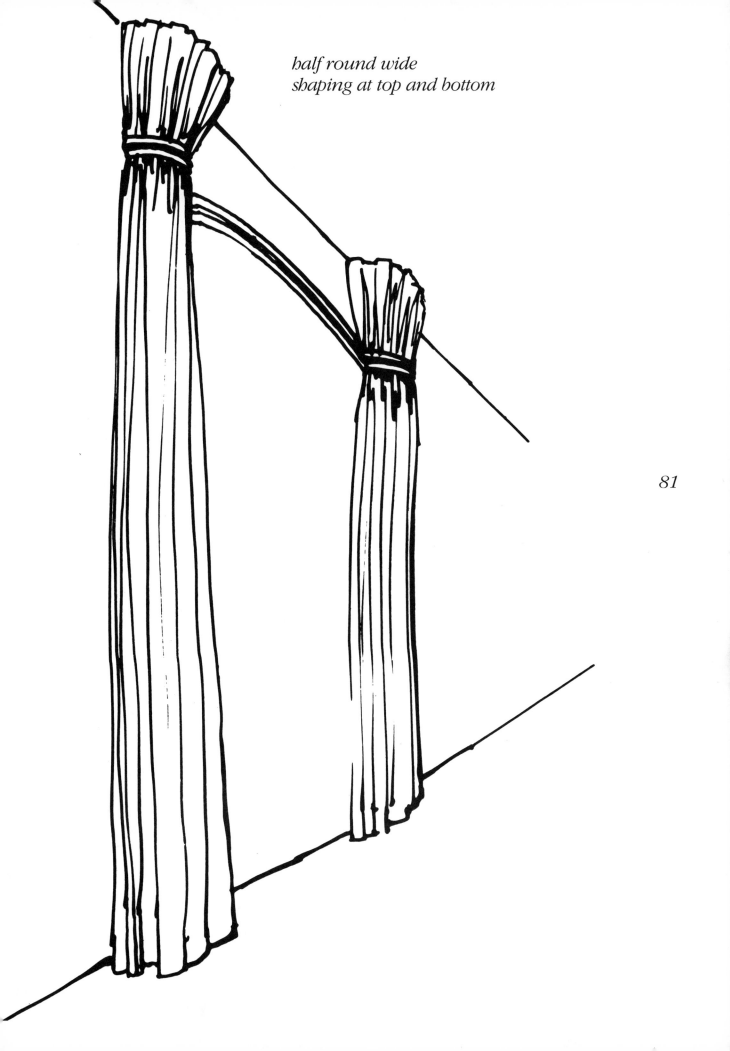

*half round wide
shaping at top and bottom*

81

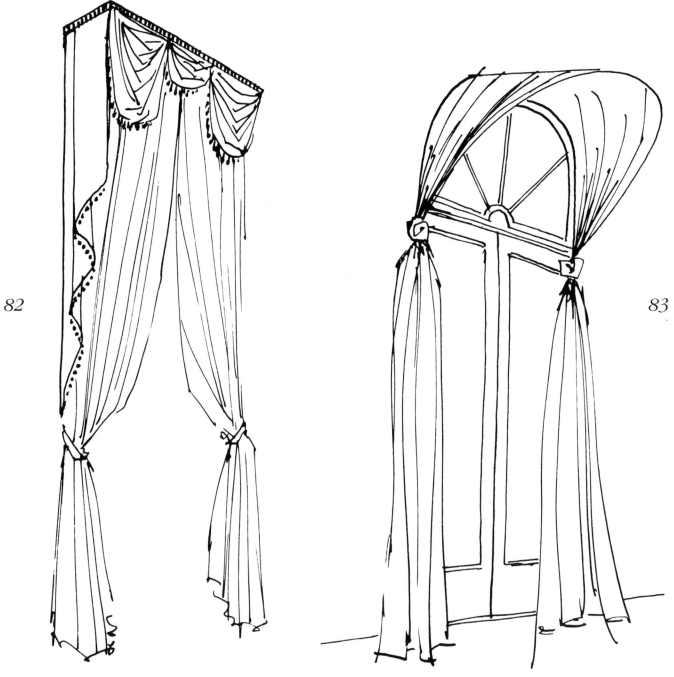

82

83

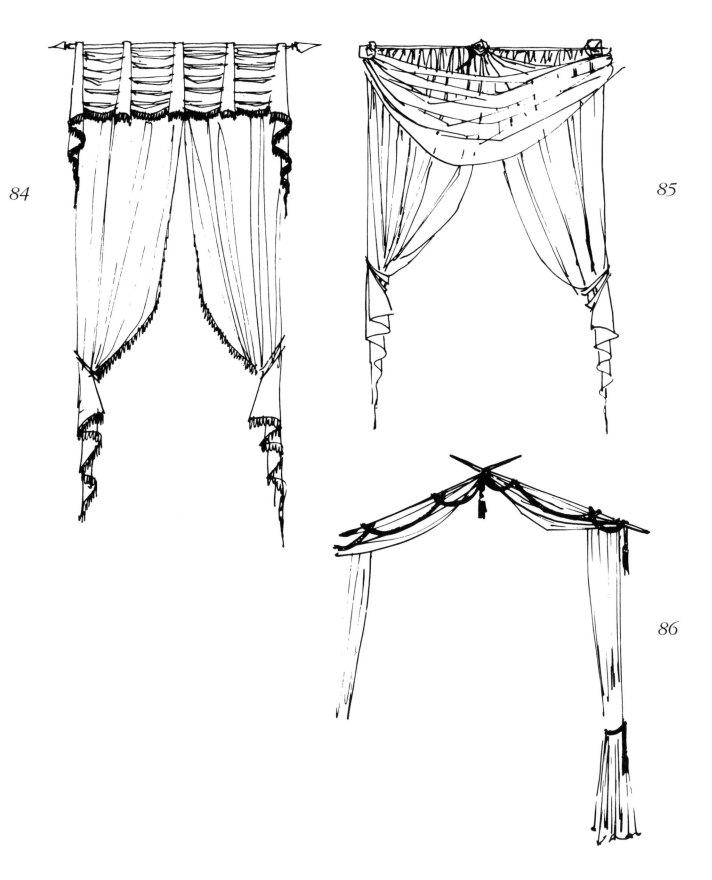

84

85

86

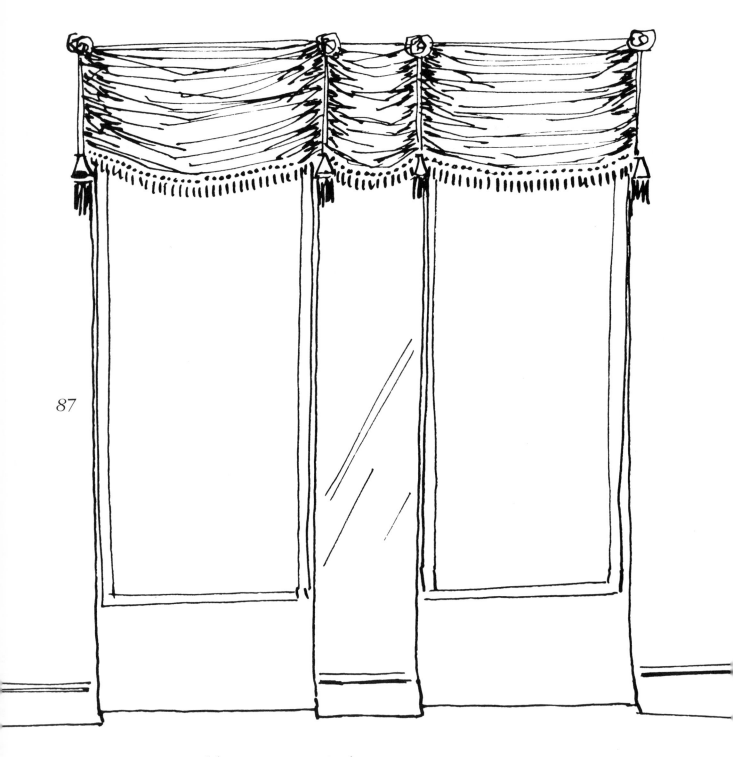

87

mirror panel between two windows,
valance continuing over

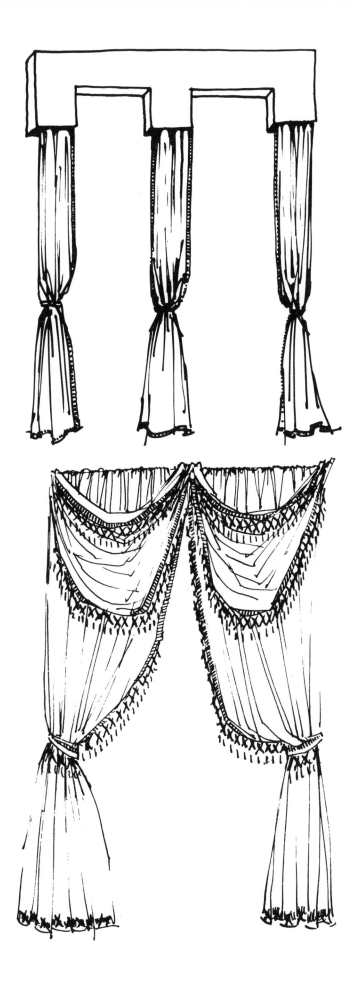

88

89

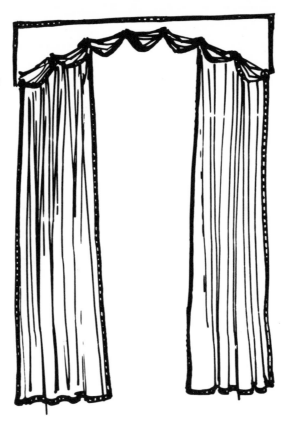

fabric rosettes

90

*elaborate cornice and curtains
in "trompe l'oeil" with
real undercurtains*

91

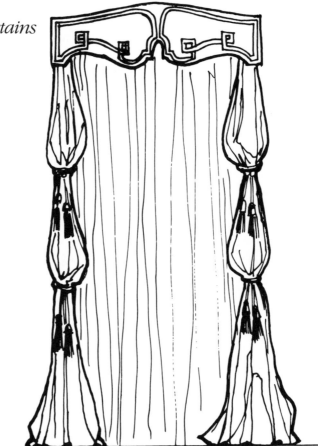

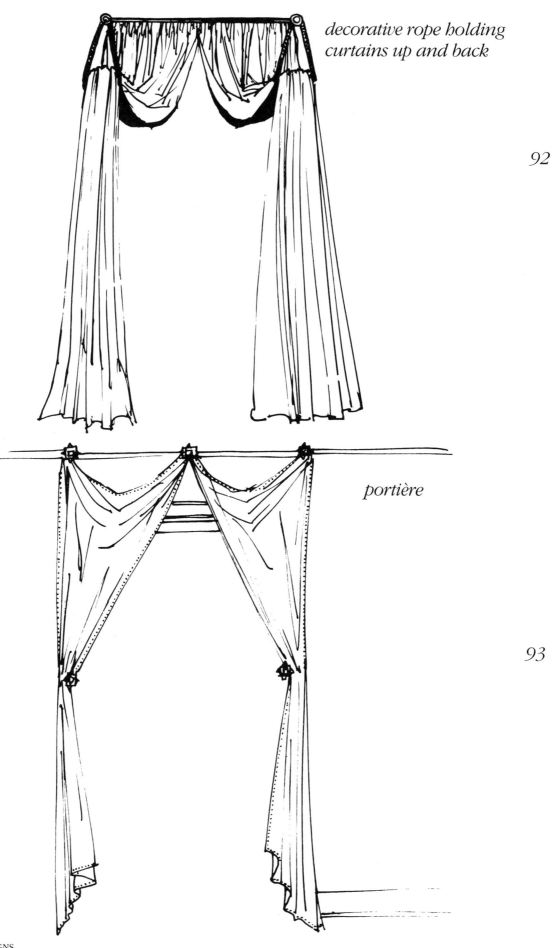

*decorative rope holding
curtains up and back*

92

portière

93

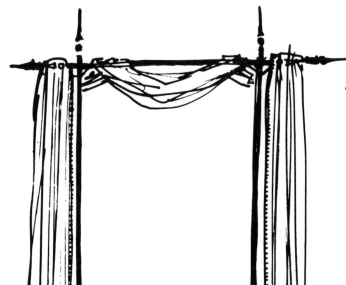

tie poles with cord

94

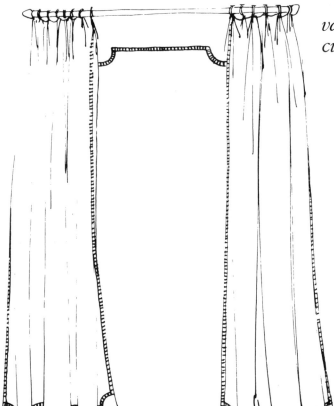

valance behind curtains and covered rod

95

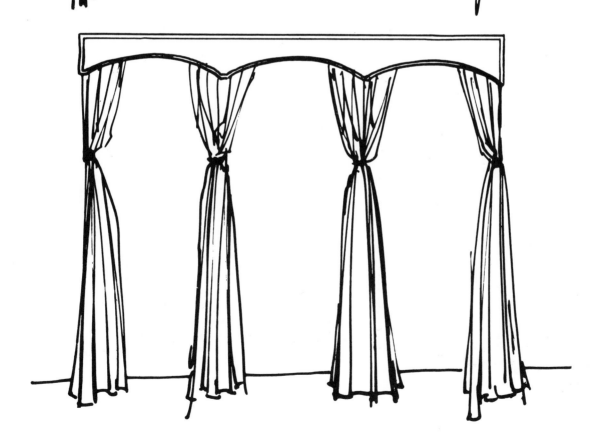

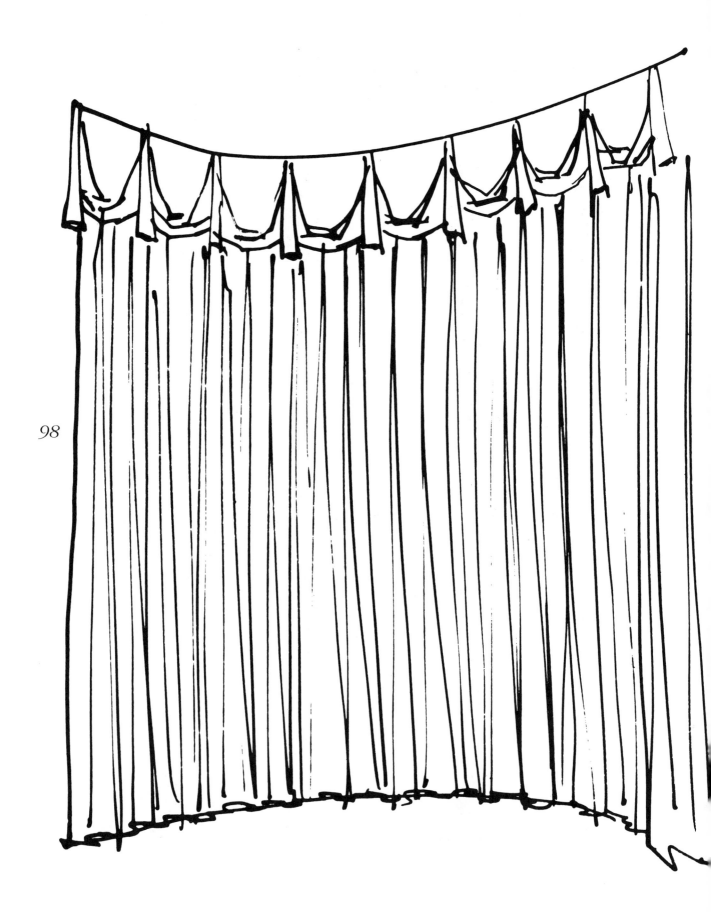

98

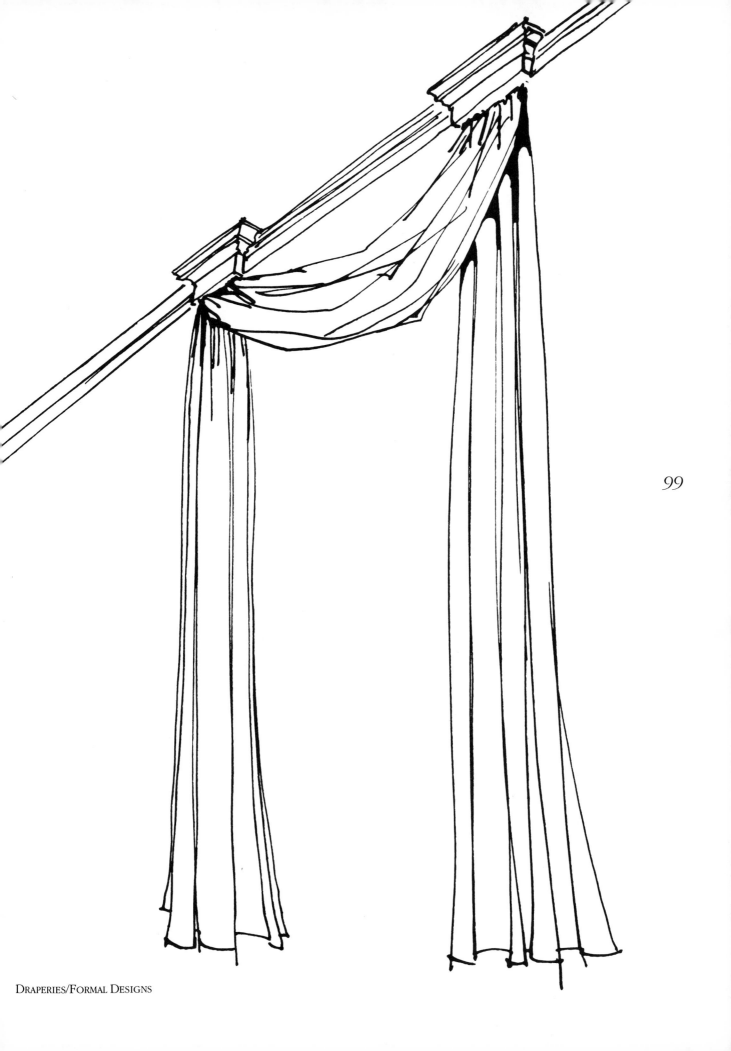

99

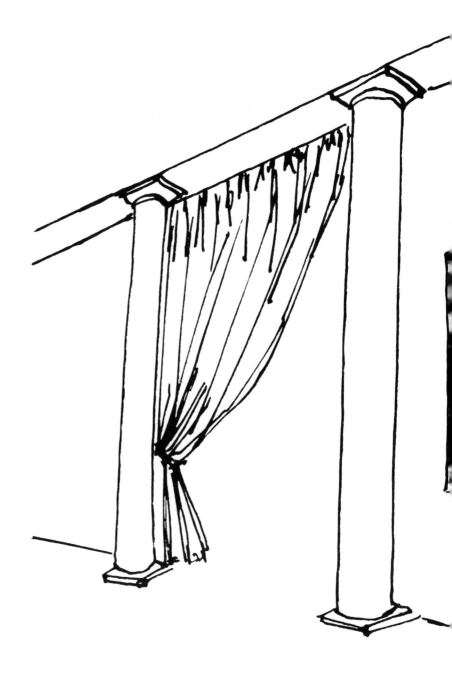

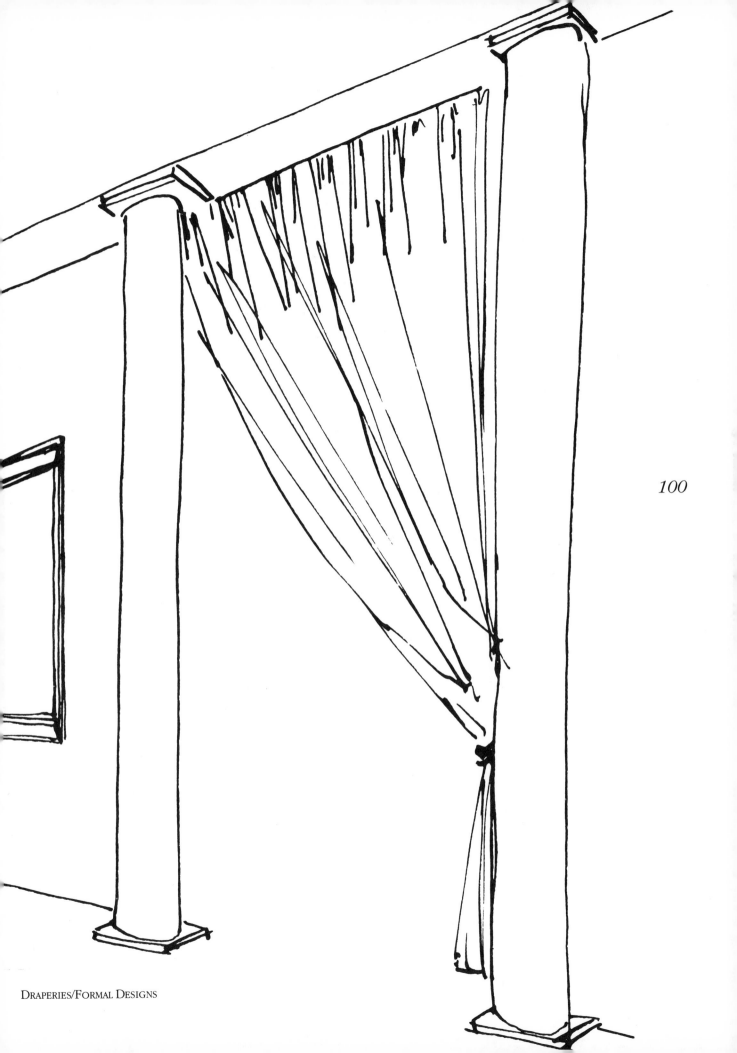

100

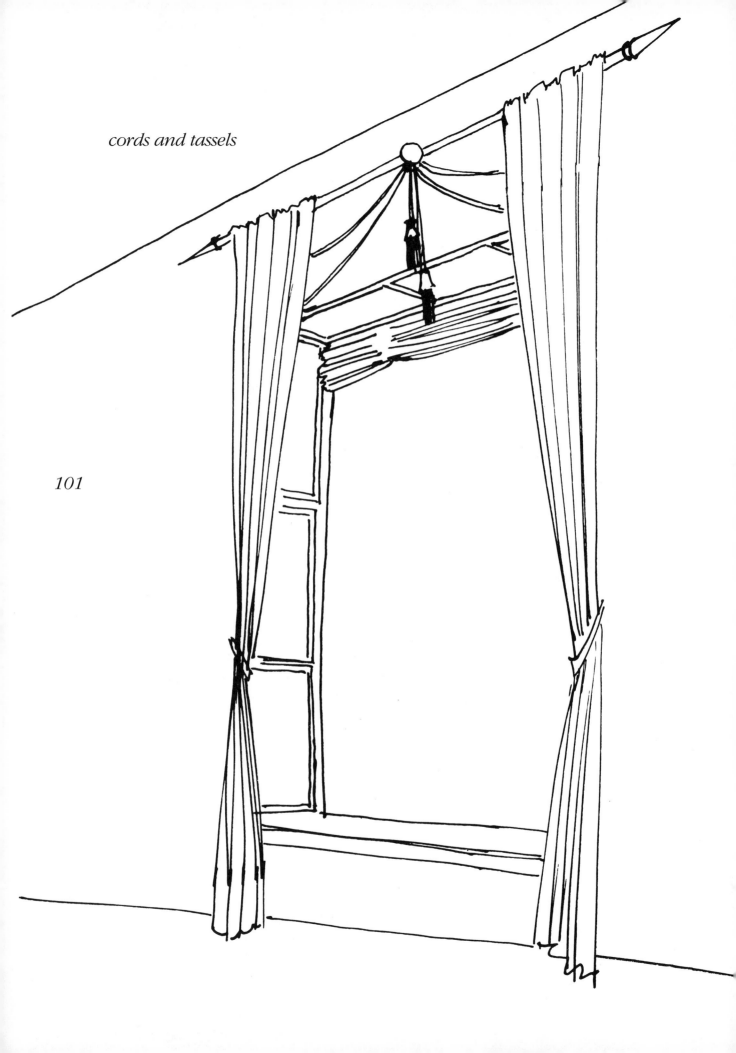

cords and tassels

French door treatment
allowing doors to open

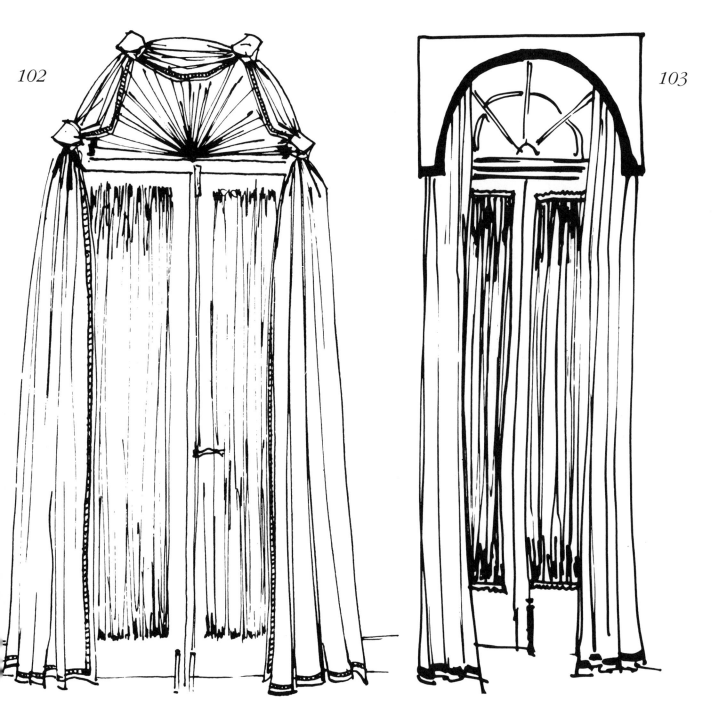

102

103

curtains hanging on doors
for easy passage

shell cornice

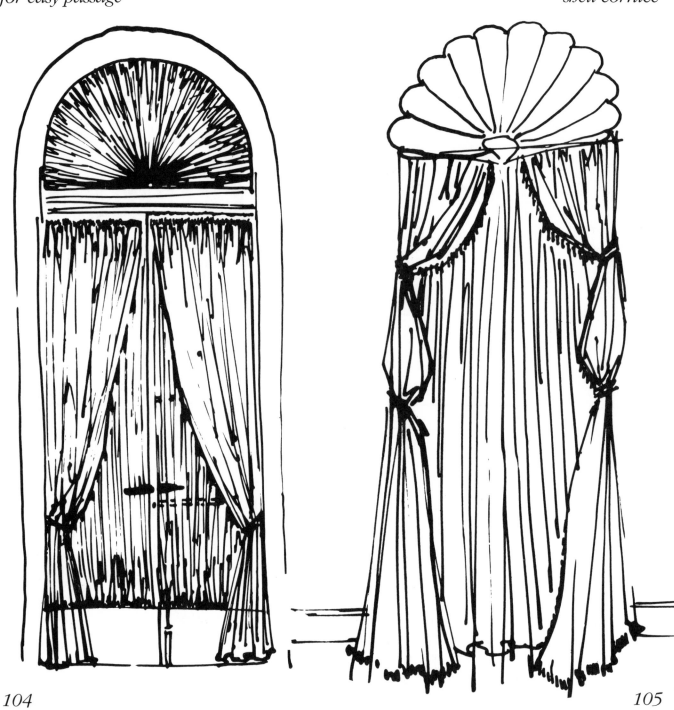

104

105

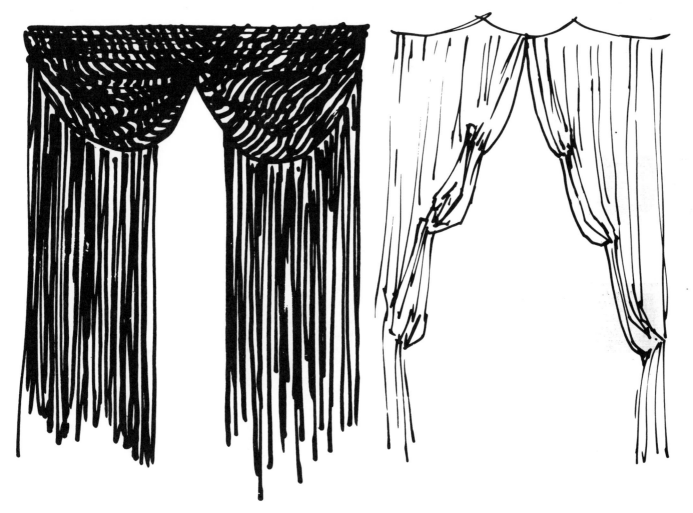

*vertical strips on curtains,
diagonal on swags*

*drapery panels swagged at edge
and drawn back with a cord
running through rings*

*two fabrics, print for
lining and tie-backs*

*metal grill inserted at top of arch,
curtains installed behind,
or sheer curtains installed in front*

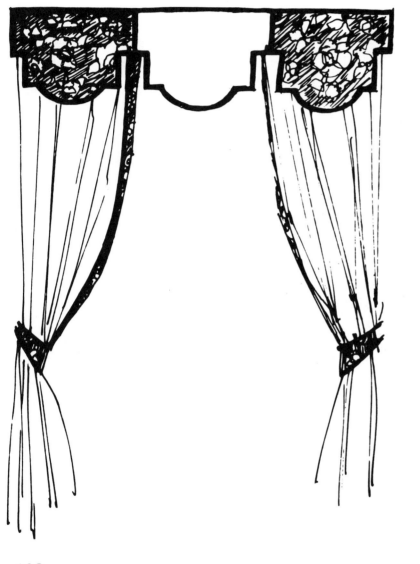

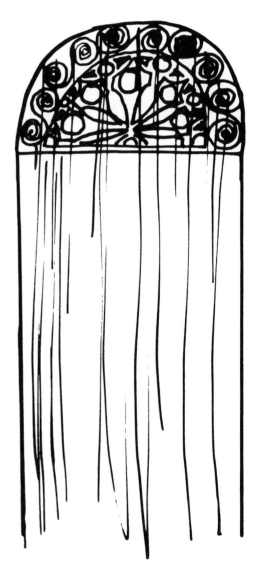

108

109

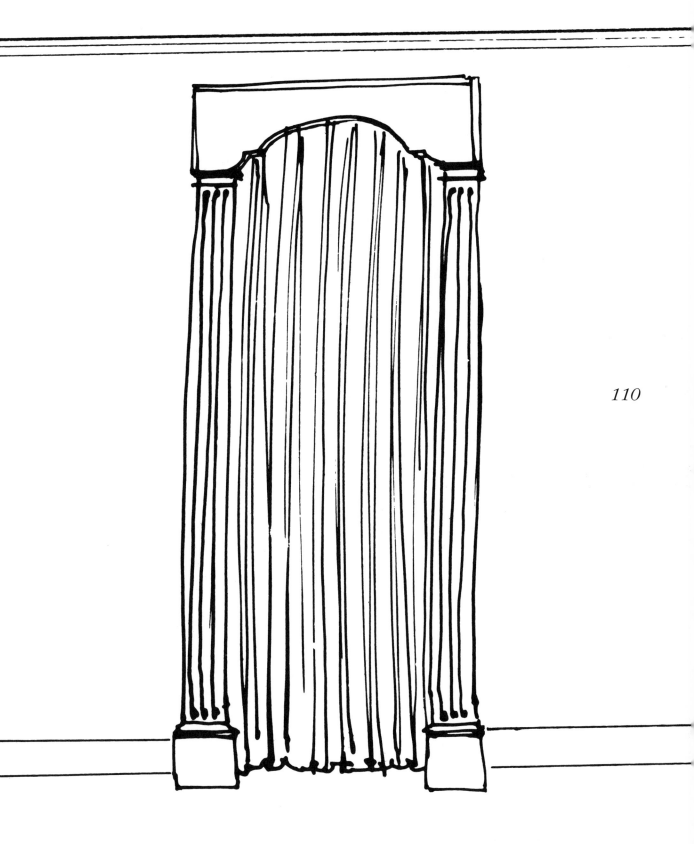

110

111

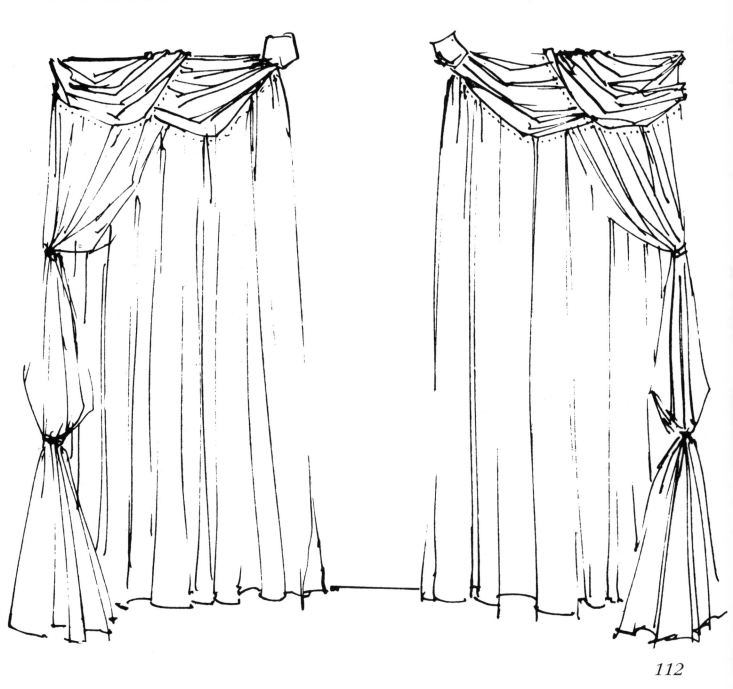

112

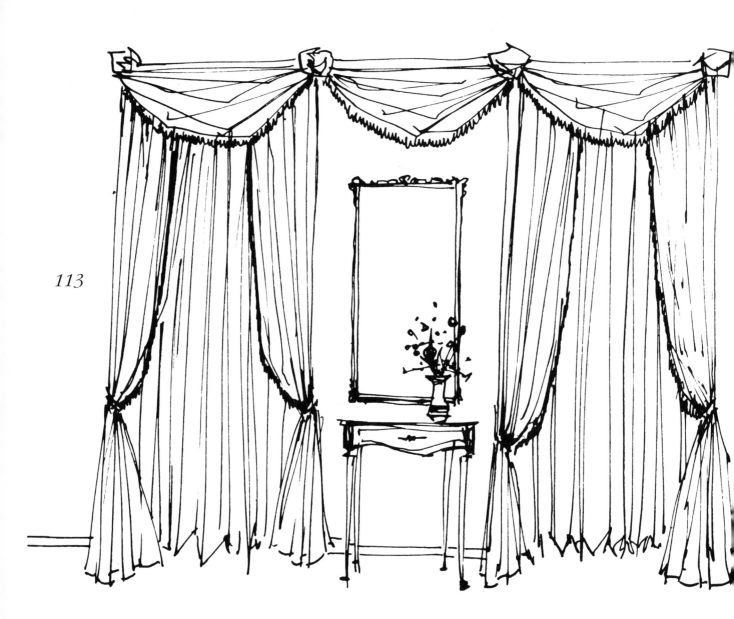

113

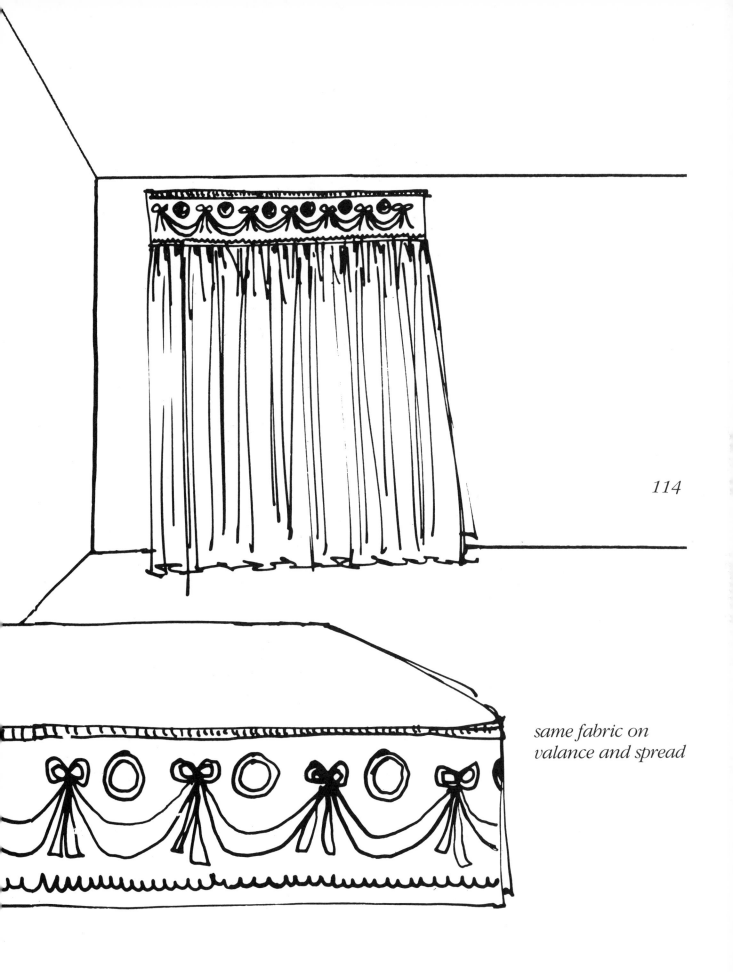

114

*same fabric on
valance and spread*

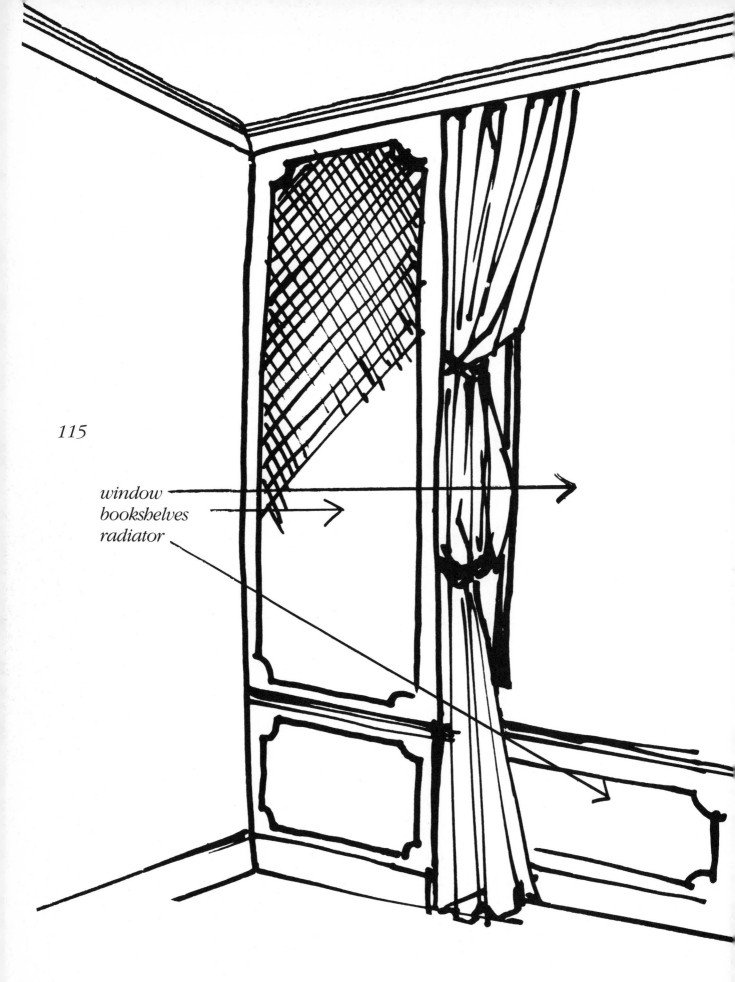

115

window
bookshelves
radiator

Casual Designs

116

*sheer curtains in front
of swag valance*

117

metal grill

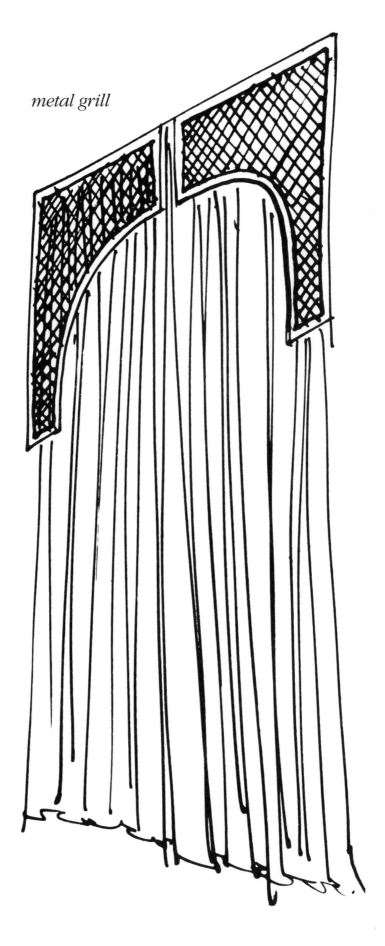

118

119

open frame with hanging tassels

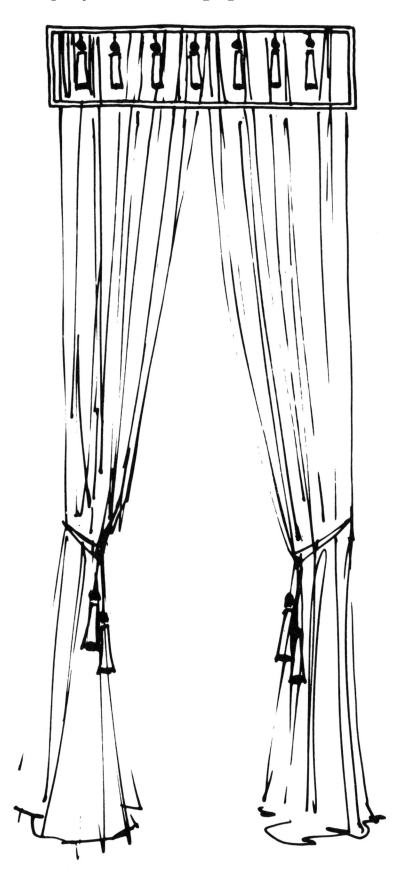

open bamboo design

121

*fabric-covered wooden frame
with curtains inside*

122

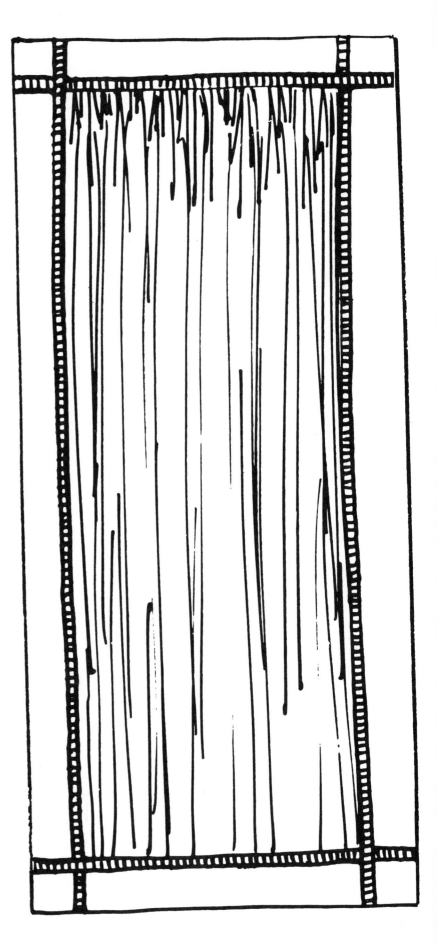

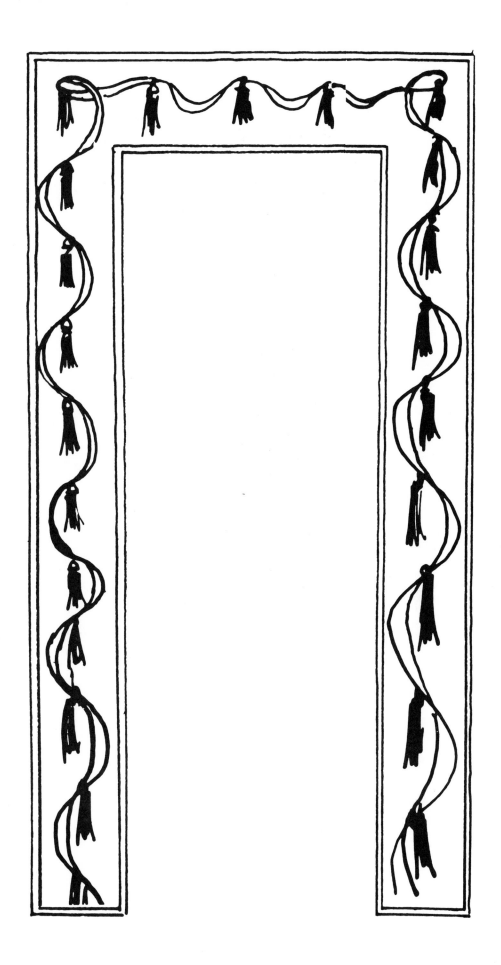

123

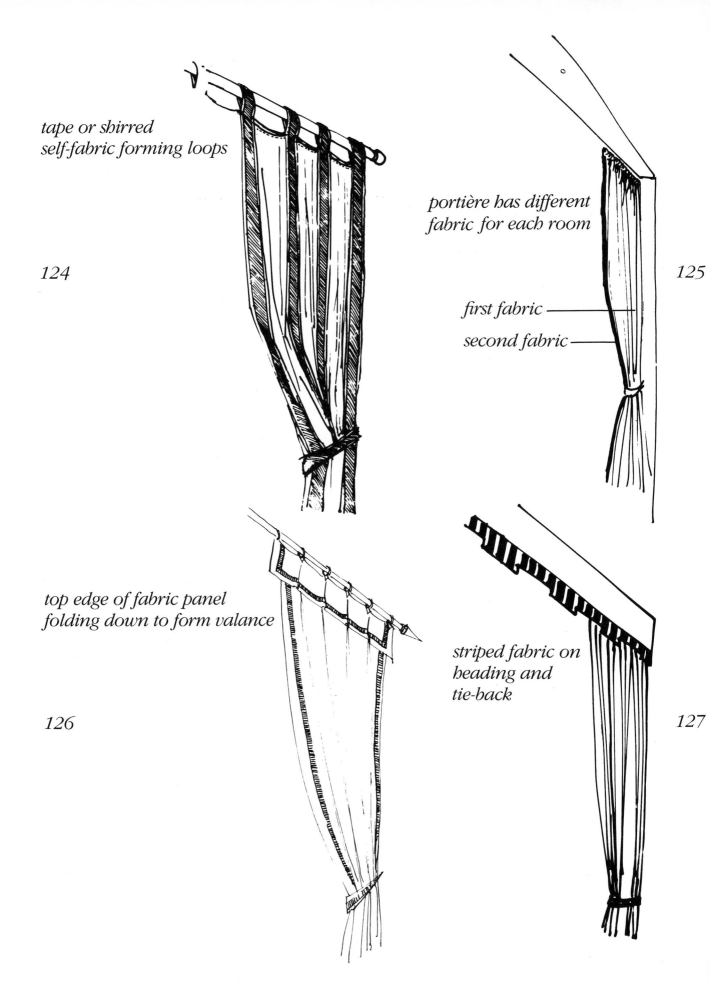

*tape or shirred
self-fabric forming loops*

124

*portière has different
fabric for each room*

125

first fabric —

second fabric —

*top edge of fabric panel
folding down to form valance*

126

*striped fabric on
heading and
tie-back*

127

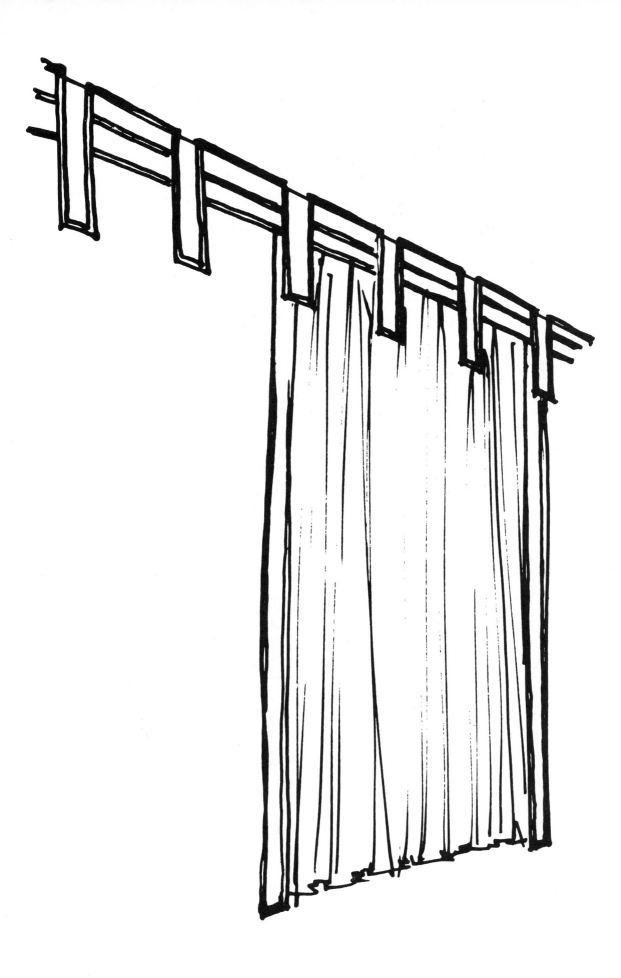

128

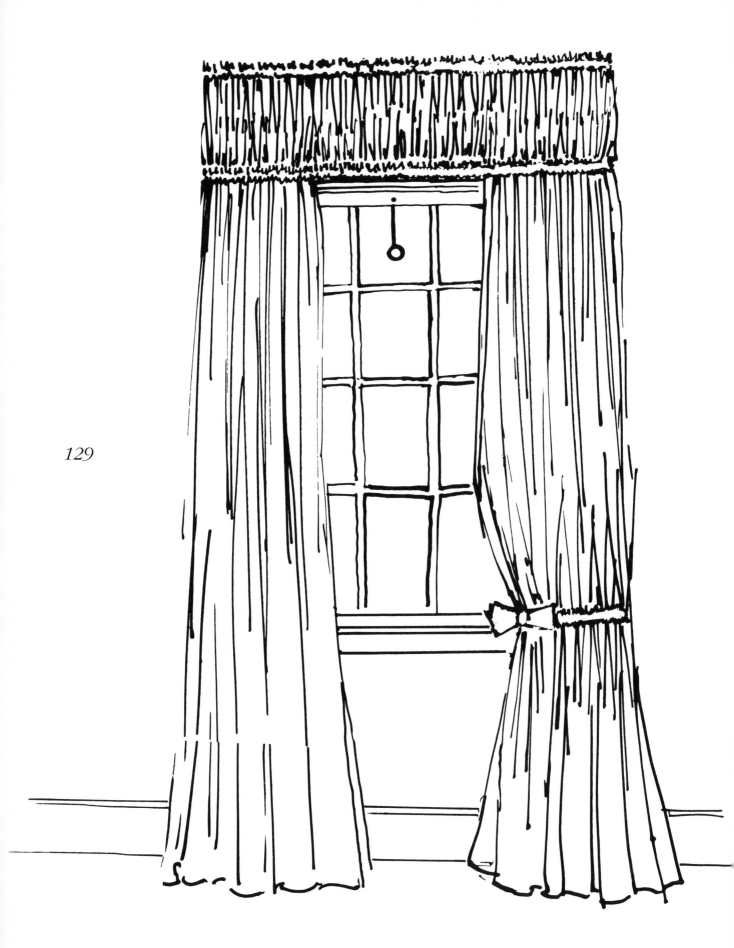

129

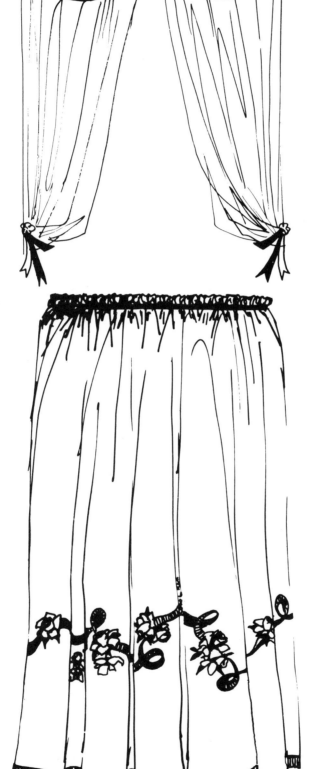

132

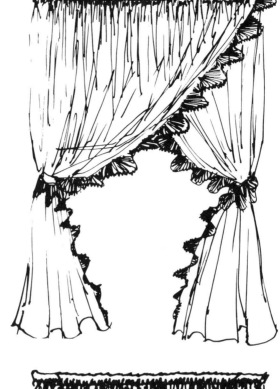

133

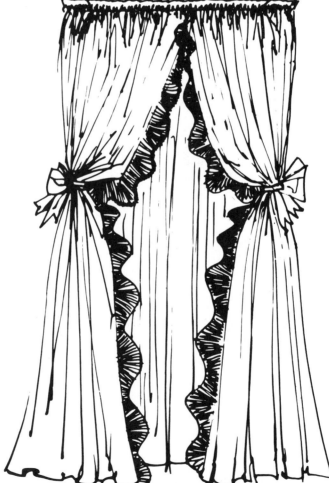

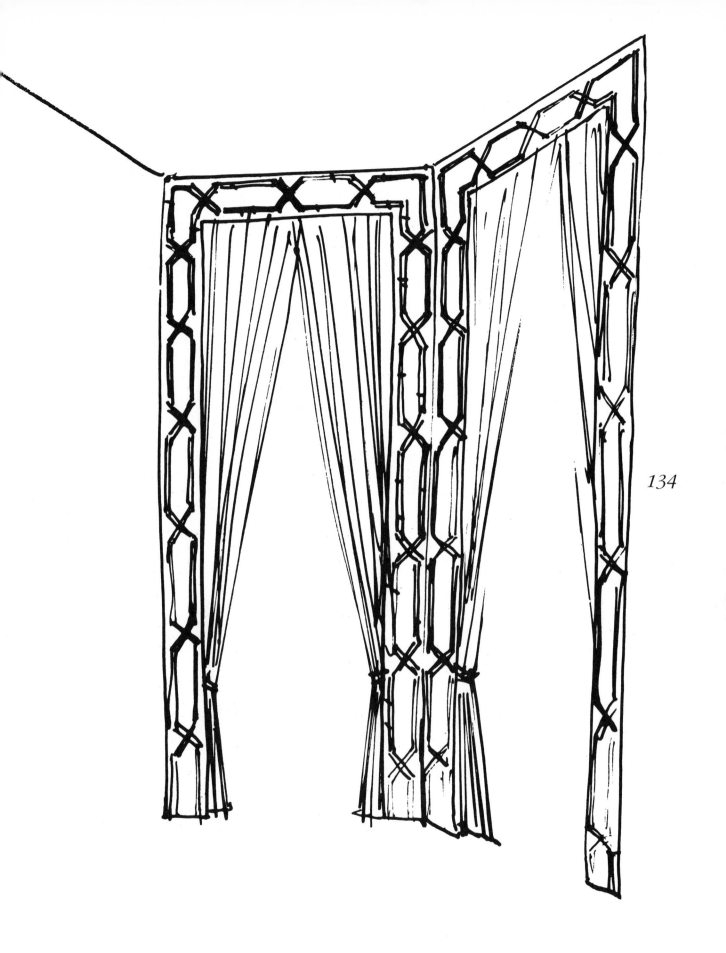

134

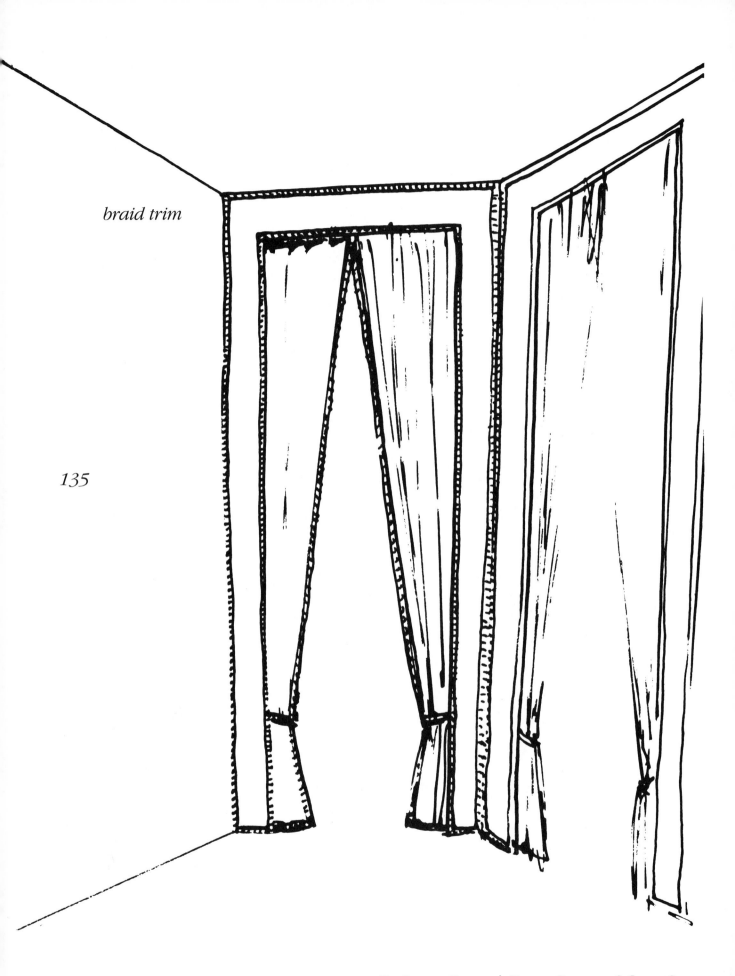

braid trim

135

bay window arches with sheer white curtains,
print of colored fabric above

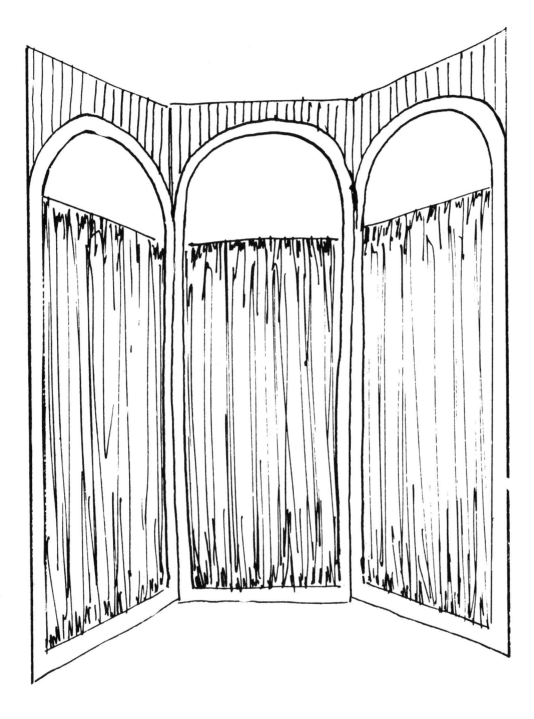

136

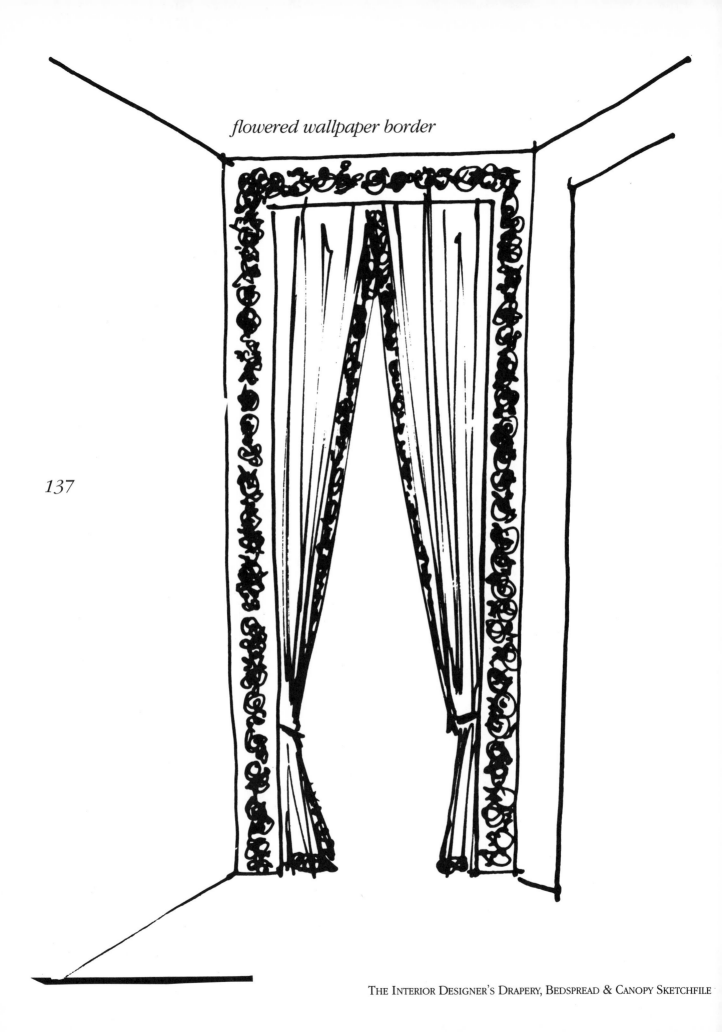

flowered wallpaper border

137

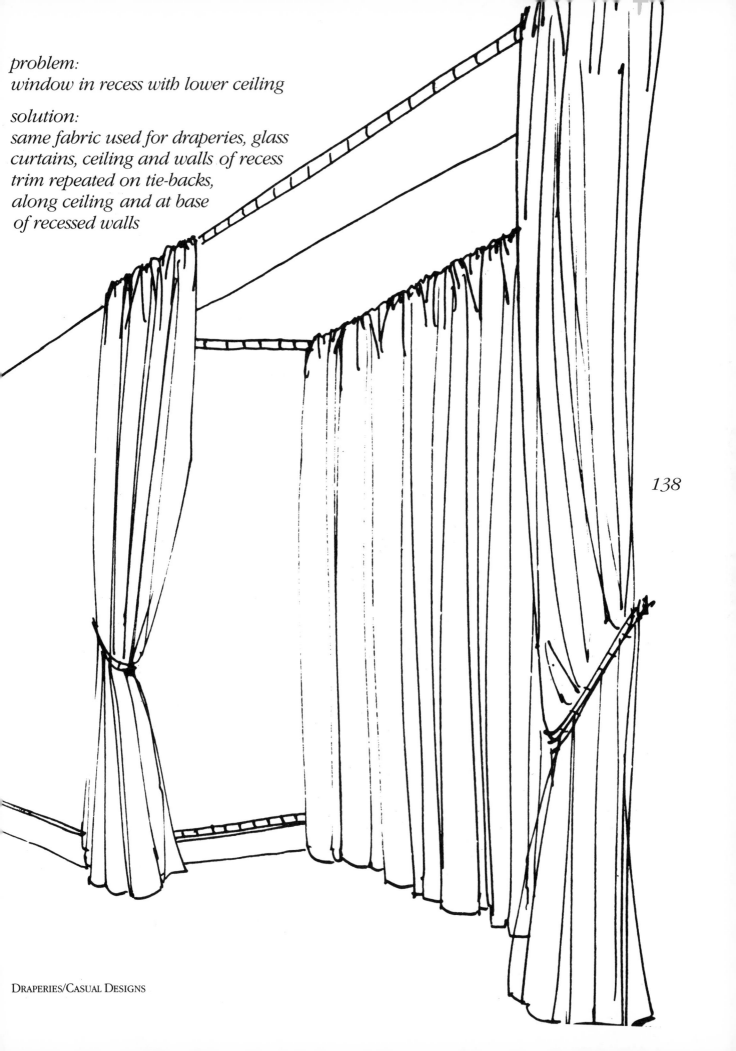

problem:
window in recess with lower ceiling

solution:
same fabric used for draperies, glass
curtains, ceiling and walls of recess
trim repeated on tie-backs,
along ceiling and at base
of recessed walls

138

DRAPERIES/CASUAL DESIGNS

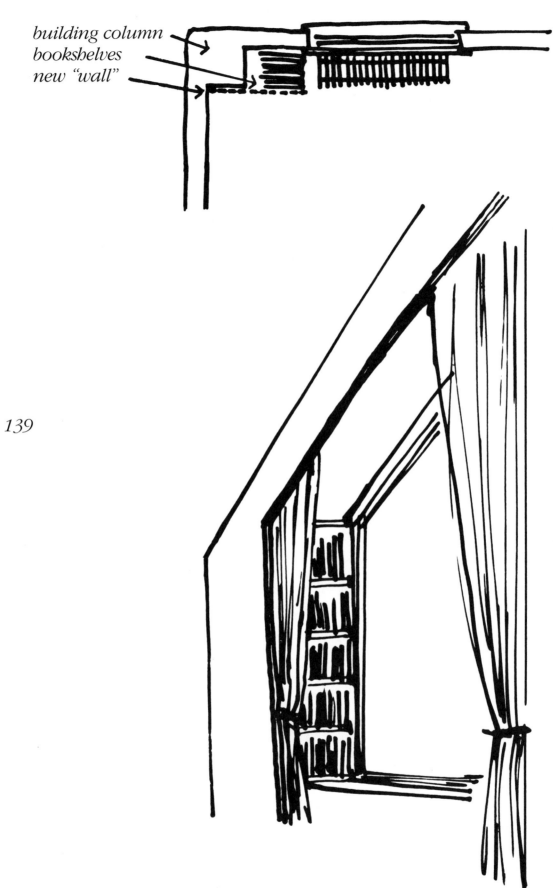

building column
bookshelves
new "wall"

139

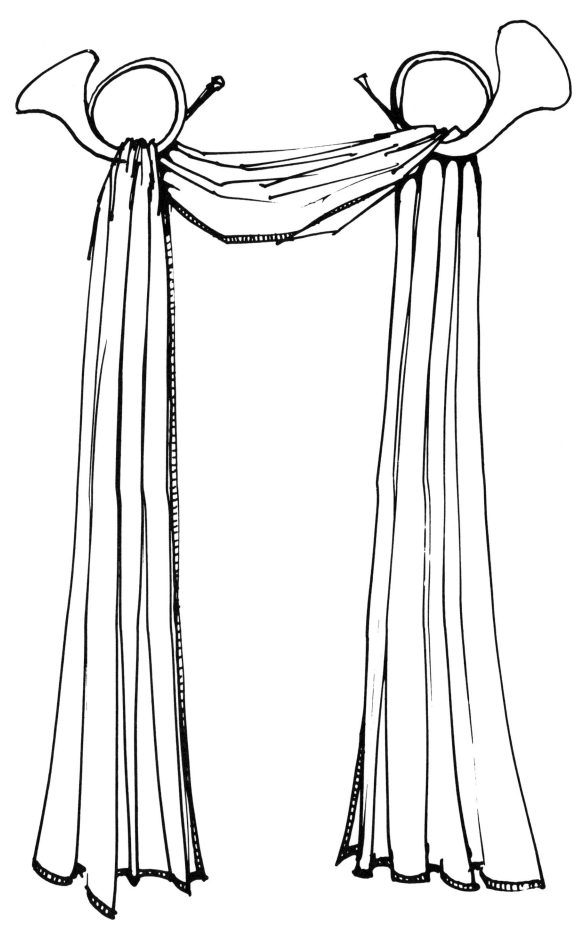

140

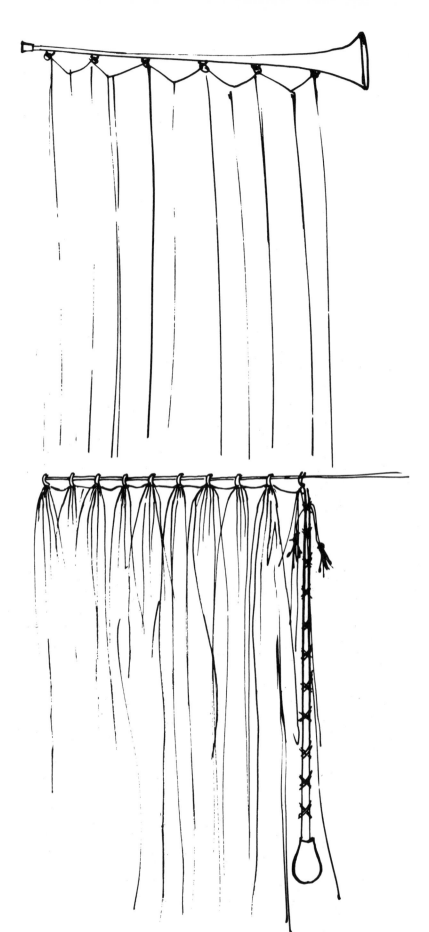

141

142

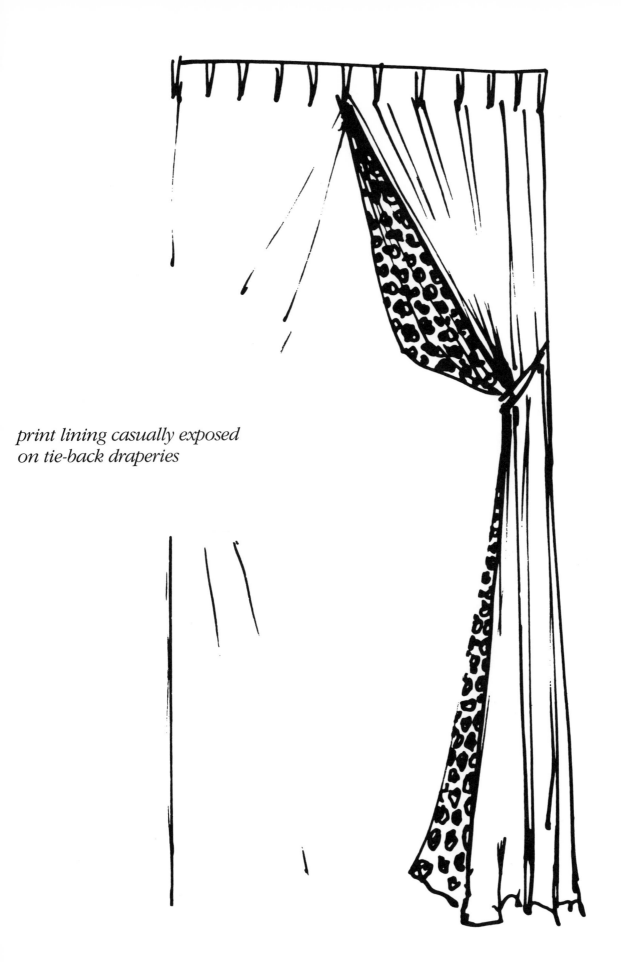

*print lining casually exposed
on tie-back draperies*

143

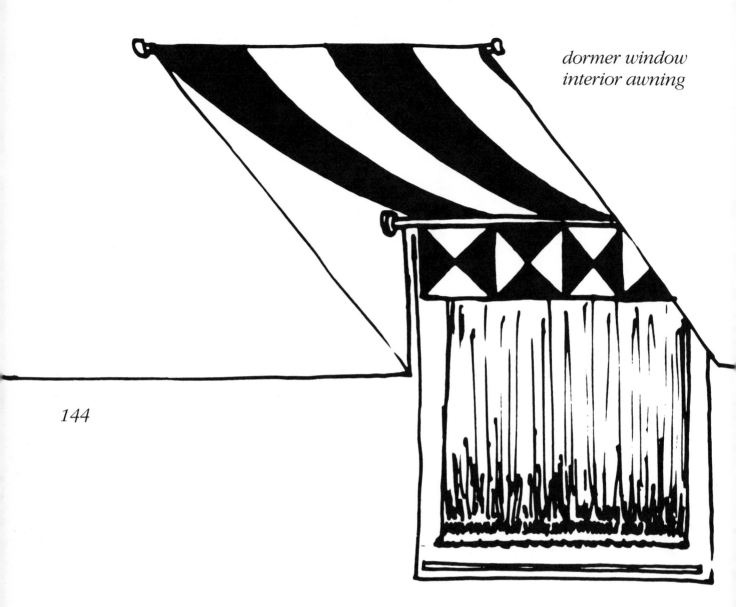

*dormer window
interior awning*

144

Headings

145

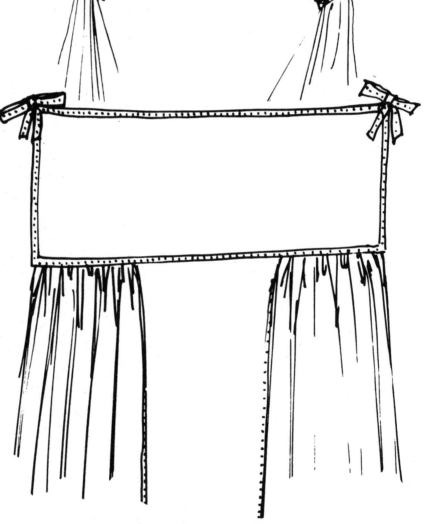

146

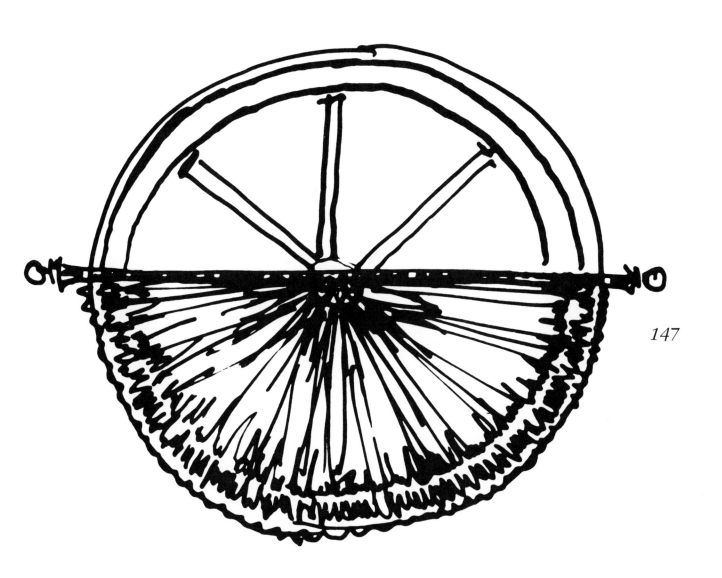

147

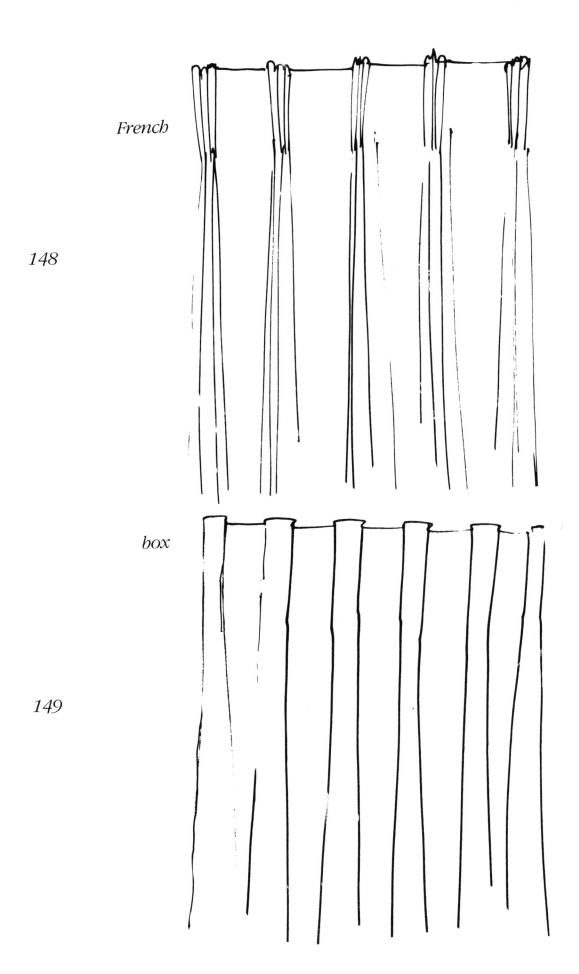

French

148

box

149

French with rings

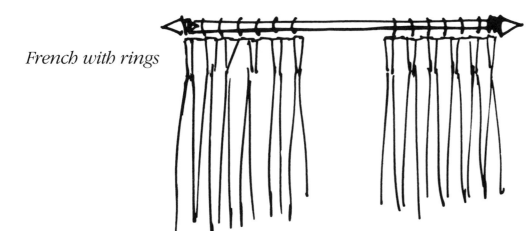

150

double shirring

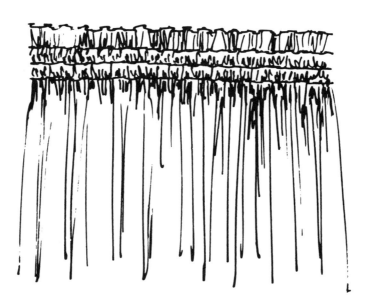

151

shirred pocket

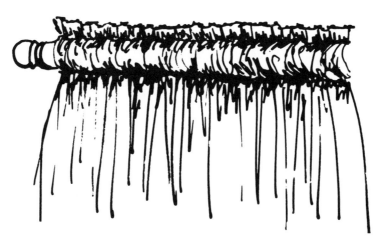

152

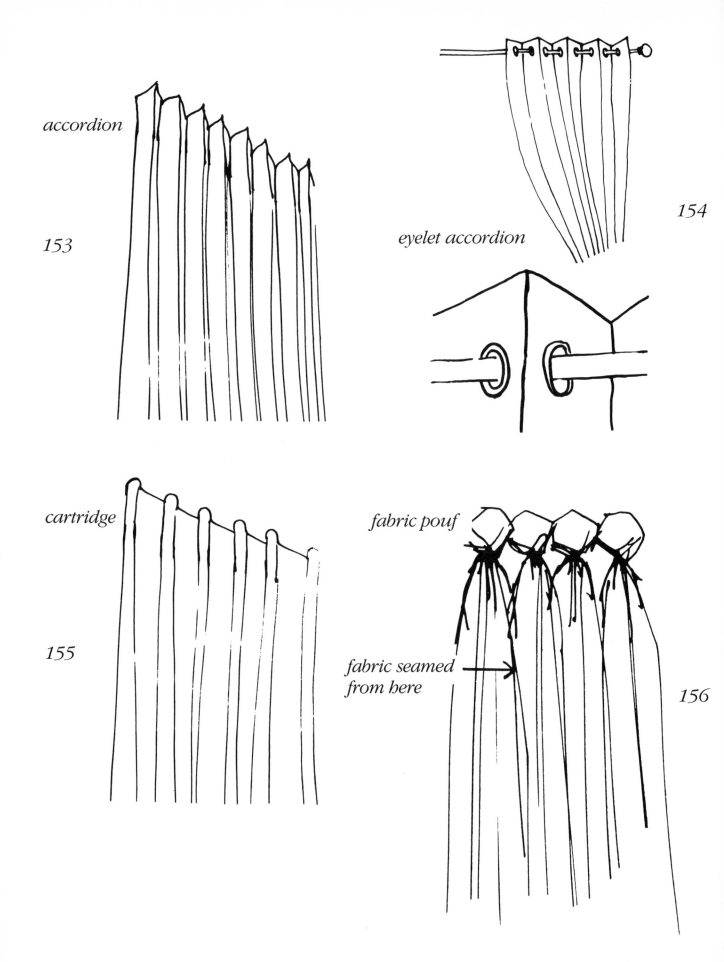

accordion

153

eyelet accordion

154

cartridge

155

fabric pouf

fabric seamed from here

156

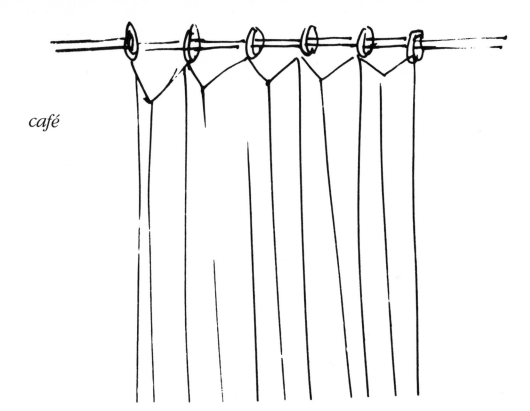

café

157

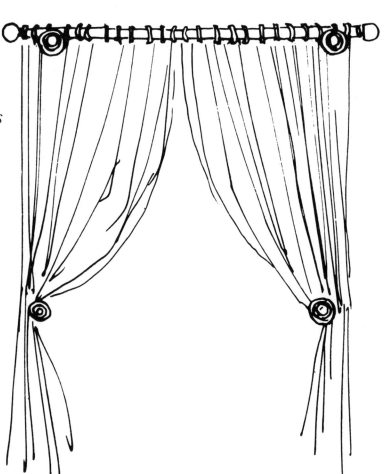

*fabric-covered pole,
brass medallions for
brackets and tie-backs*

158

Tie-backs

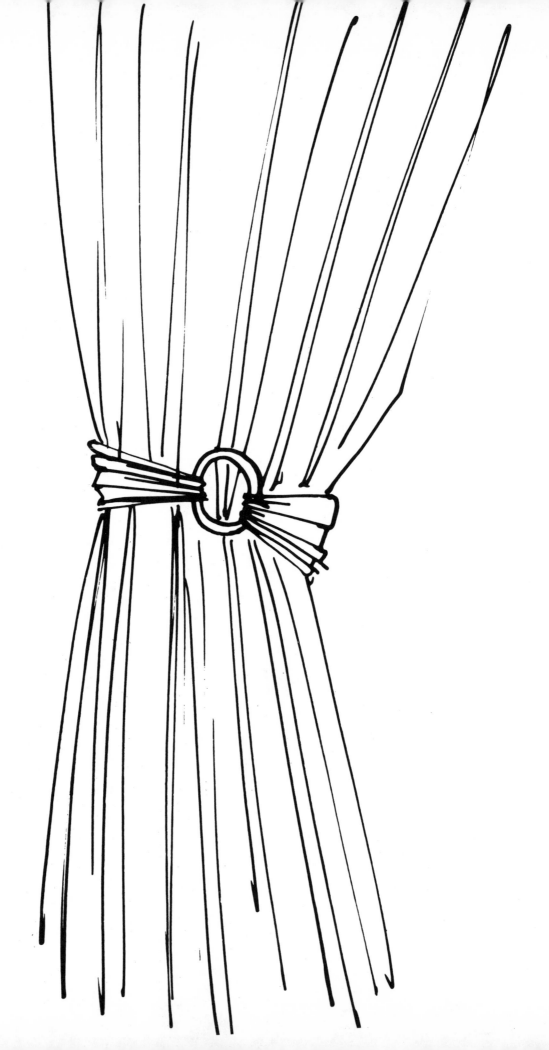

159

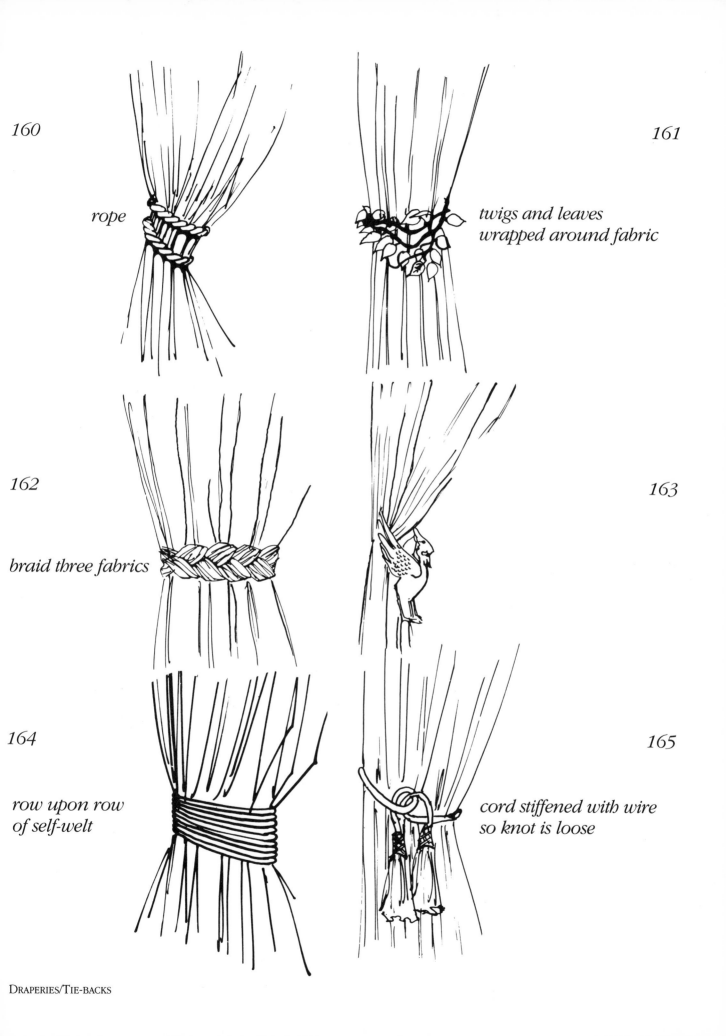

160

rope

161

twigs and leaves
wrapped around fabric

162

braid three fabrics

163

164

row upon row
of self-welt

165

cord stiffened with wire
so knot is loose

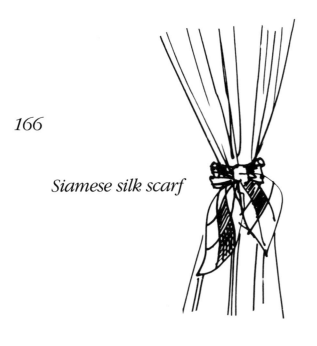

166

Siamese silk scarf

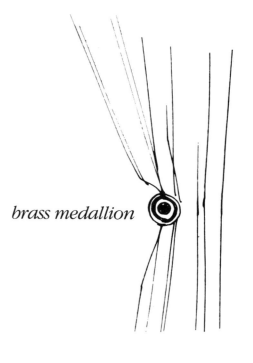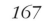

167

brass medallion

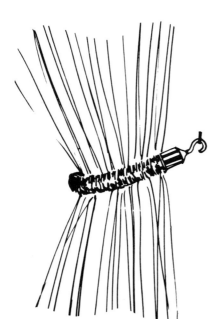

168

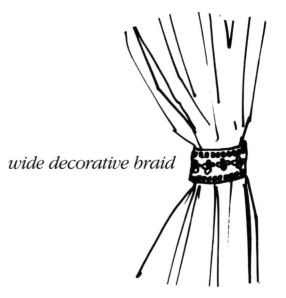

169

wide decorative braid

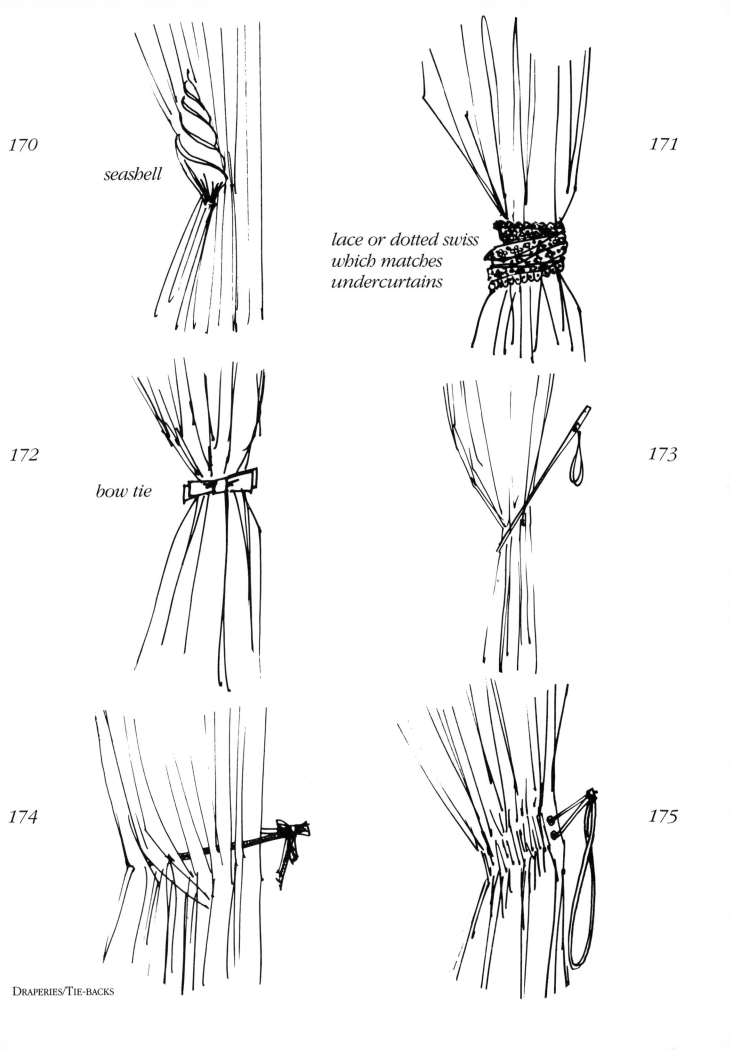

170

seashell

171

*lace or dotted swiss
which matches
undercurtains*

172

bow tie

173

174

175

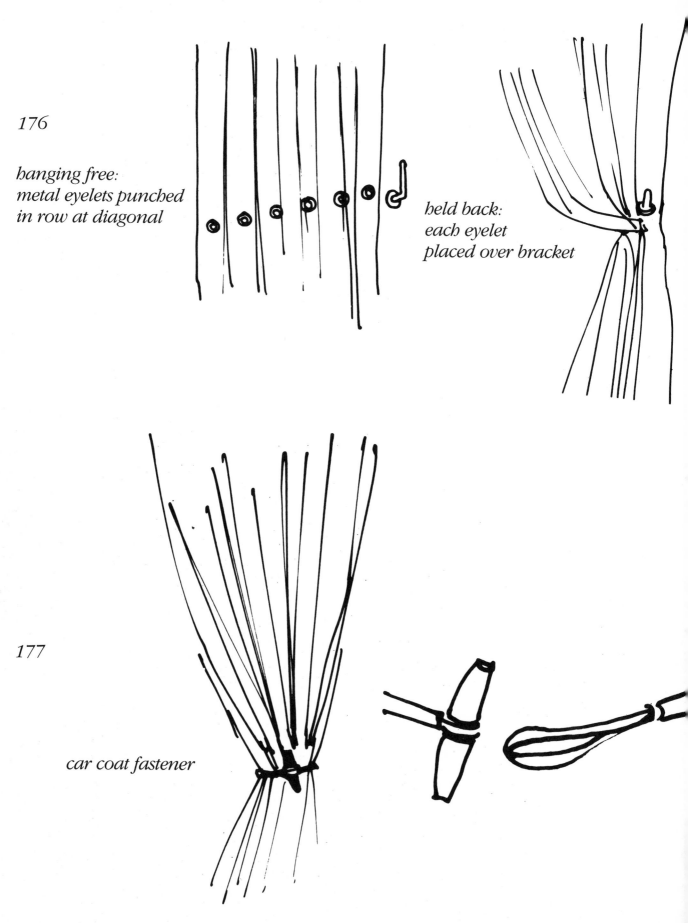

176

hanging free:
metal eyelets punched
in row at diagonal

held back:
each eyelet
placed over bracket

177

car coat fastener

Valances

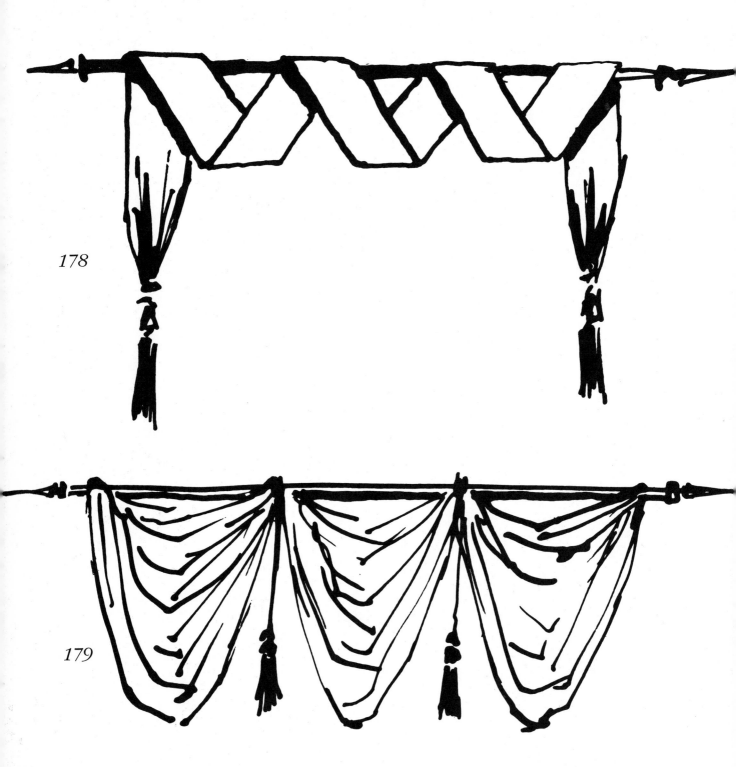

178

179

soft, straight with
alternate fabric in pleats

180

two fabrics

181

two fabrics

182

red, white, blue

183

two poles with separate
pieces of fabric

184

185 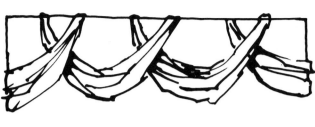 *swags over shaped board*

186 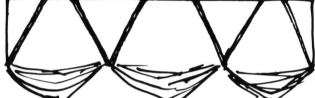 *cord trim*
soft swag bottom

187 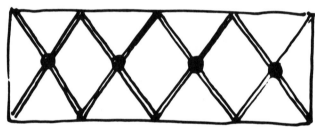 *braid and buttons*

188 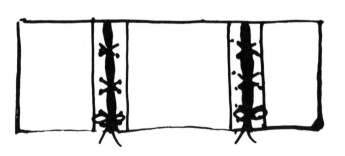 *second fabric peeking*
through draw-strings

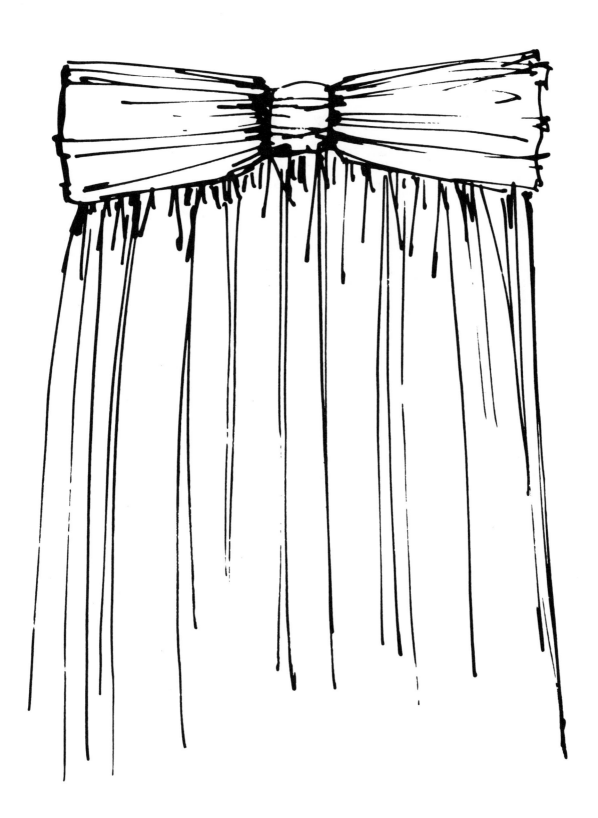

189

190

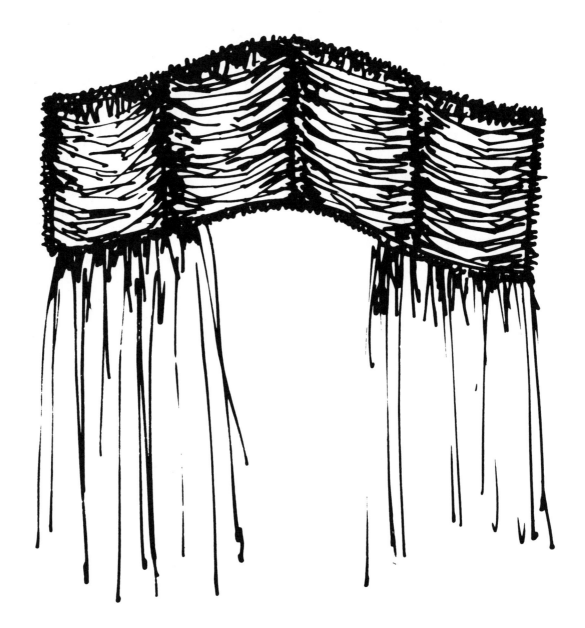

shirred fabric in fan shape
wooden frame cut out to
form floral pattern
and faced with applied
decorative braid

191

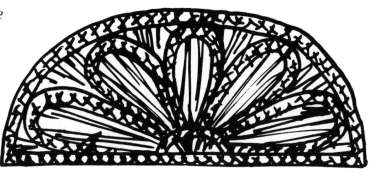

fabric thrown over rod,
edges trimmed with
braid or fringe

192

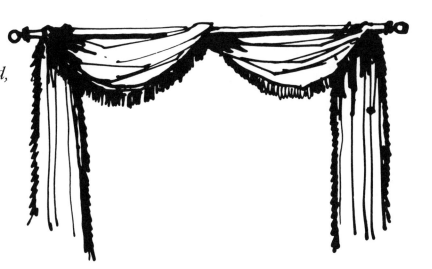

193

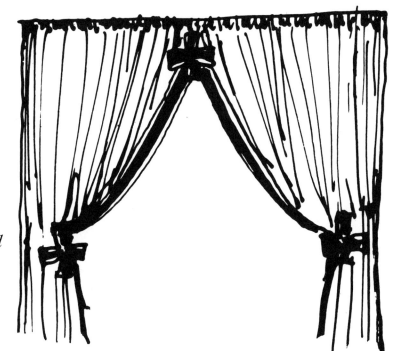

bows made of same braid
as edges of curtains

194

*wooden frame faced
with decorative braid,
shirred fabric behind*

195

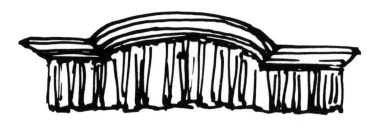

*fabric shirred over board
with painted wooden
molding on top*

196

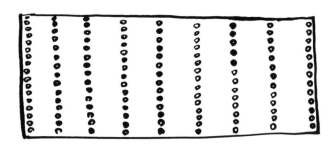

nailheads

197

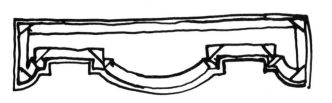

*ribbon trim reversed
at each corner*

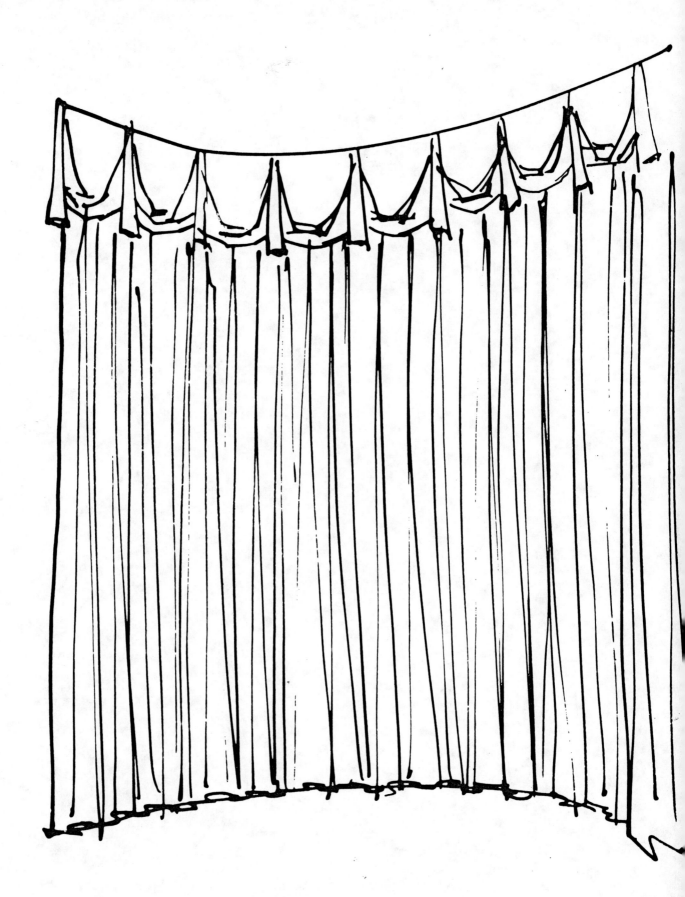

design formed on
flat straight valance
by using braid and tassels

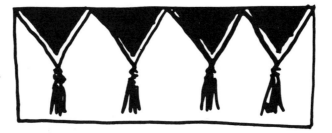

198

same idea

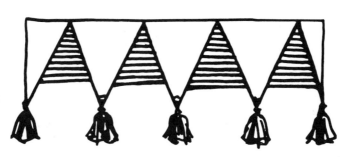

199

poufy cotton tassels

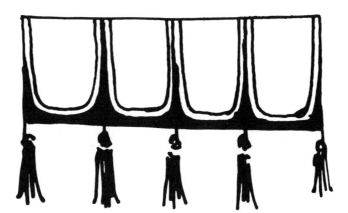

200

tasseled lace fringe

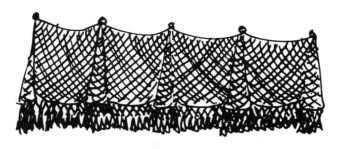

201

print and plain fabric

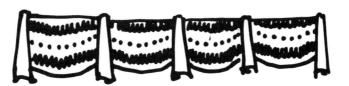

202

203

204

205

206

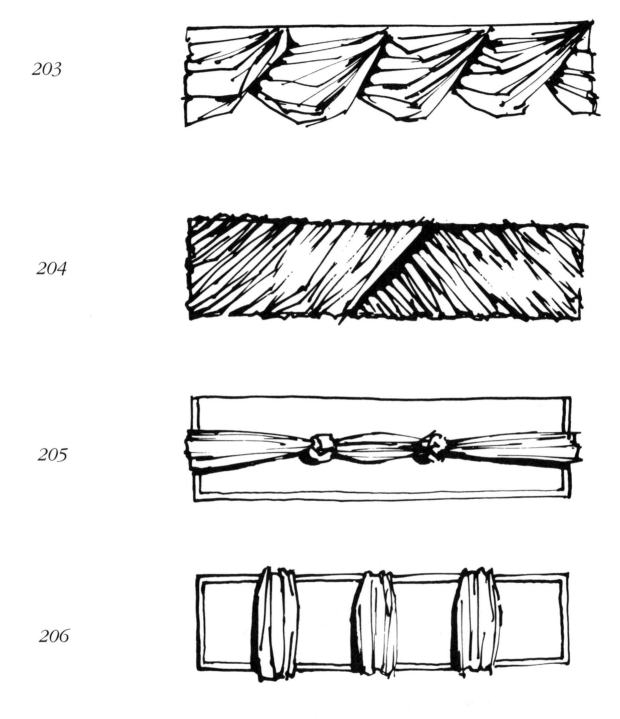

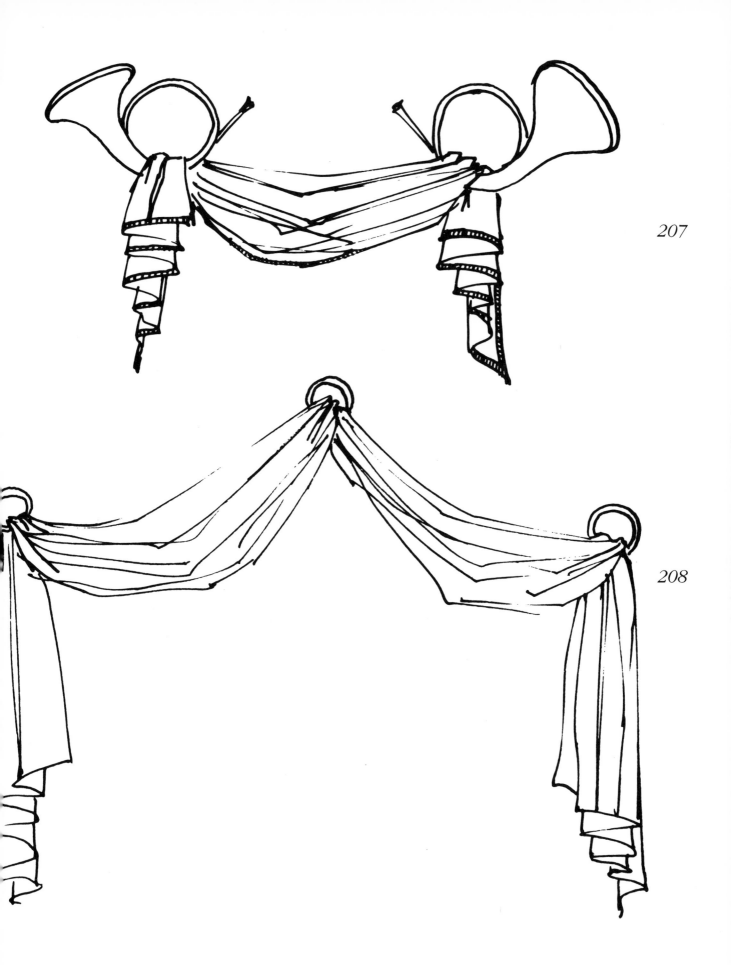

207

208

209

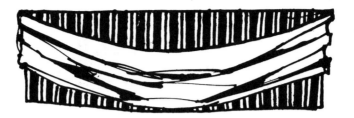

210

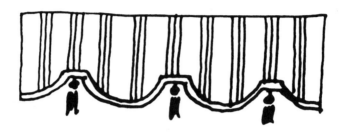

211

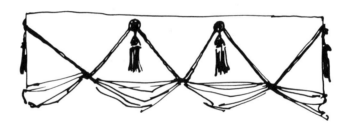

212

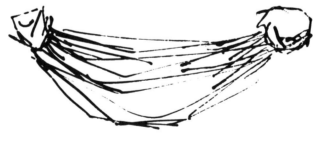

213

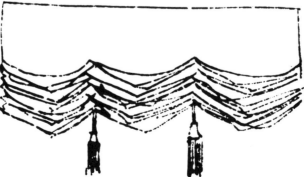

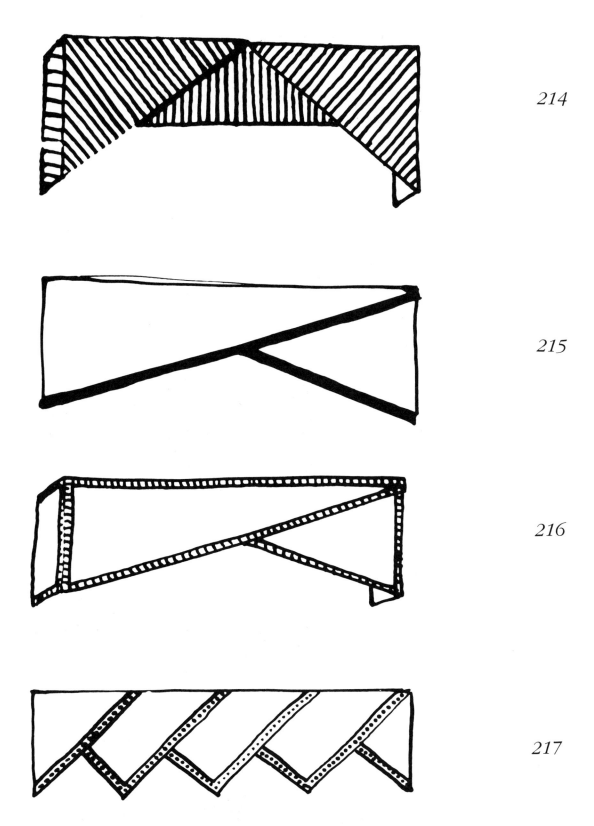

214

215

216

217

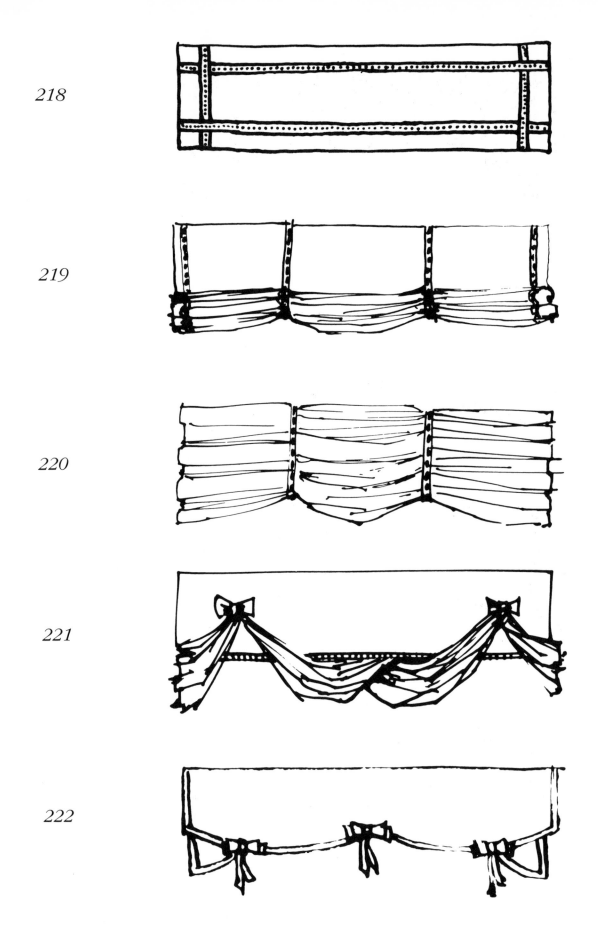

218

219

220

221

222

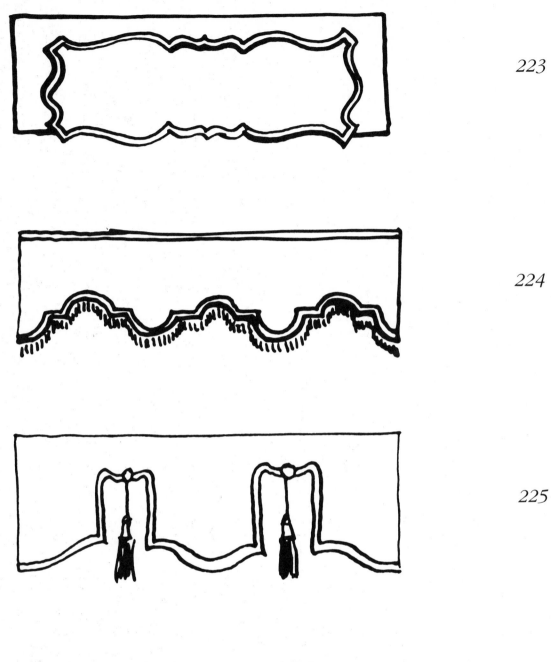

223

224

225

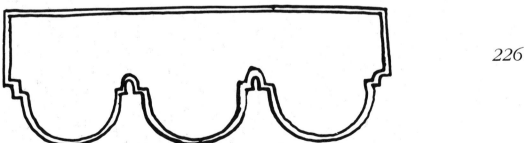

226

BEDSPREADS
& CANOPIES

Period Designs

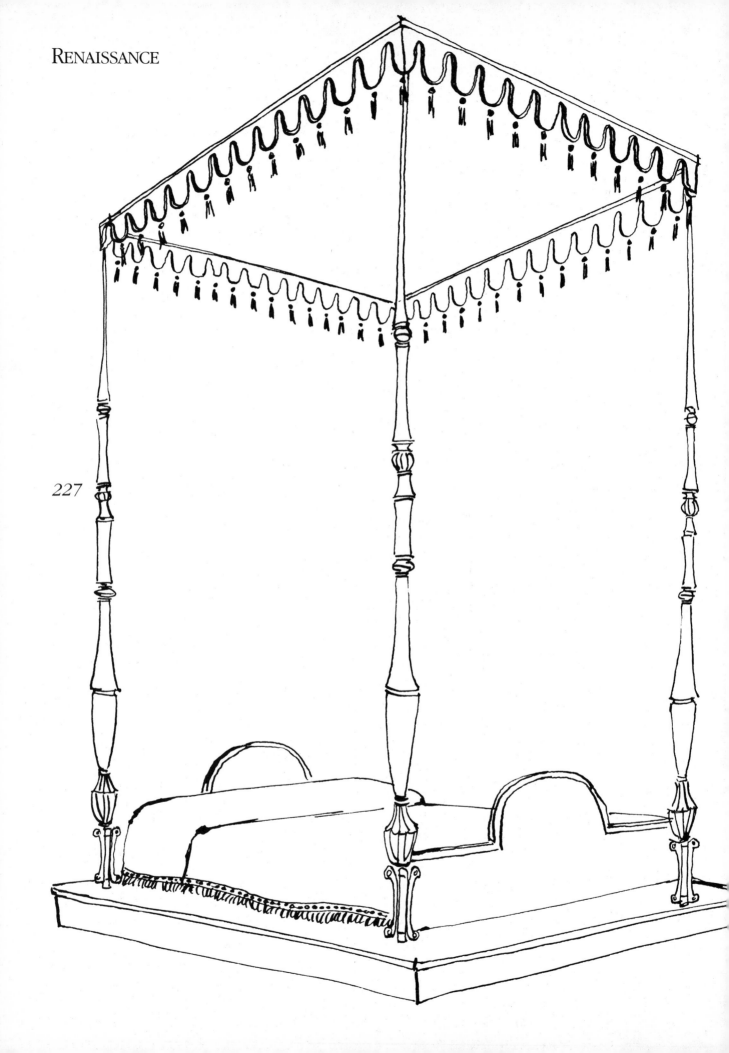

227

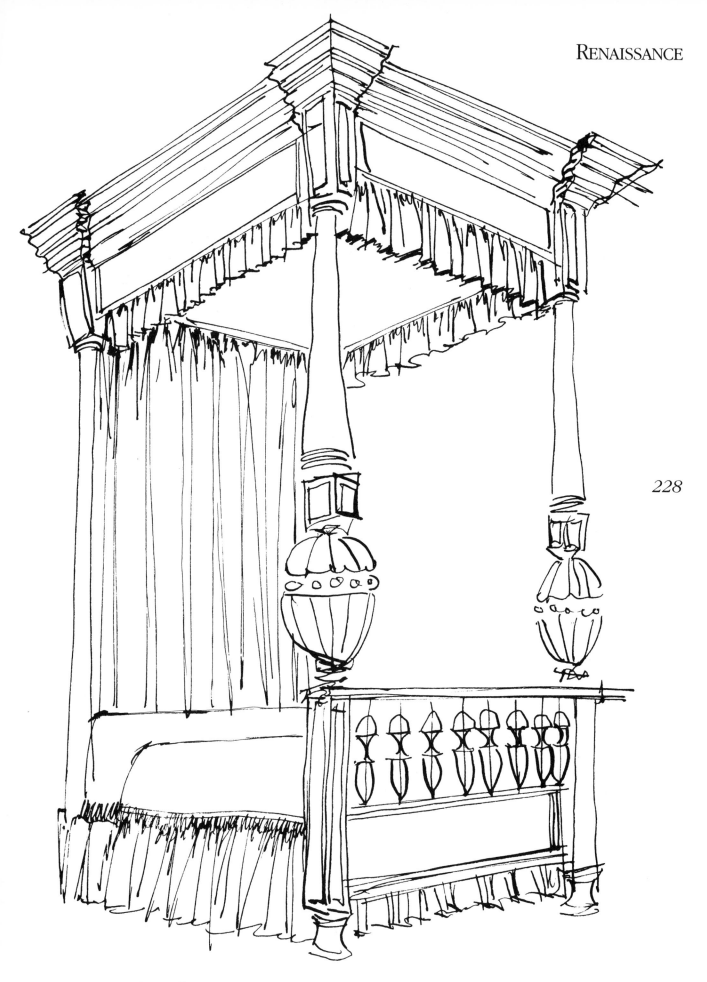

228

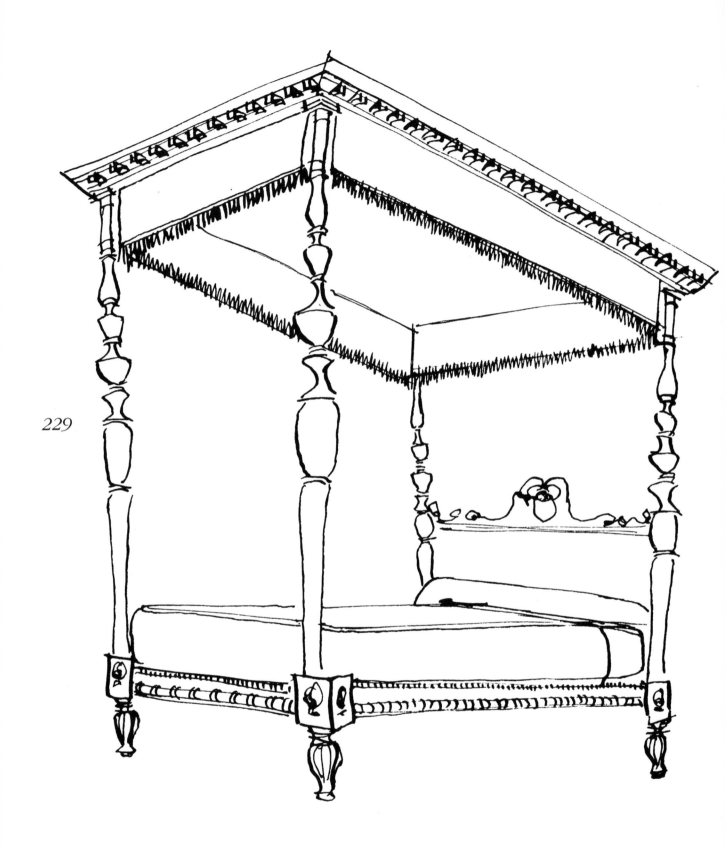

229

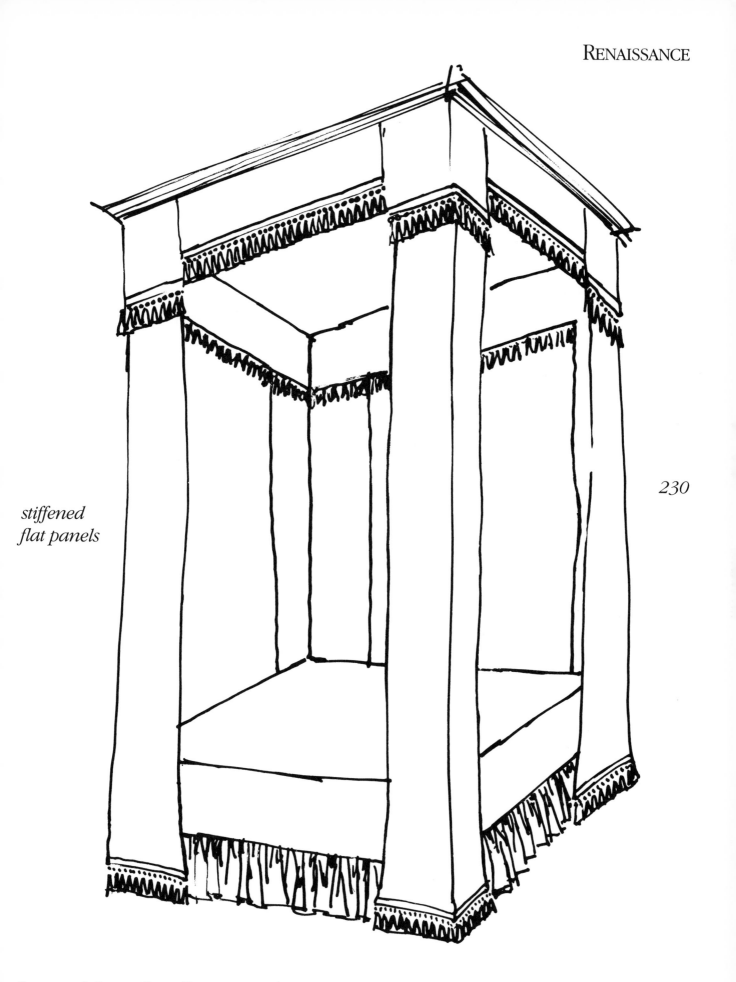

*stiffened
flat panels*

230

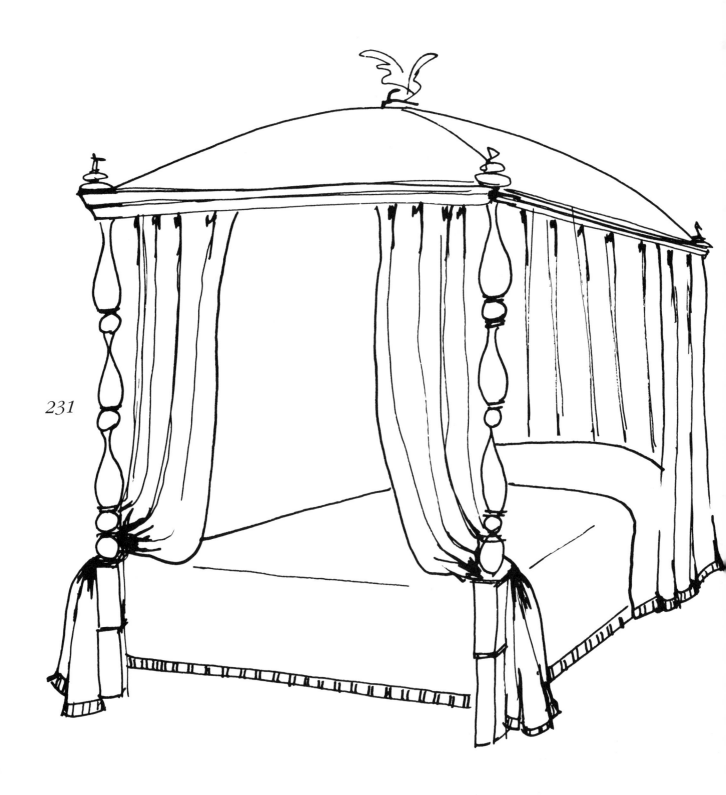

231

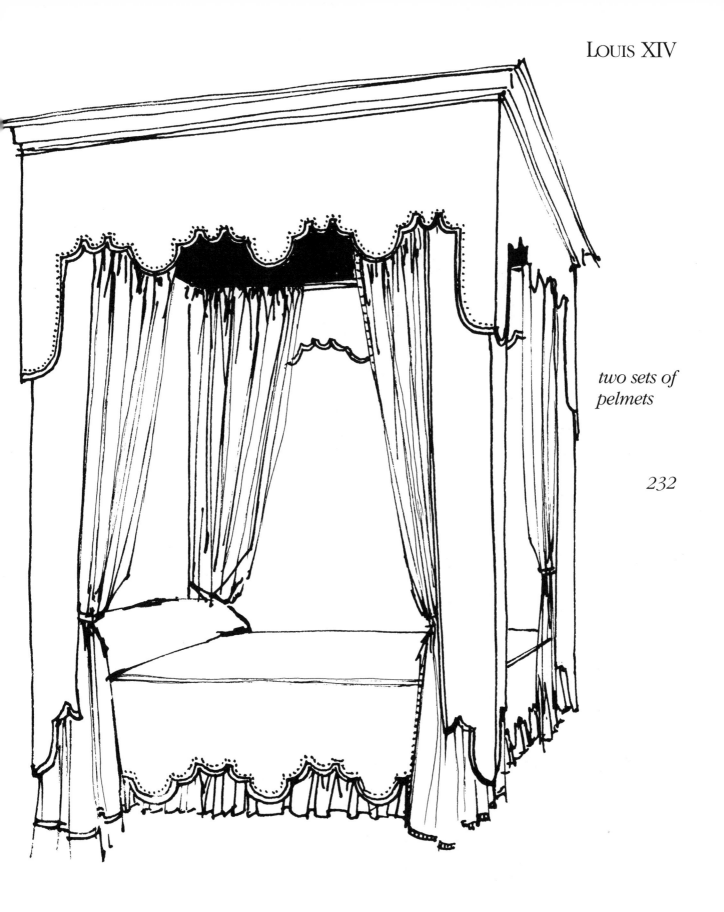

*two sets of
pelmets*

232

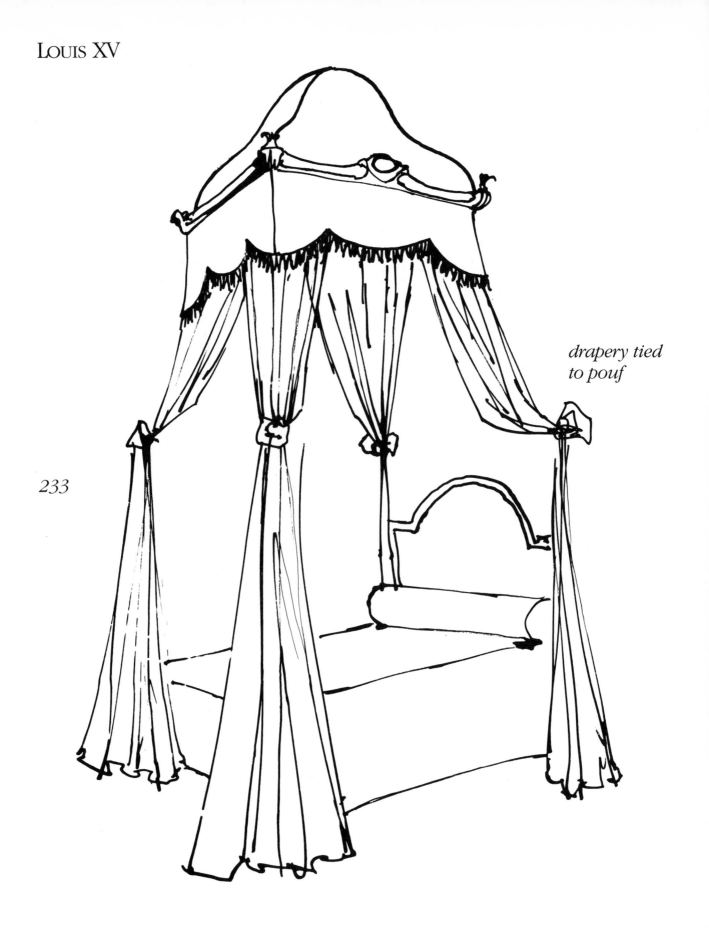

*drapery tied
to pouf*

233

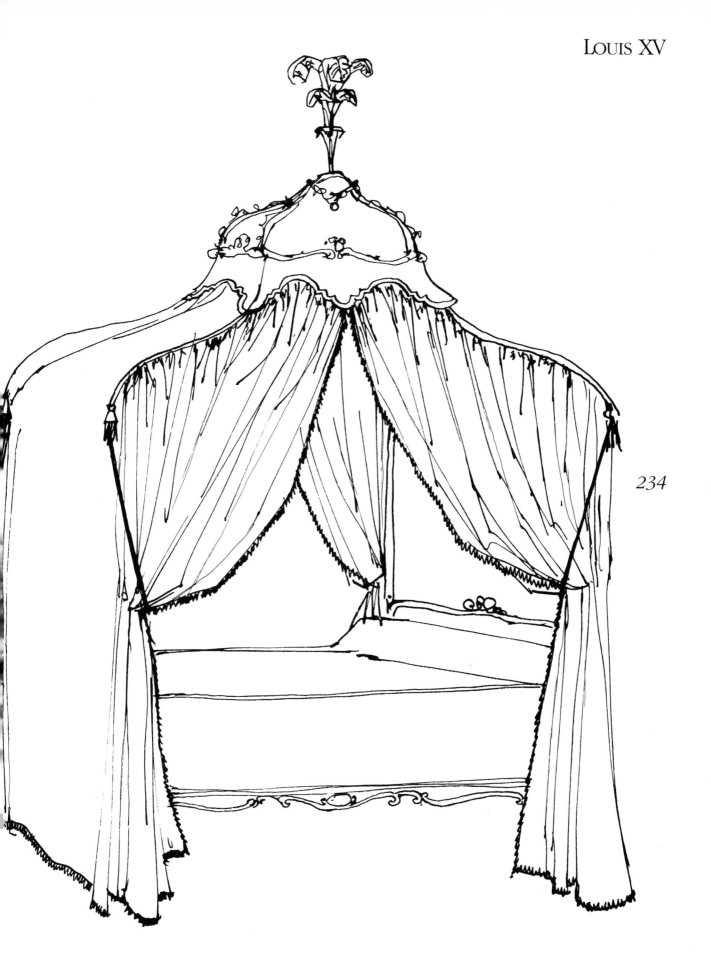

234

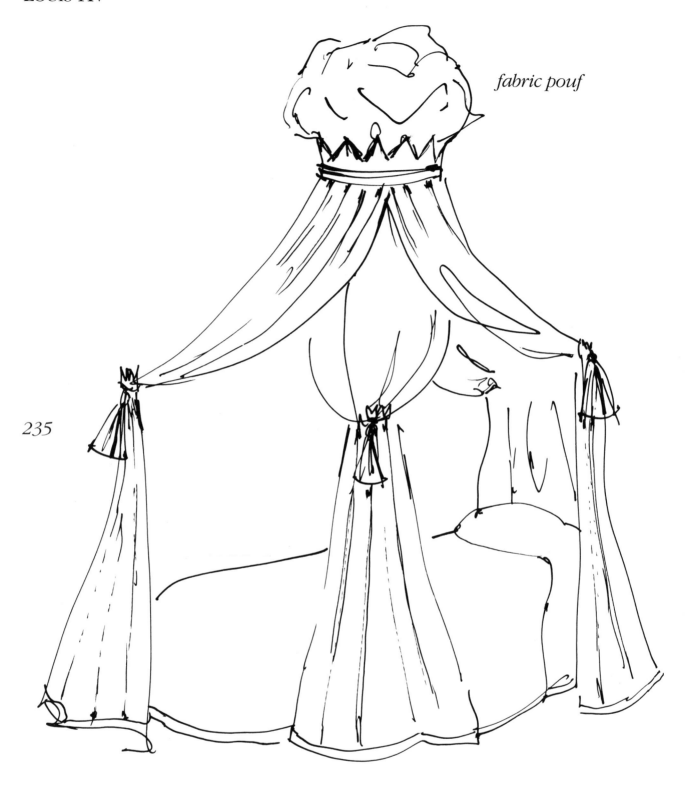

fabric pouf

235

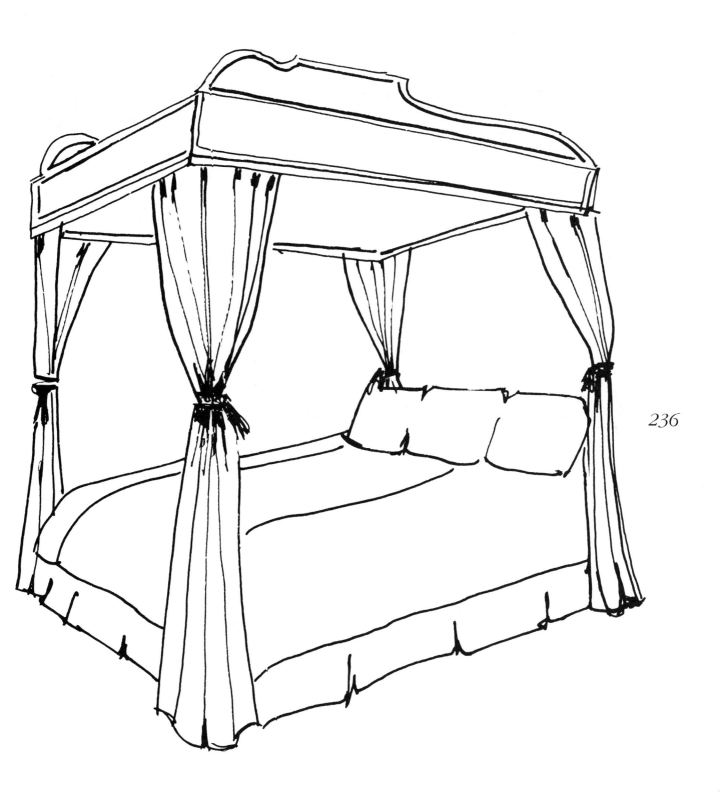

236

237

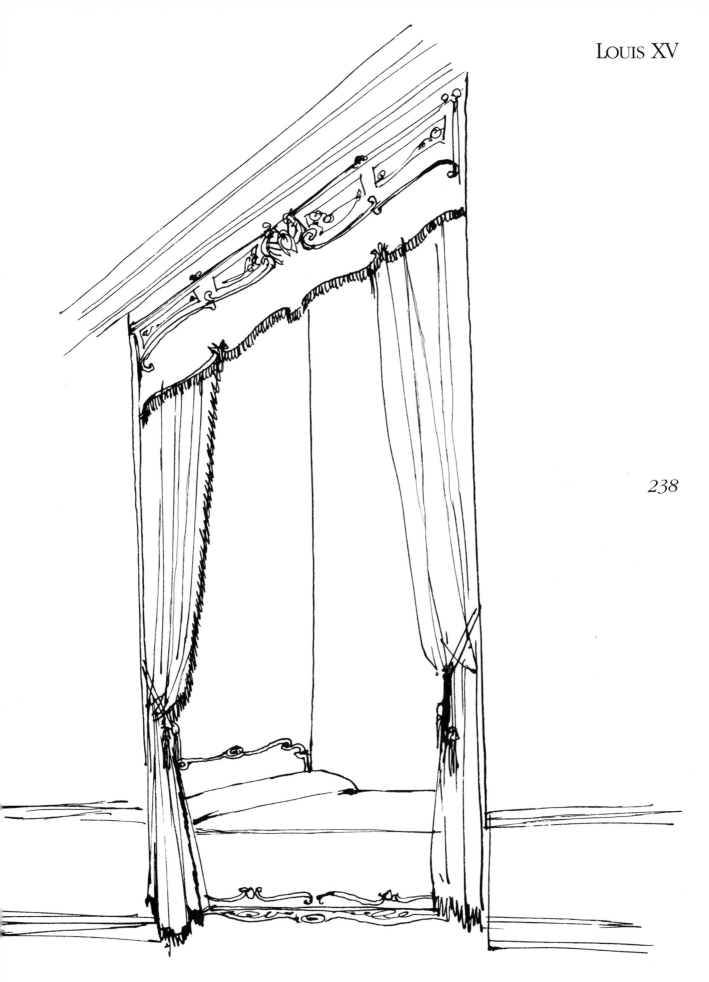

238

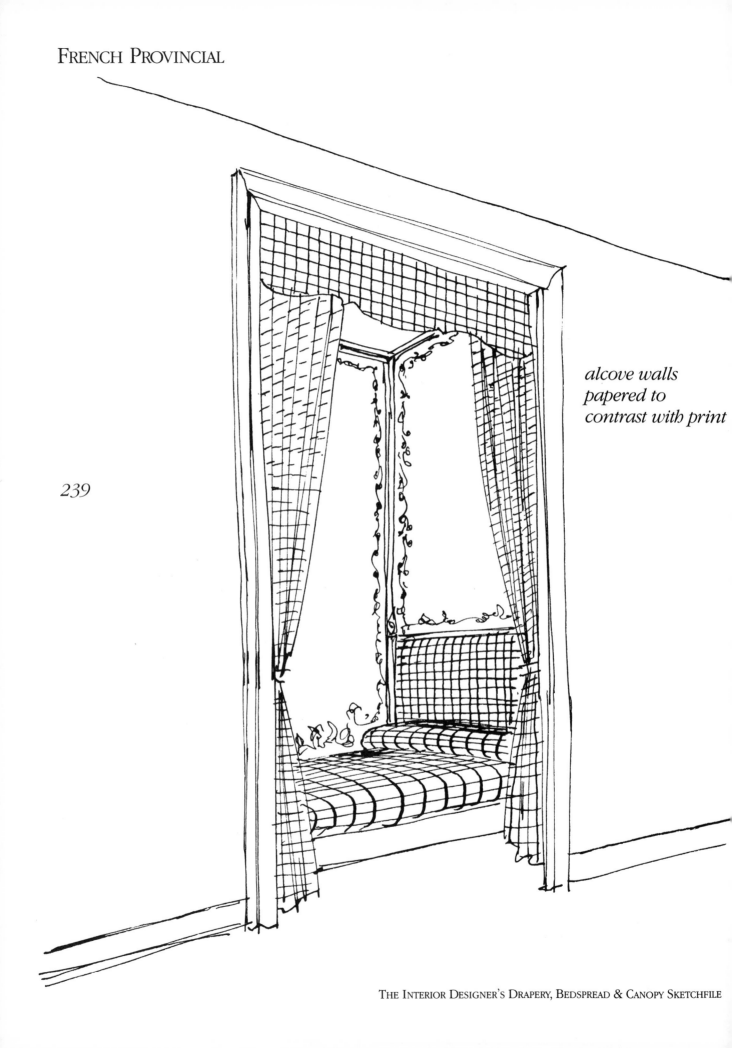

*alcove walls
papered to
contrast with print*

239

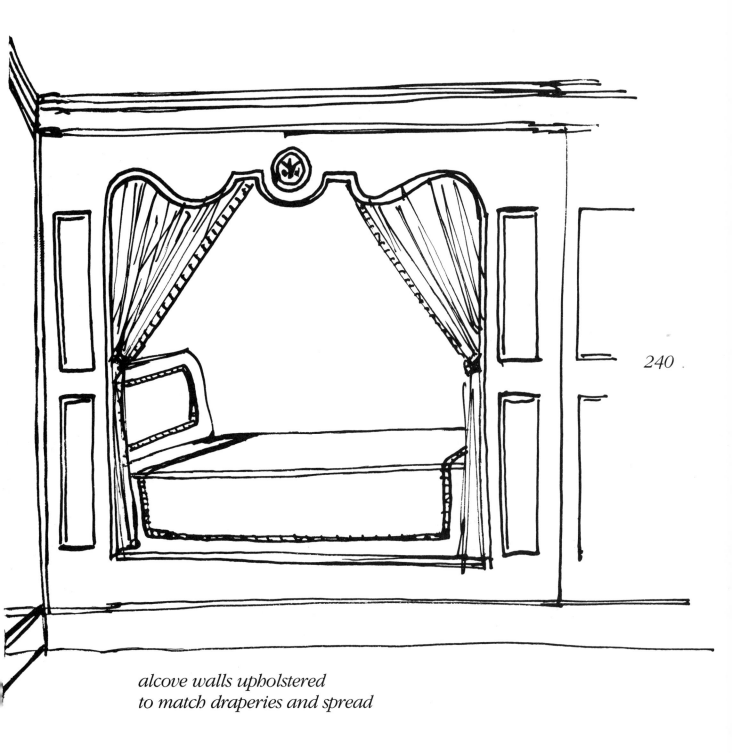

240

*alcove walls upholstered
to match draperies and spread*

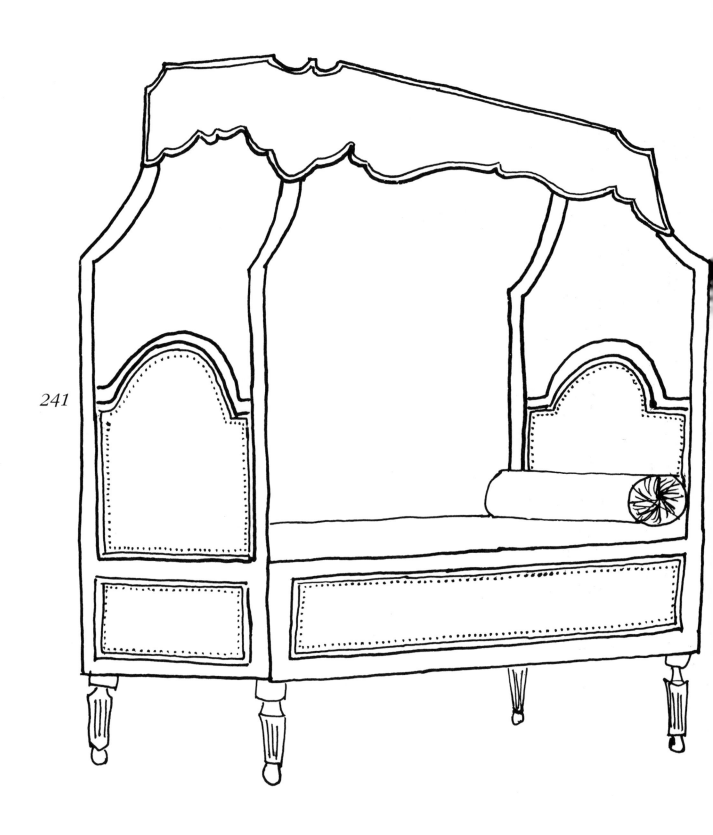

241

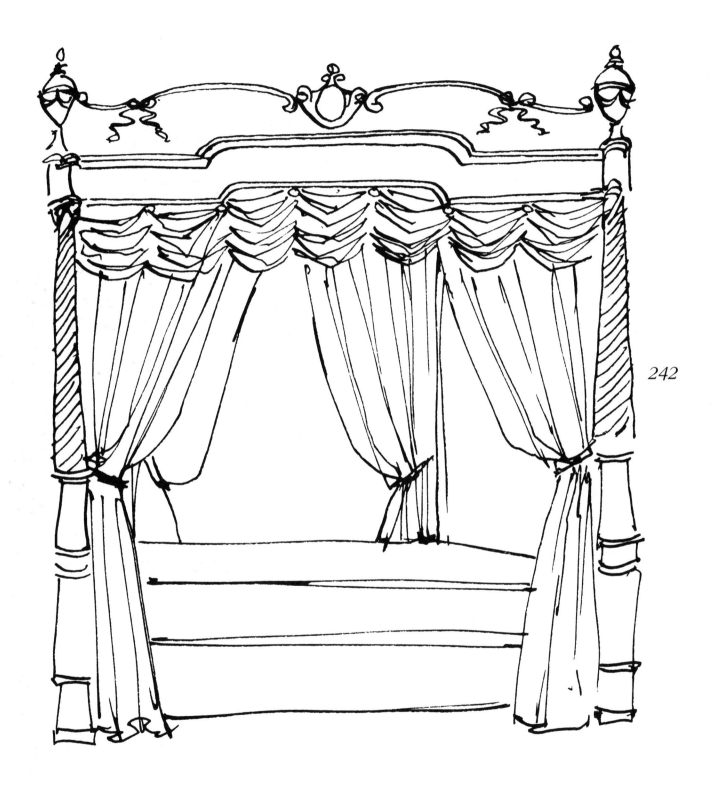

242

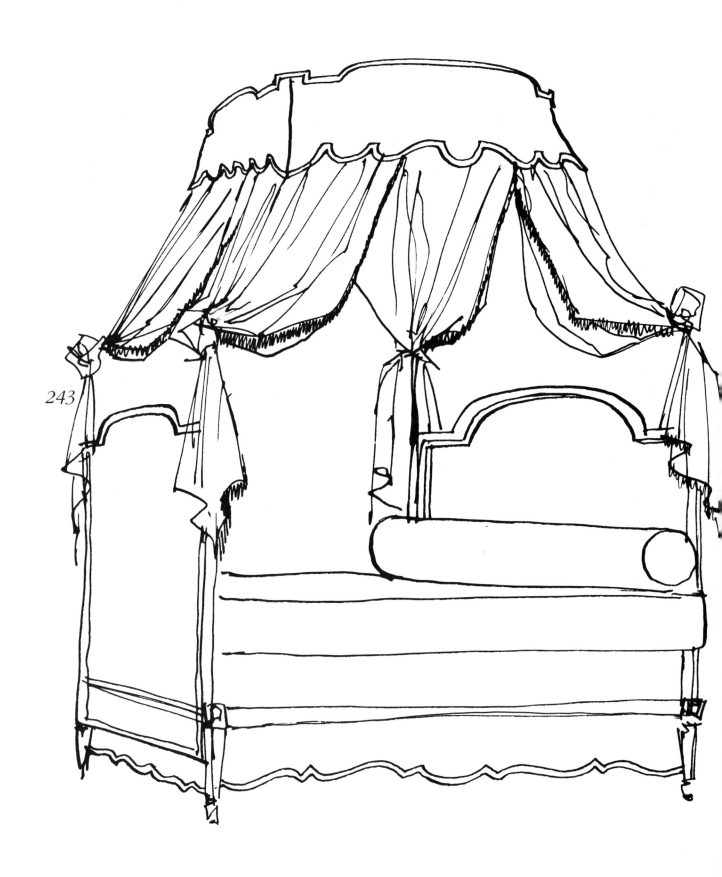

243

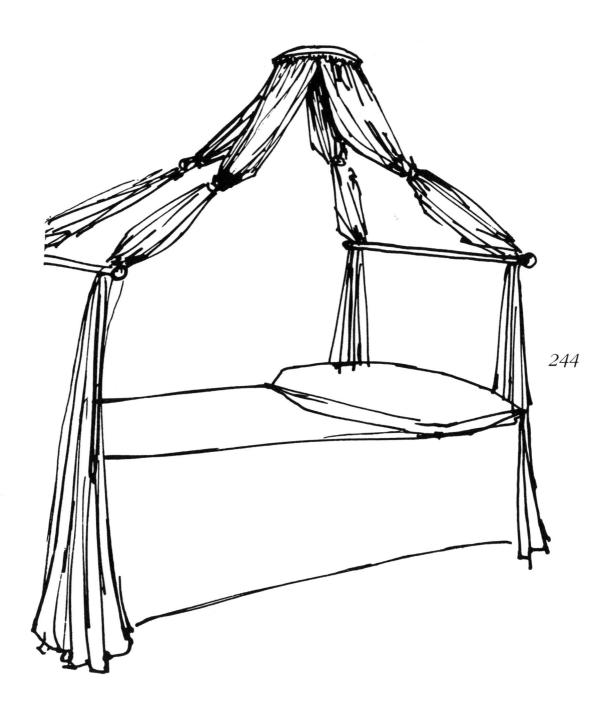

244

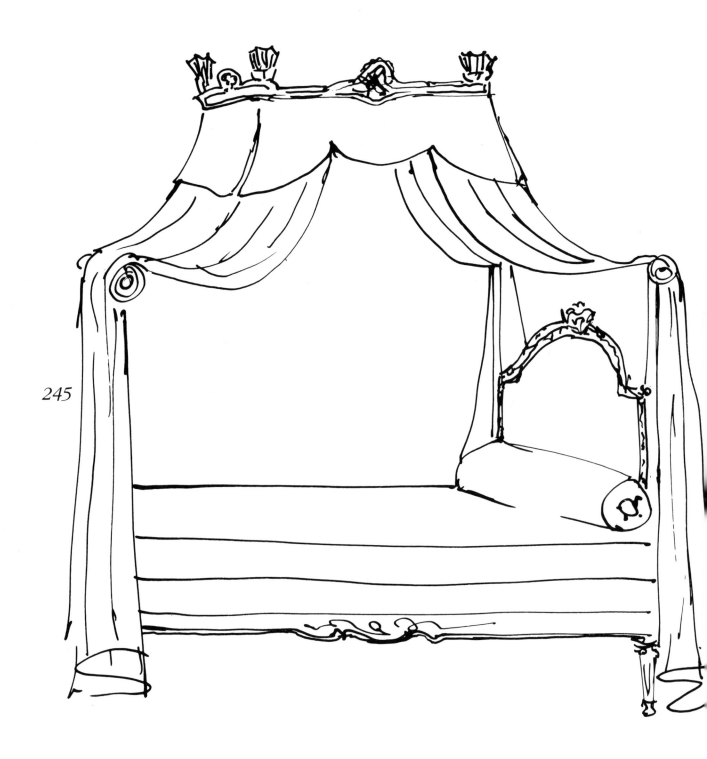

245

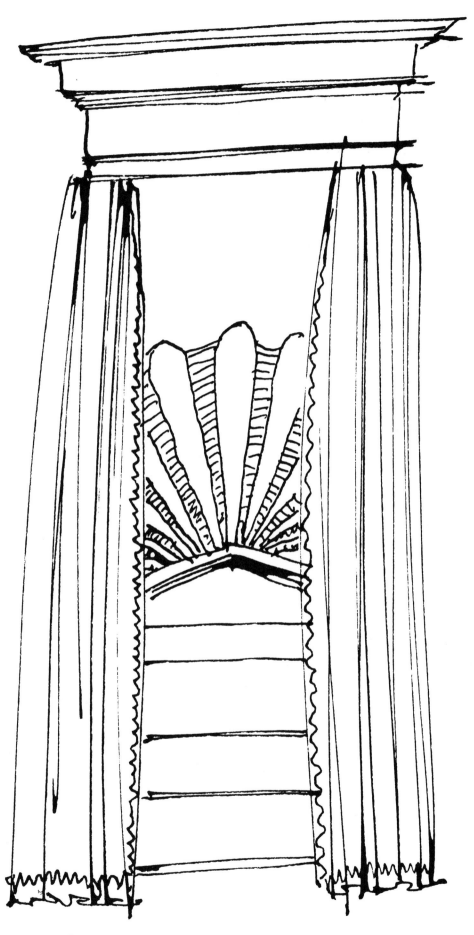

246

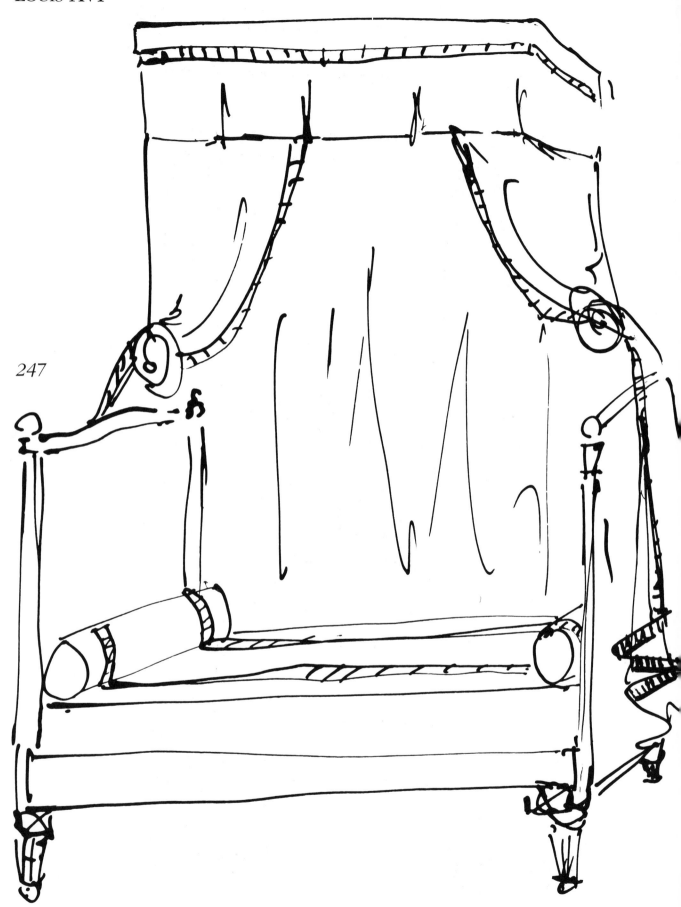

247

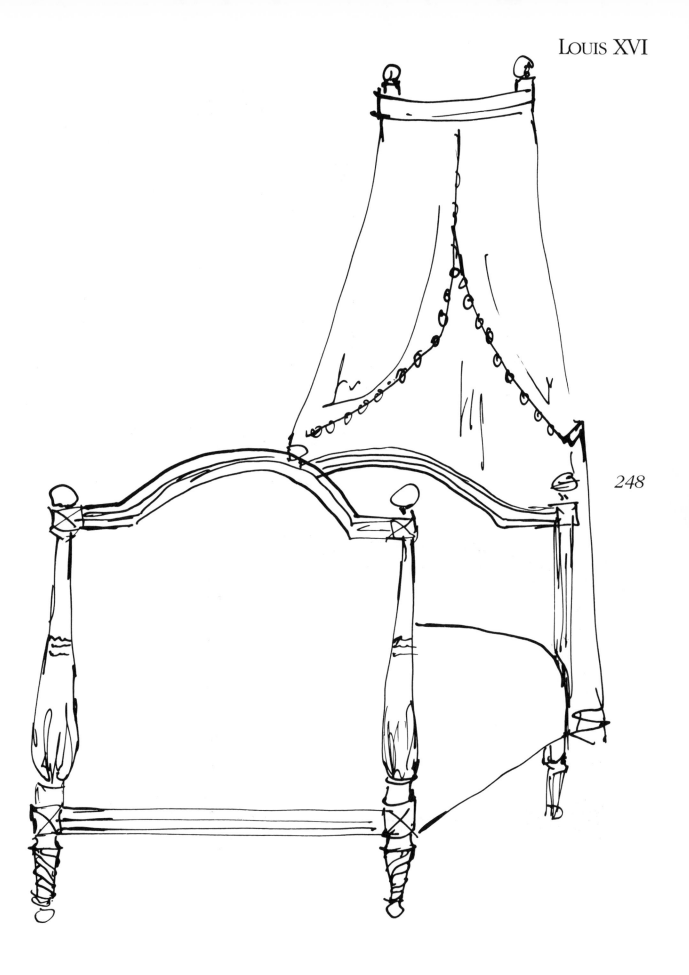

248

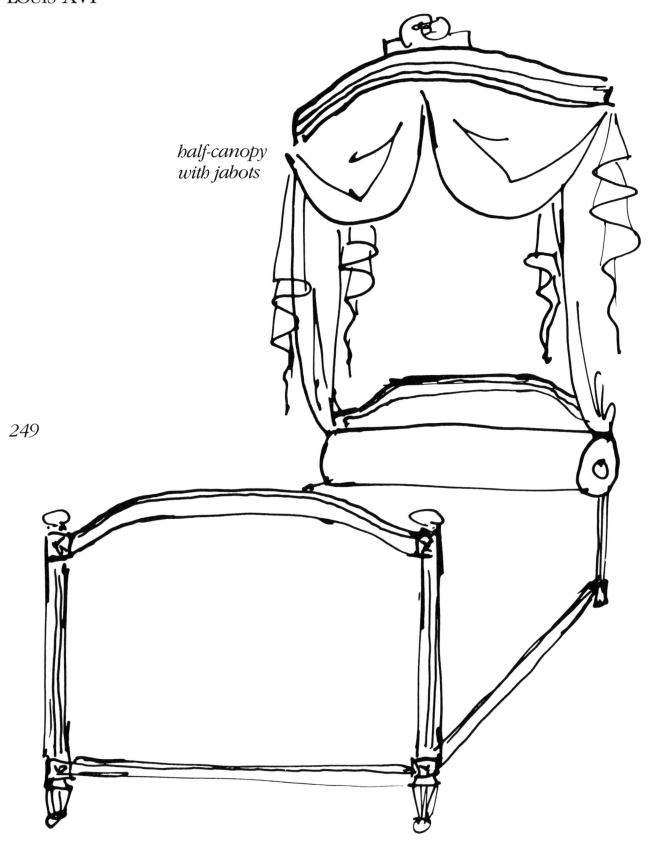

*half-canopy
with jabots*

249

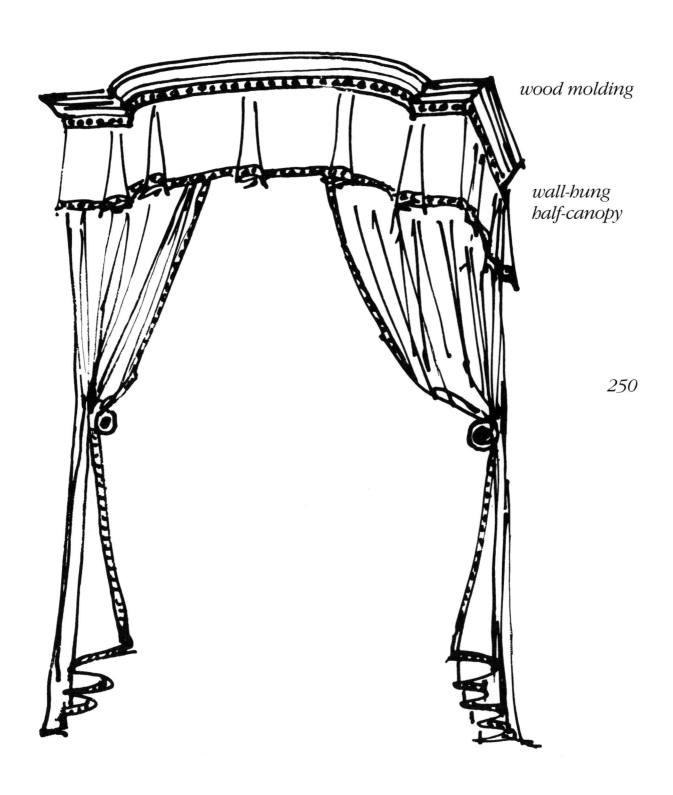

wood molding

wall-hung half-canopy

250

251

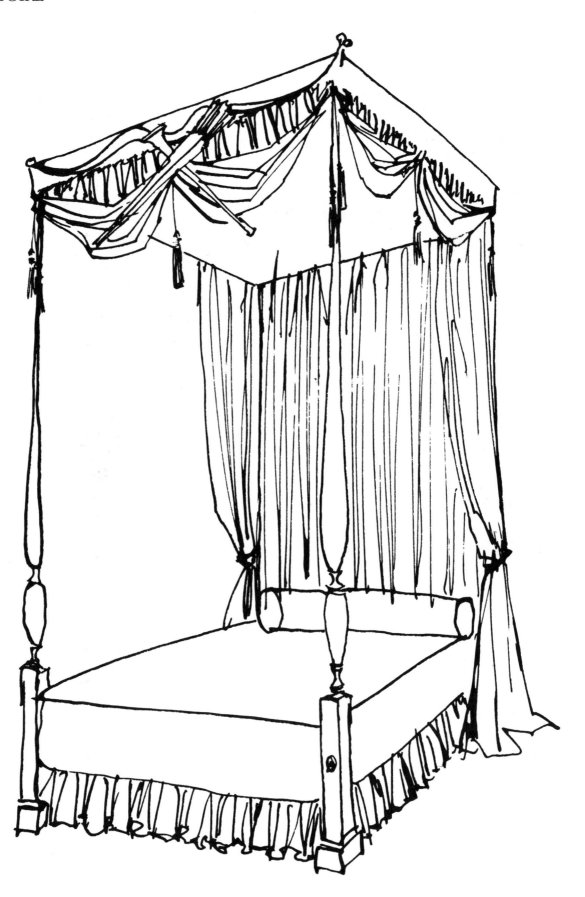

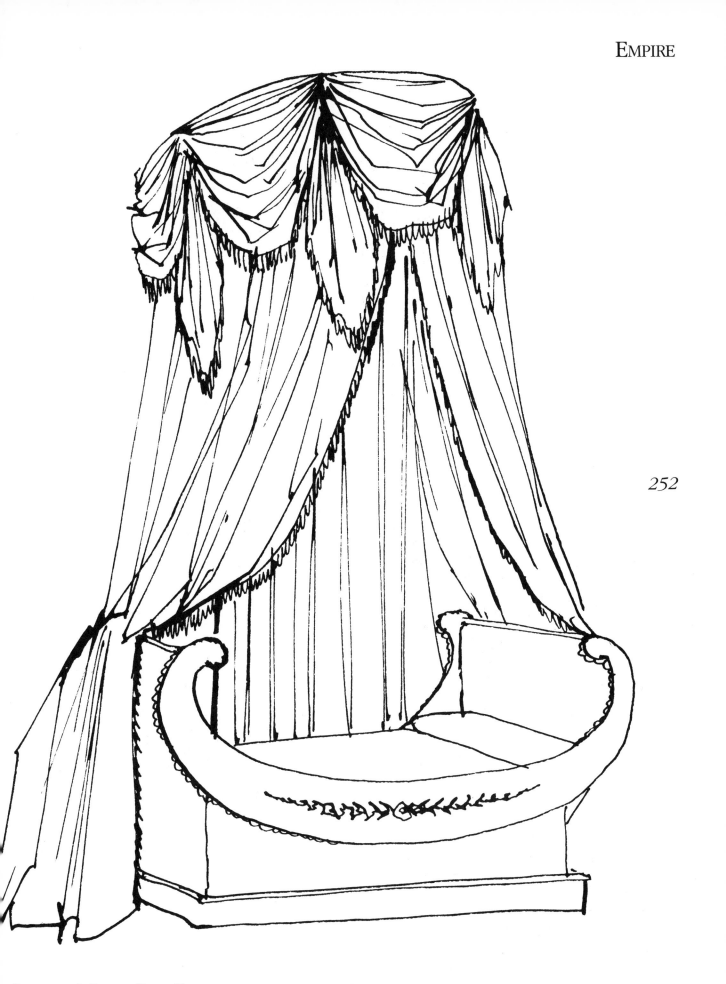

252

253

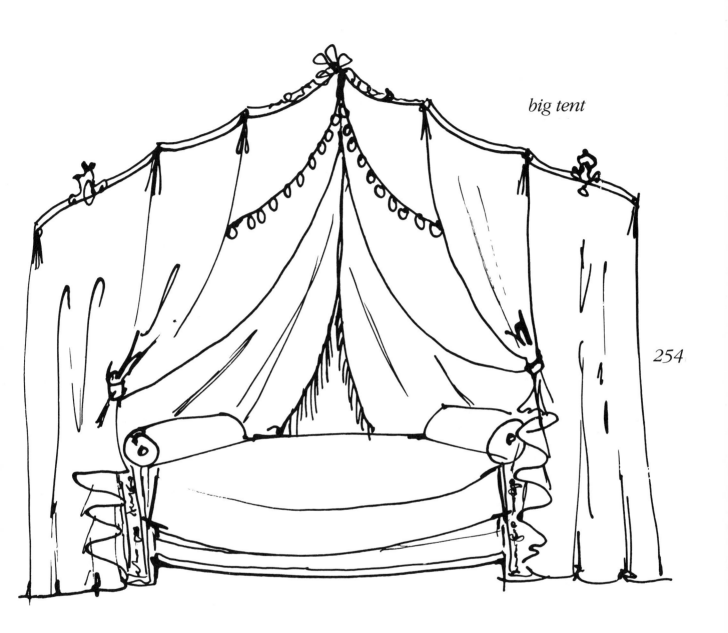

big tent

254

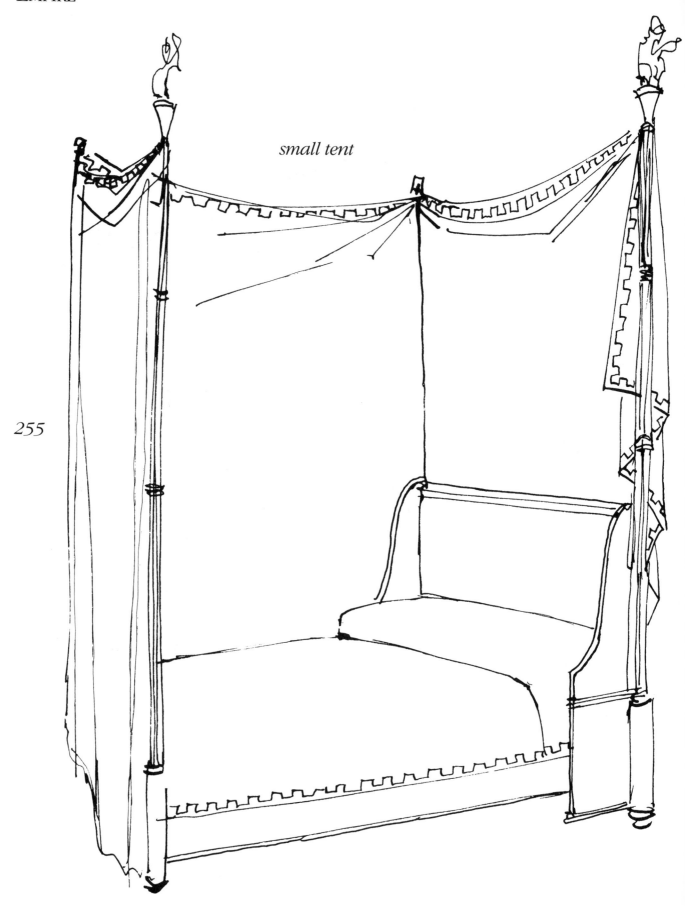

small tent

255

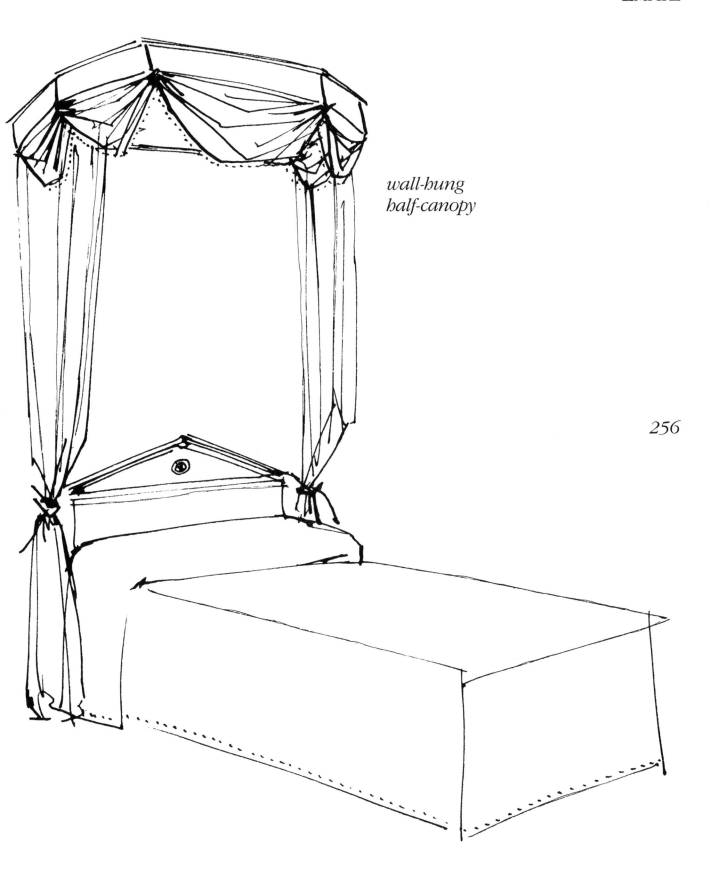

*wall-hung
half-canopy*

256

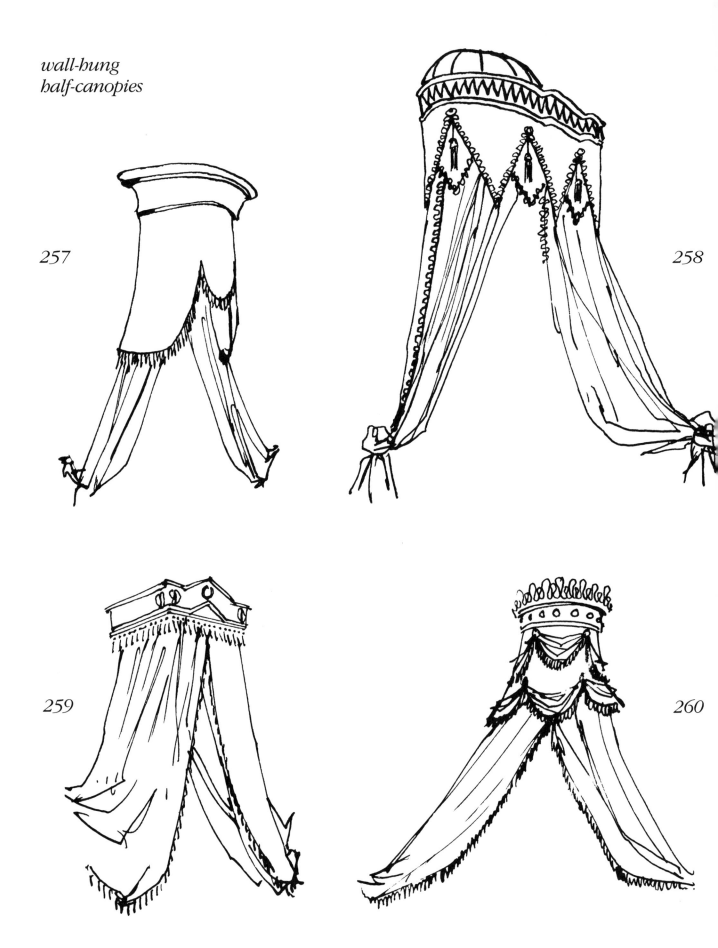

*wall-hung
half-canopies*

257

258

259

260

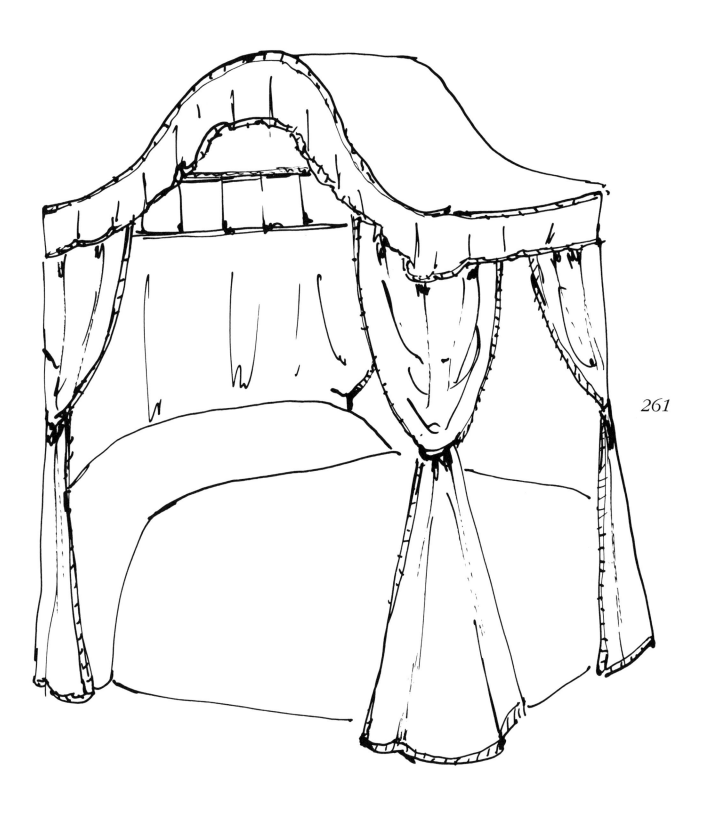

261

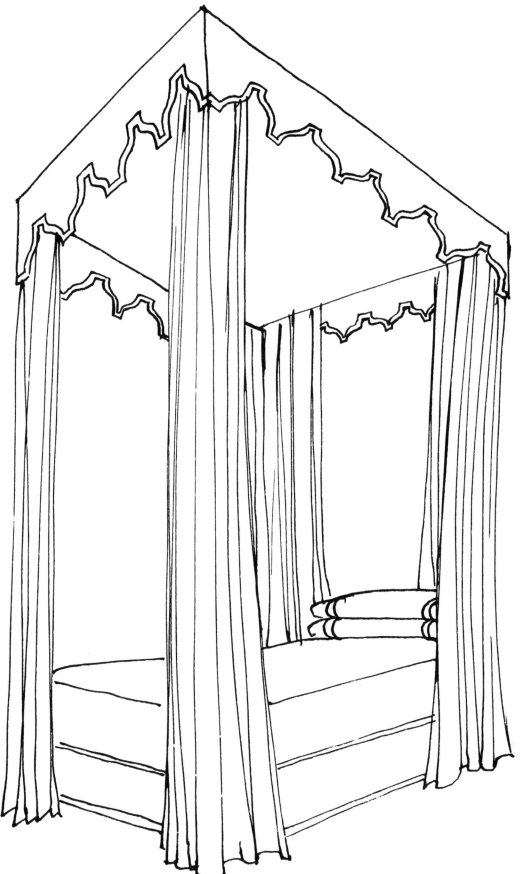

262

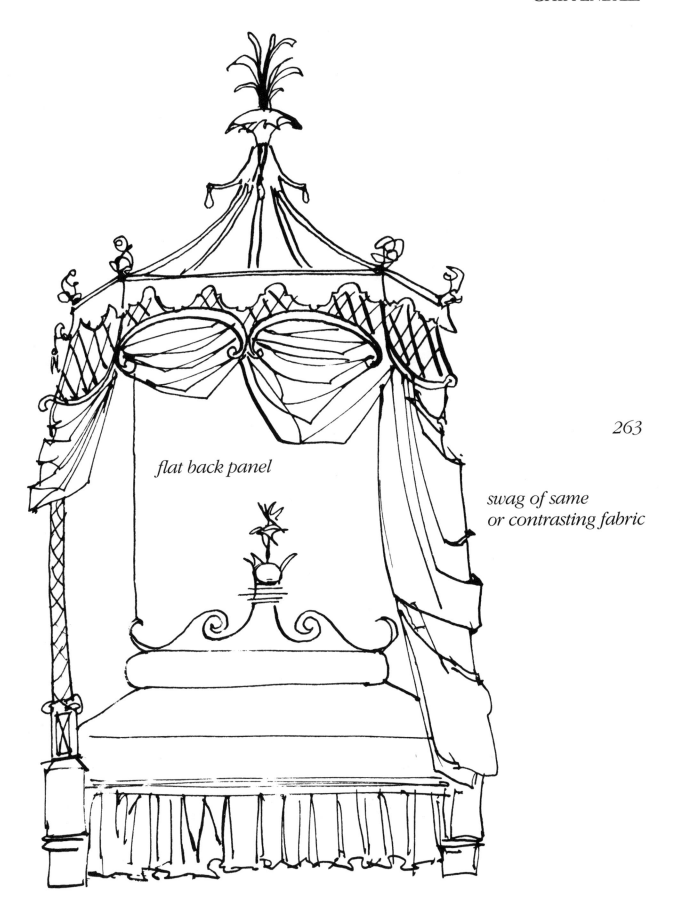

263

flat back panel

*swag of same
or contrasting fabric*

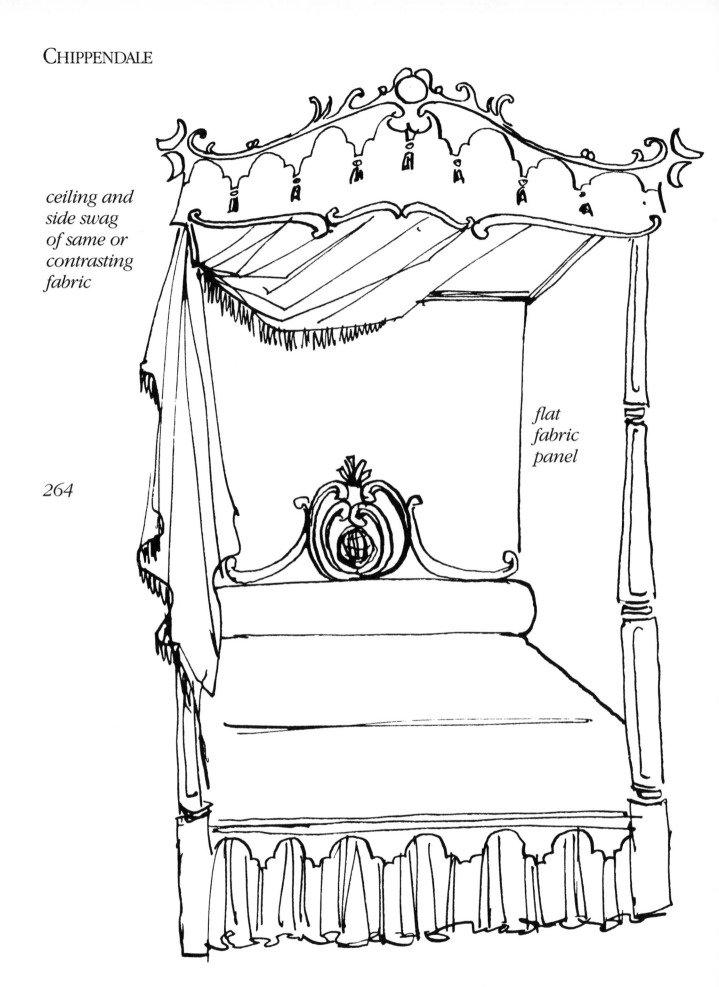

ceiling and side swag of same or contrasting fabric

flat fabric panel

264

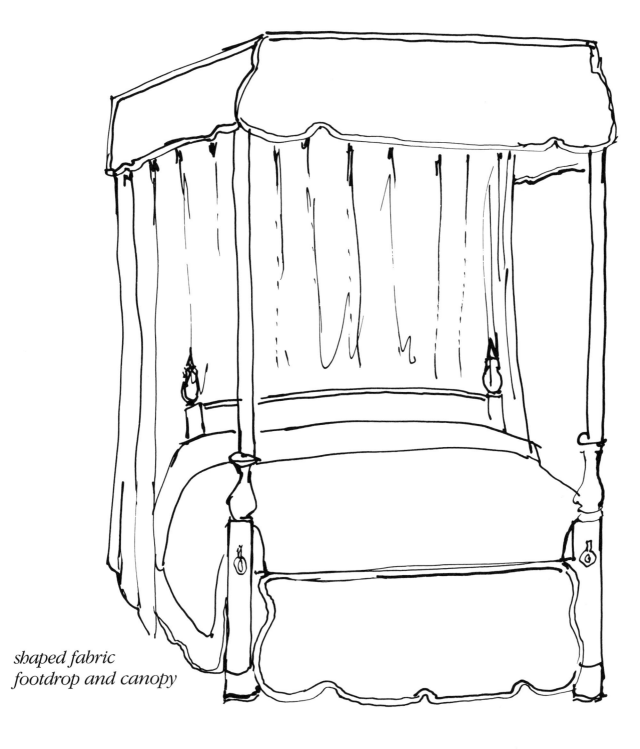

265

*shaped fabric
footdrop and canopy*

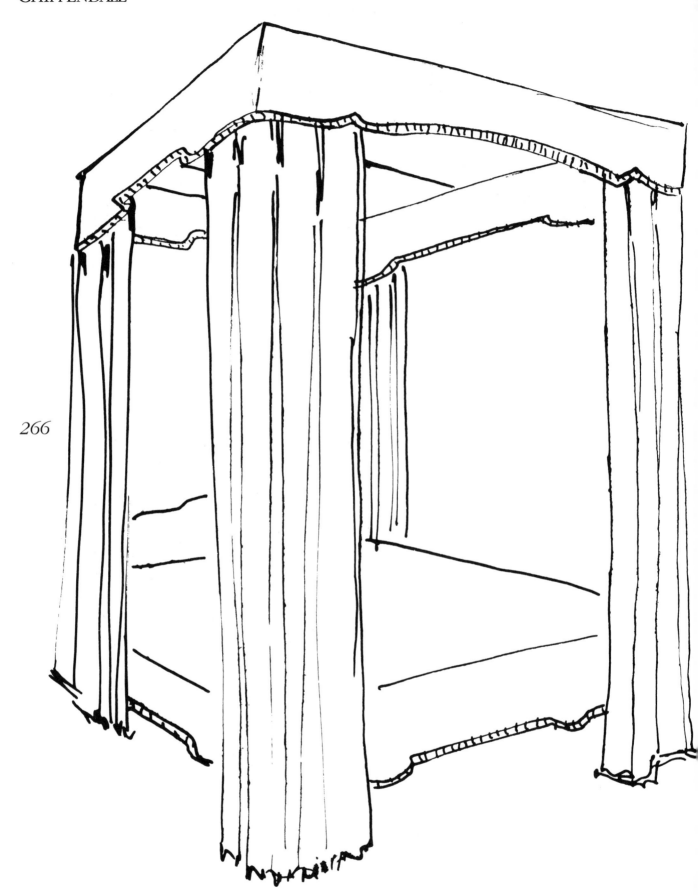

266

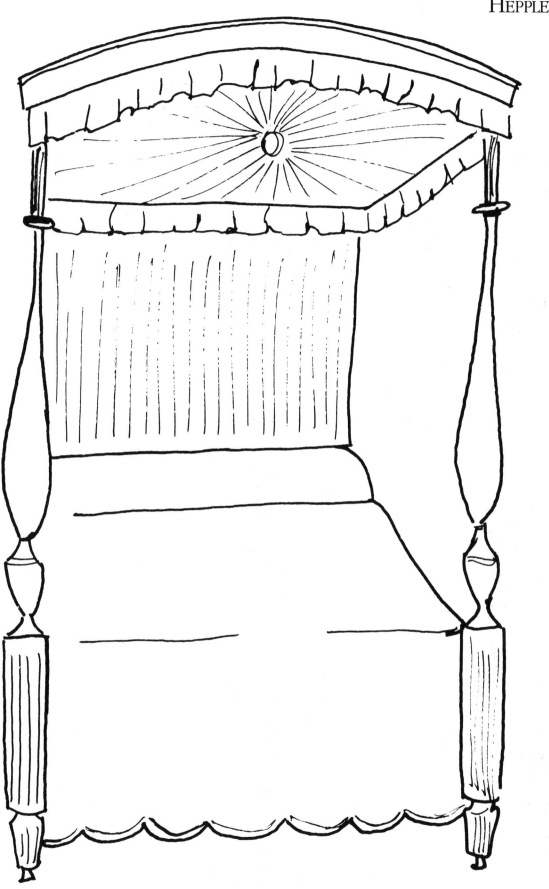

267

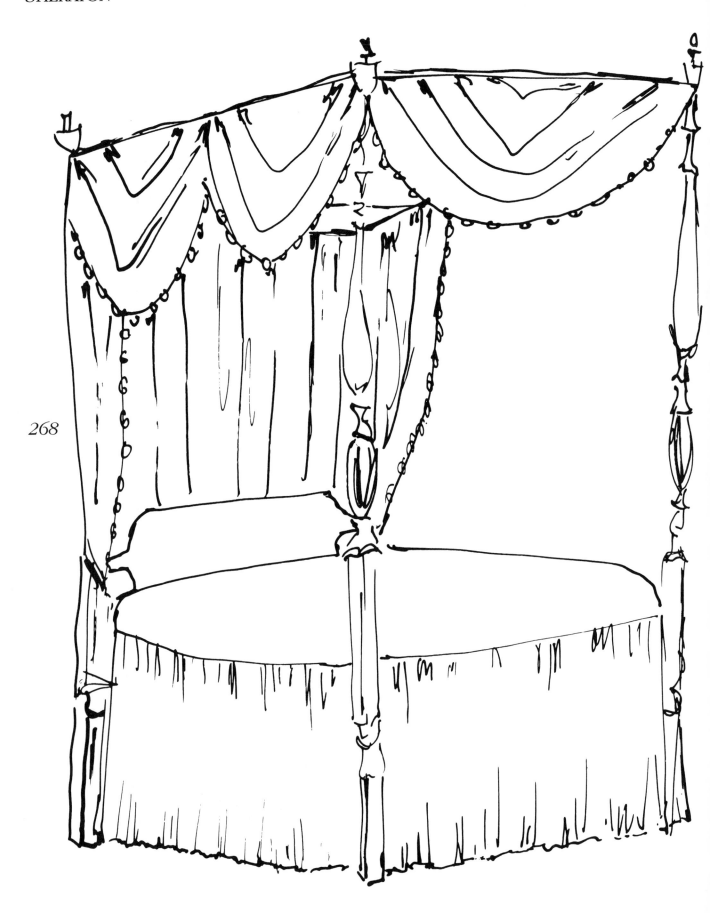

268

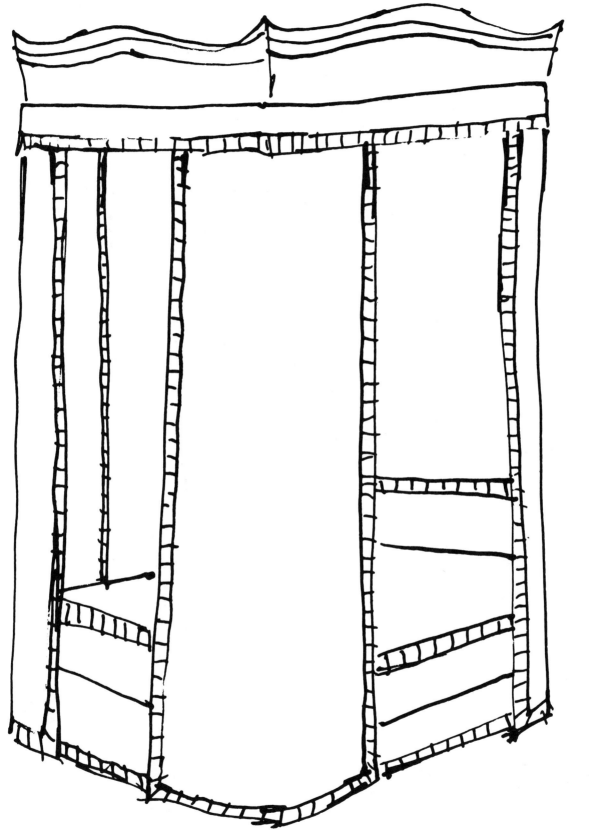

269

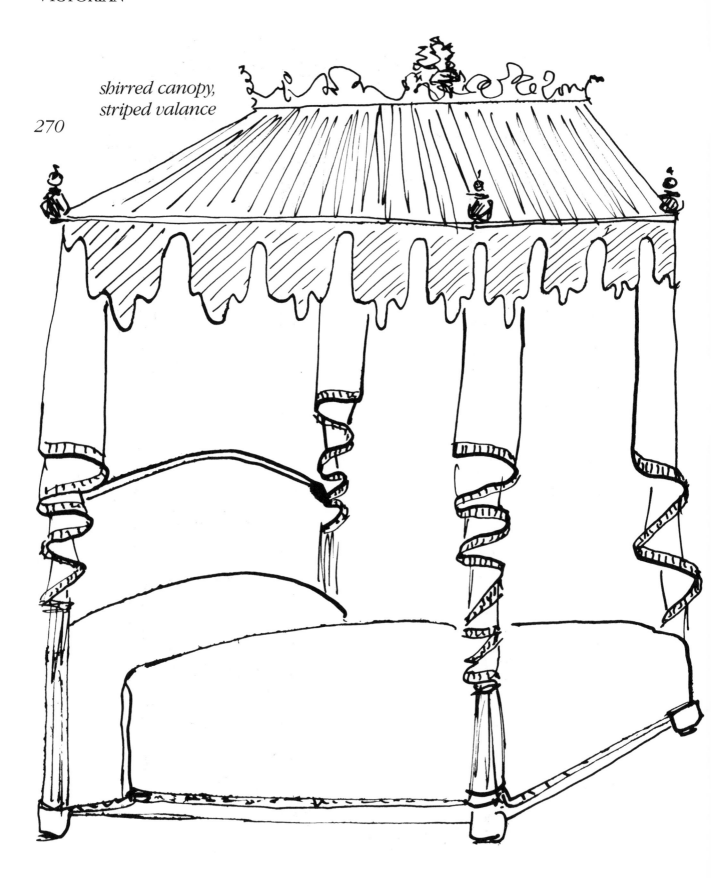

*shirred canopy,
striped valance*

270

*shirred
inside and out*

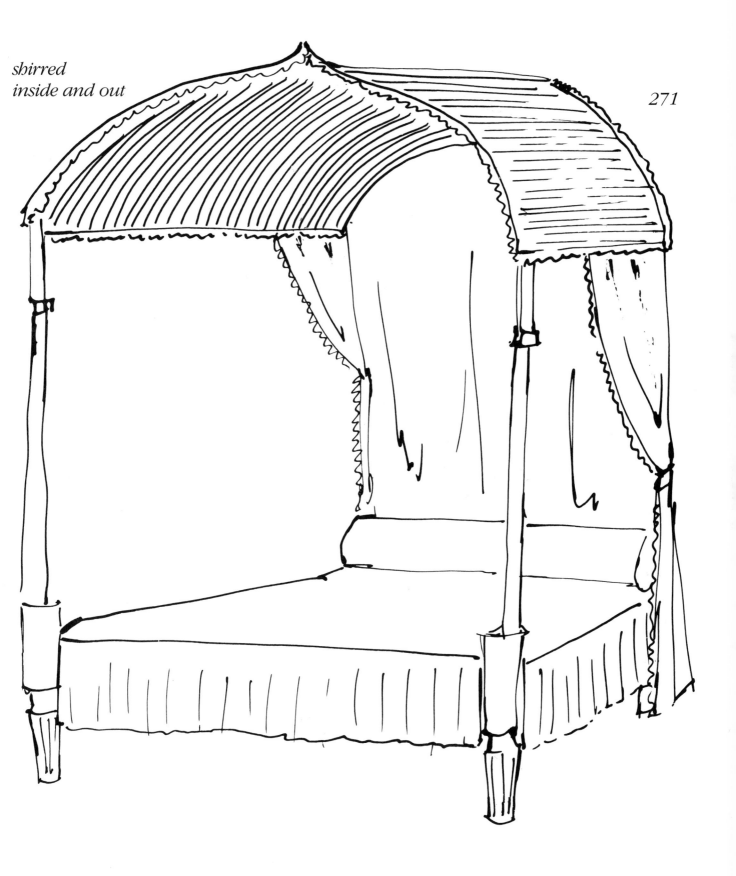

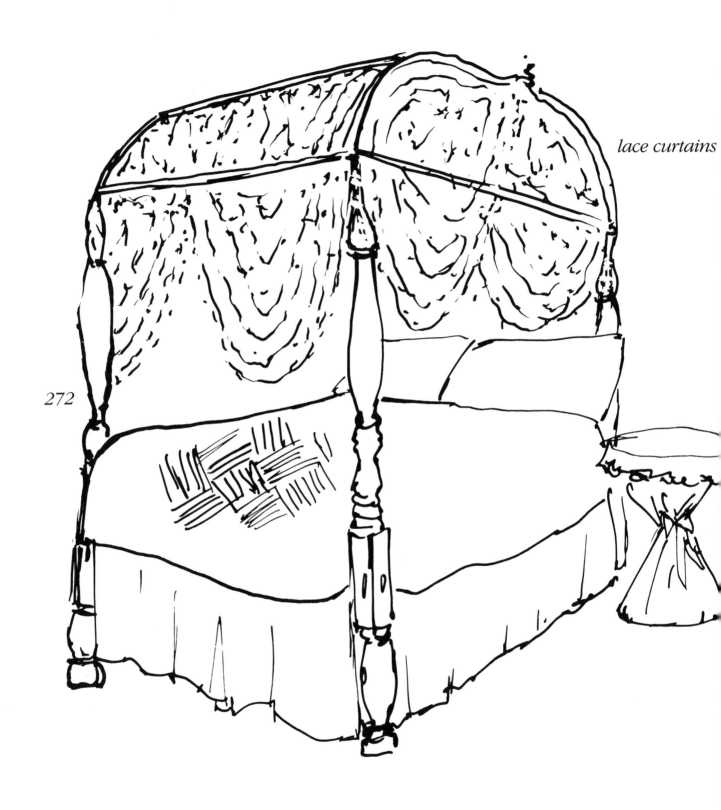

lace curtains

272

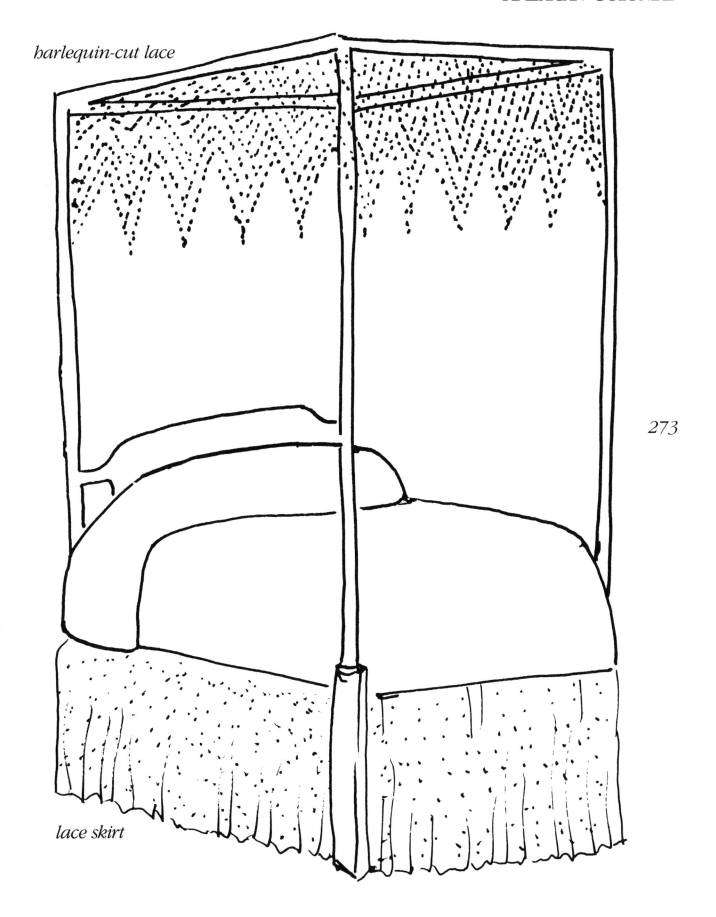

harlequin-cut lace

273

lace skirt

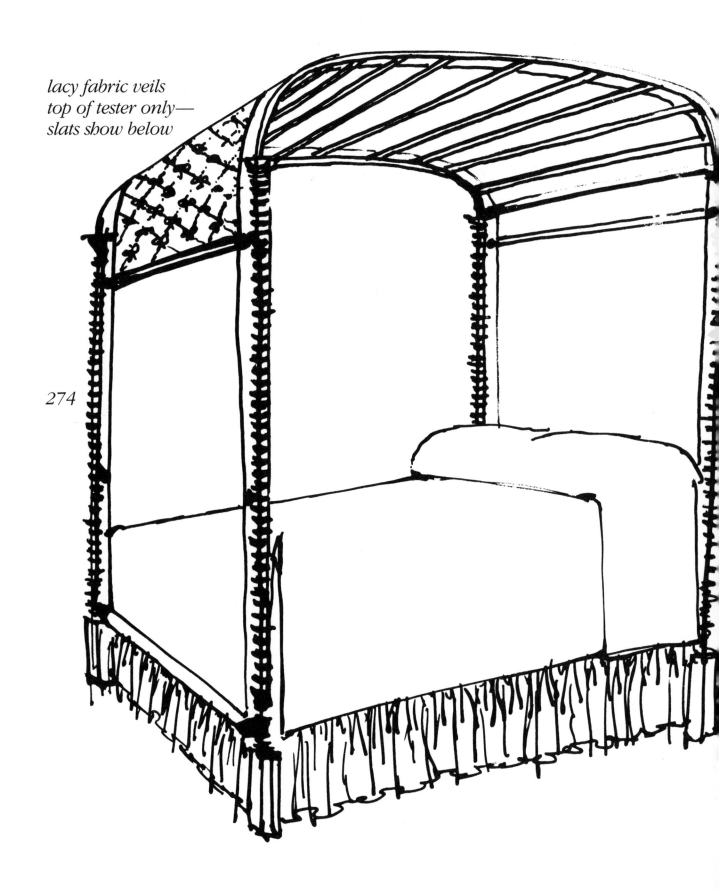

*lacy fabric veils
top of tester only—
slats show below*

274

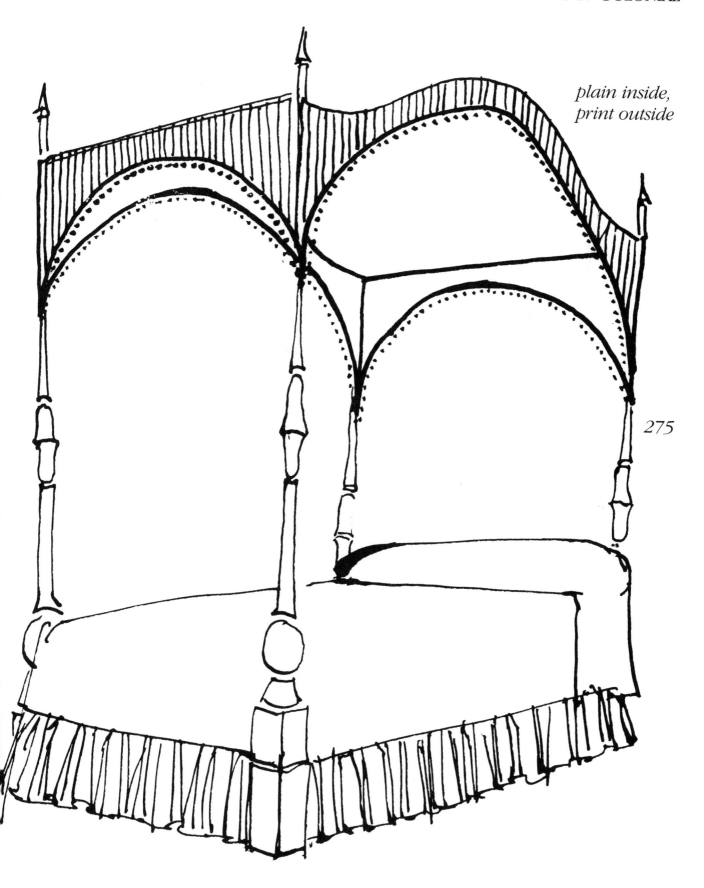

*plain inside,
print outside*

275

pleated tester

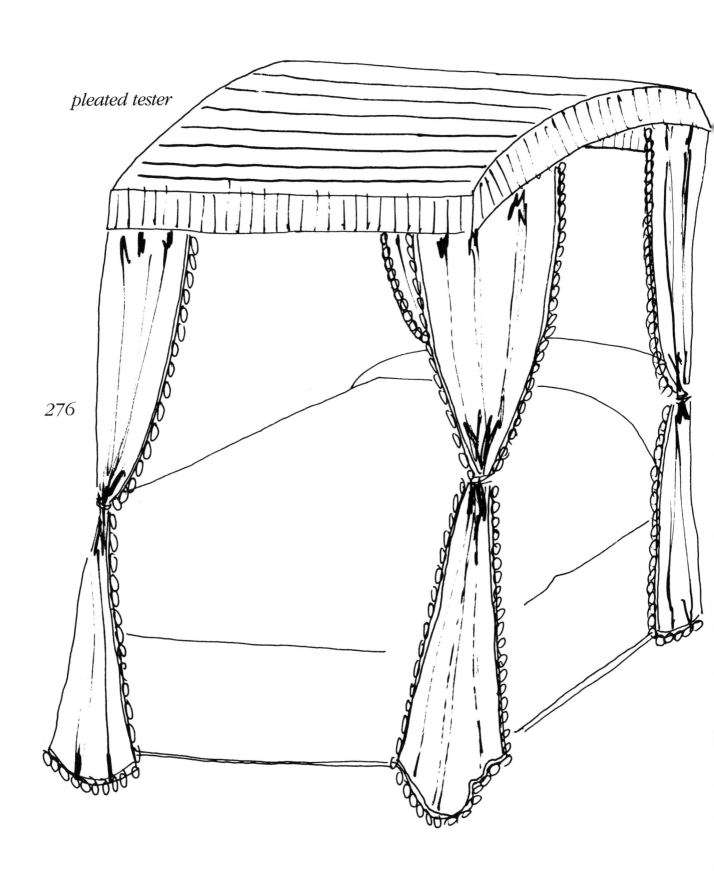

276

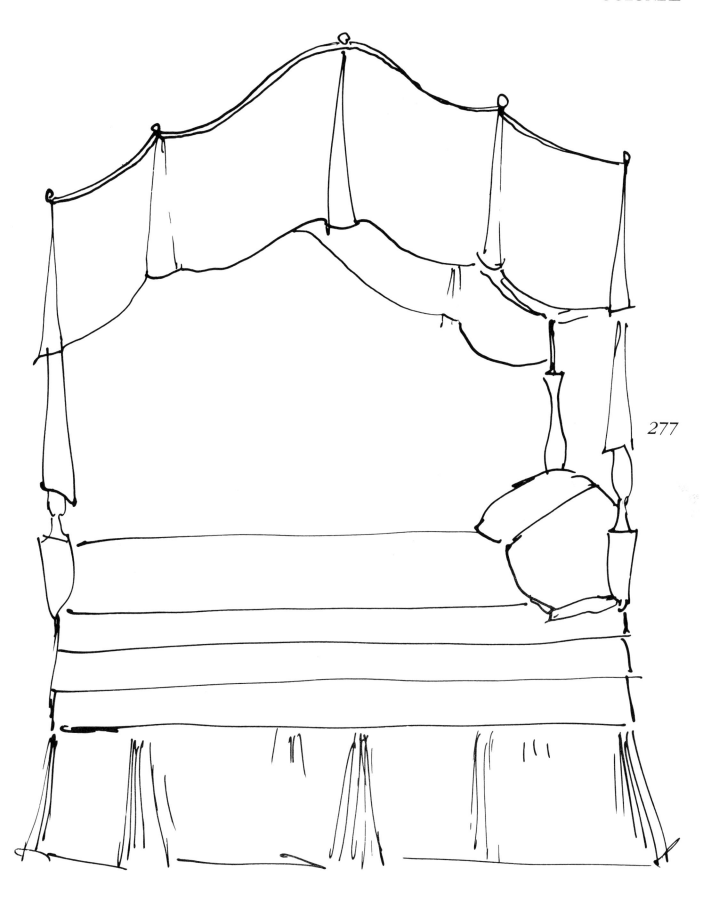

277

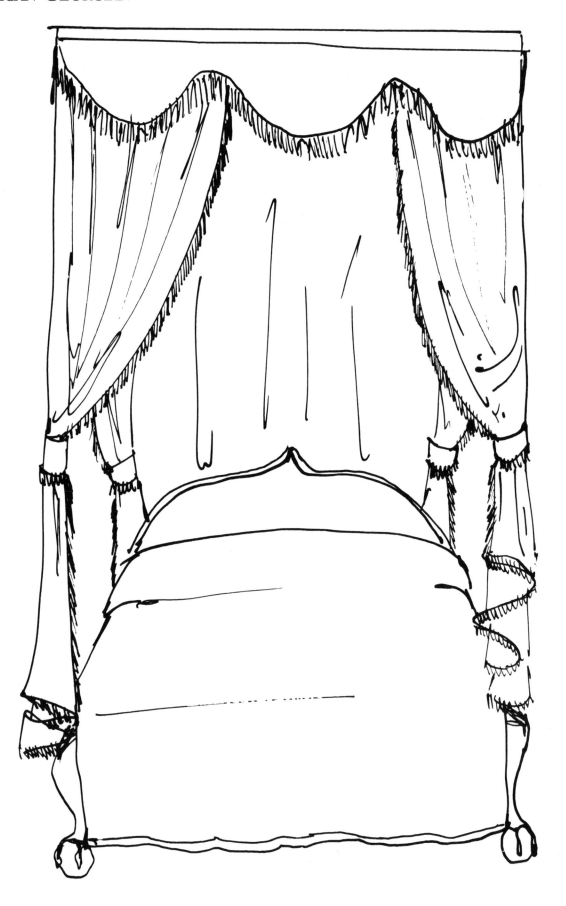

278

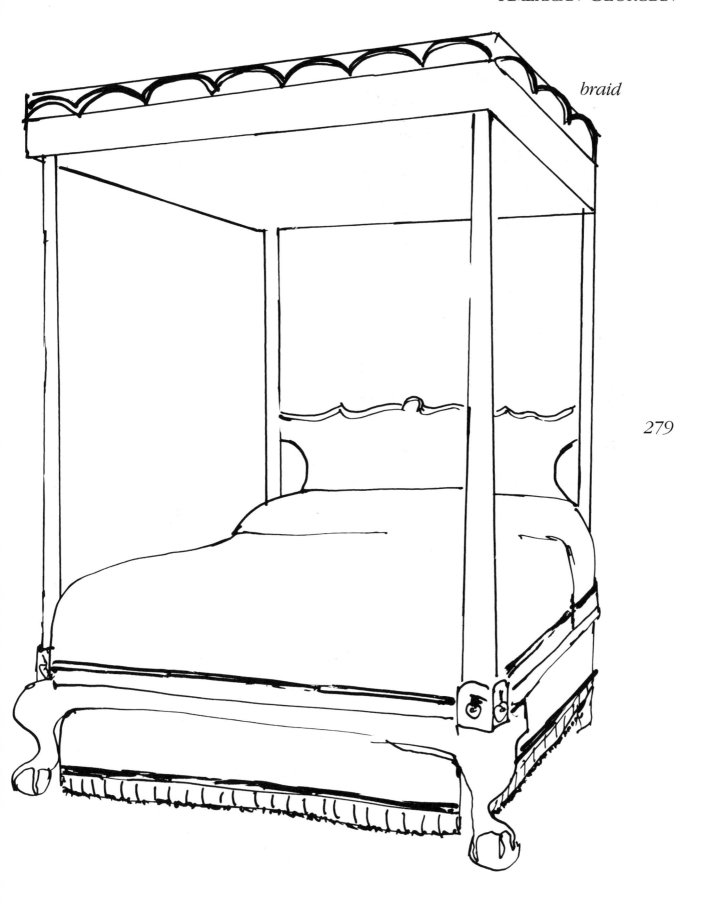

braid

279

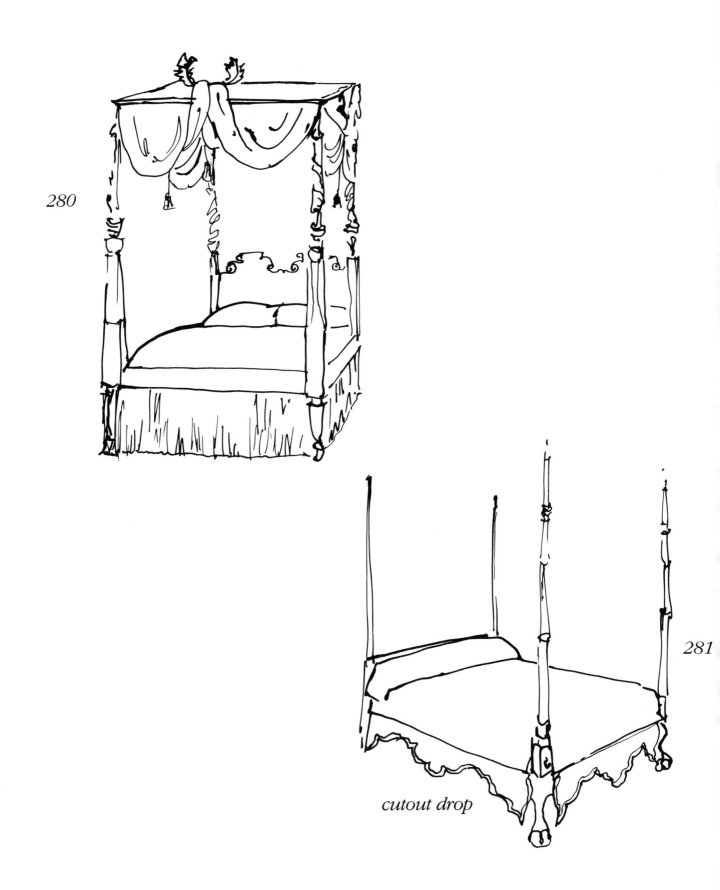

280

281

cutout drop

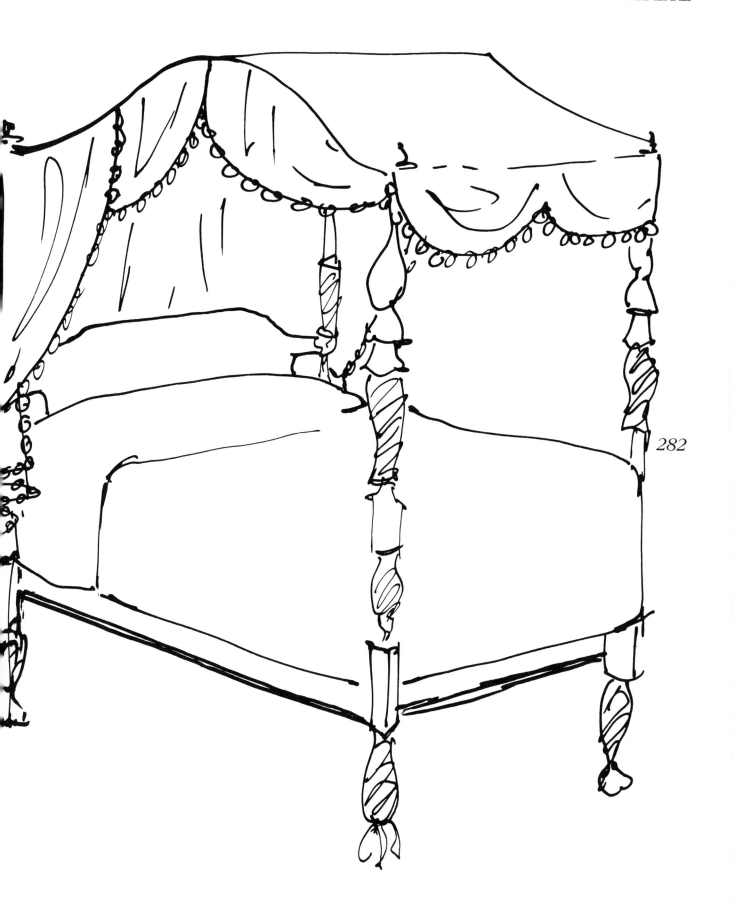

282

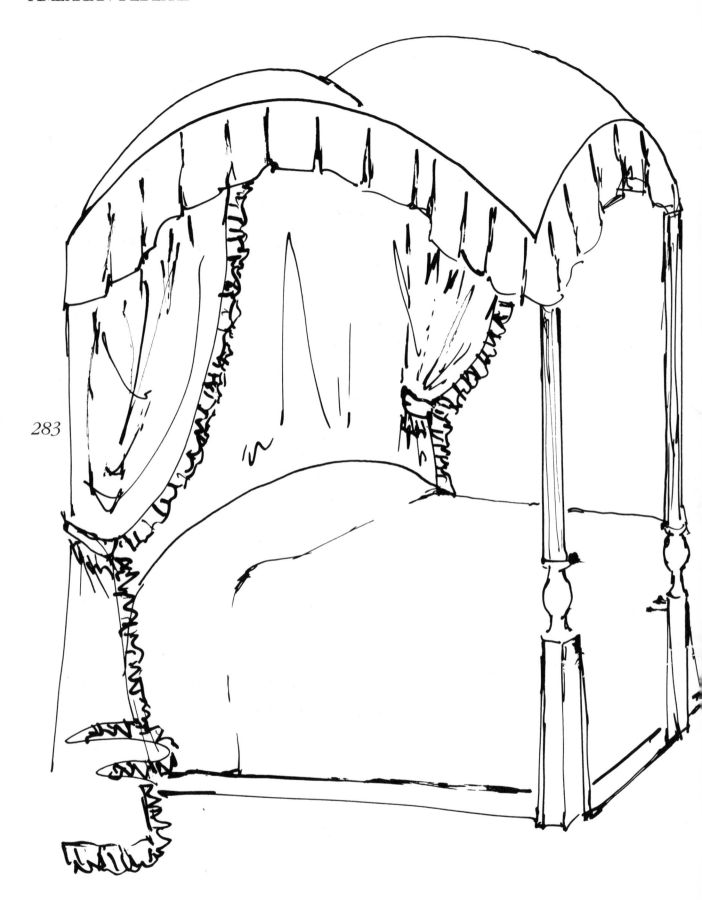

283

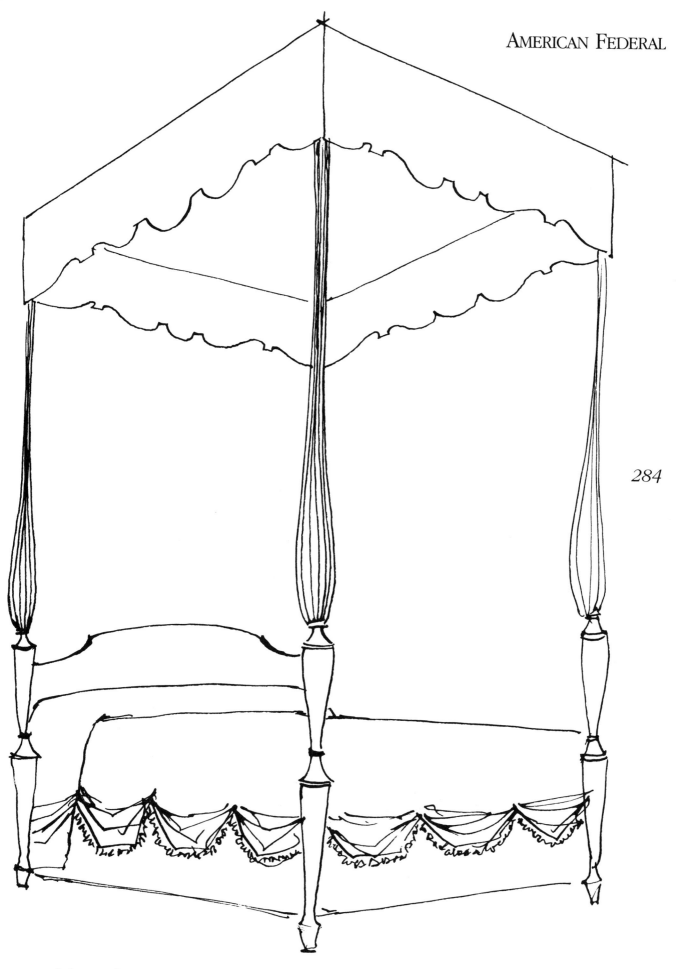

284

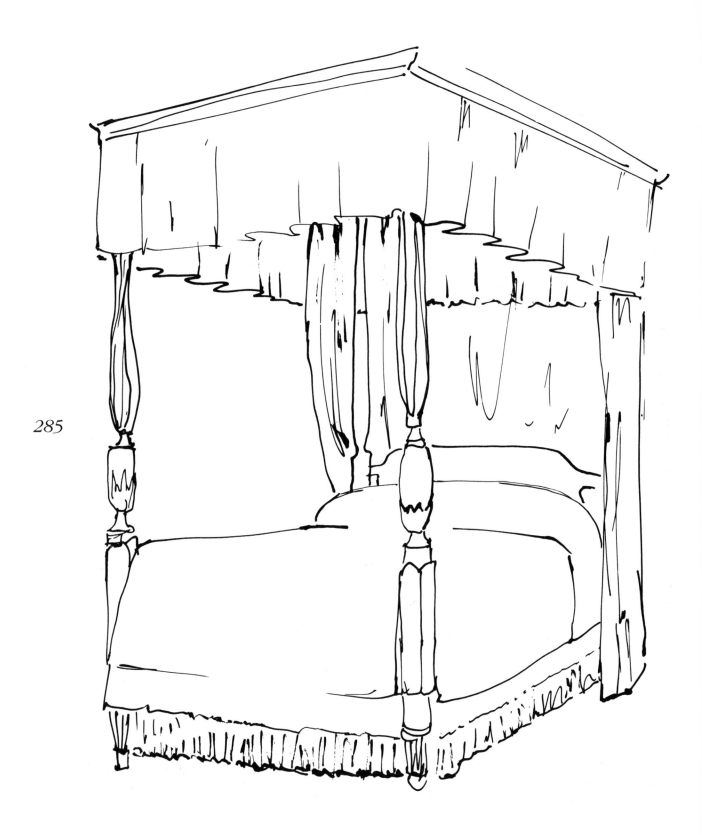

285

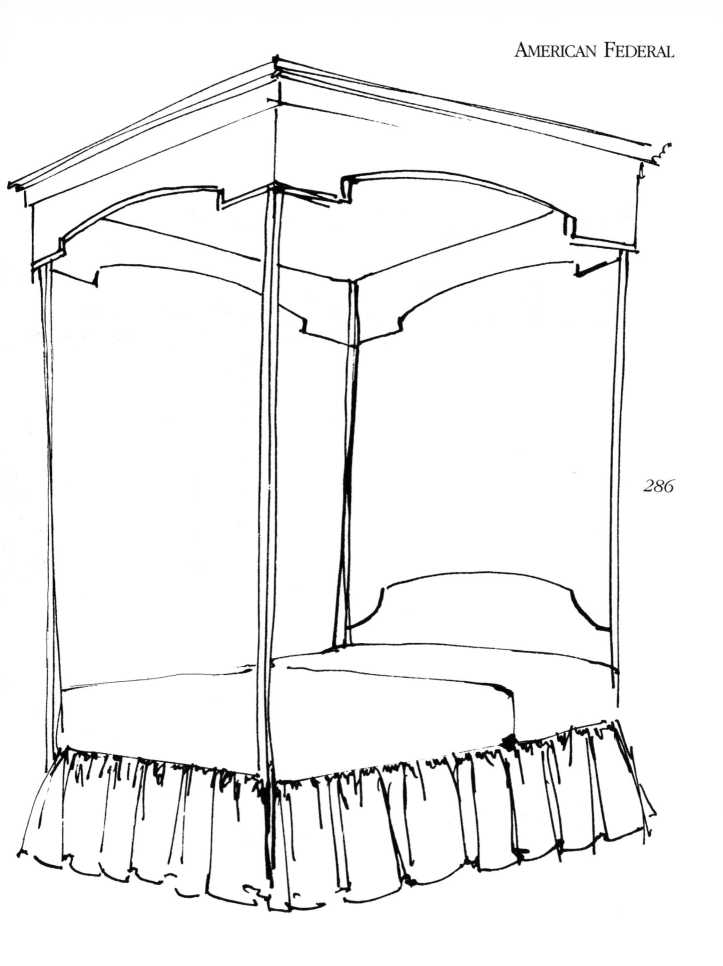

286

287

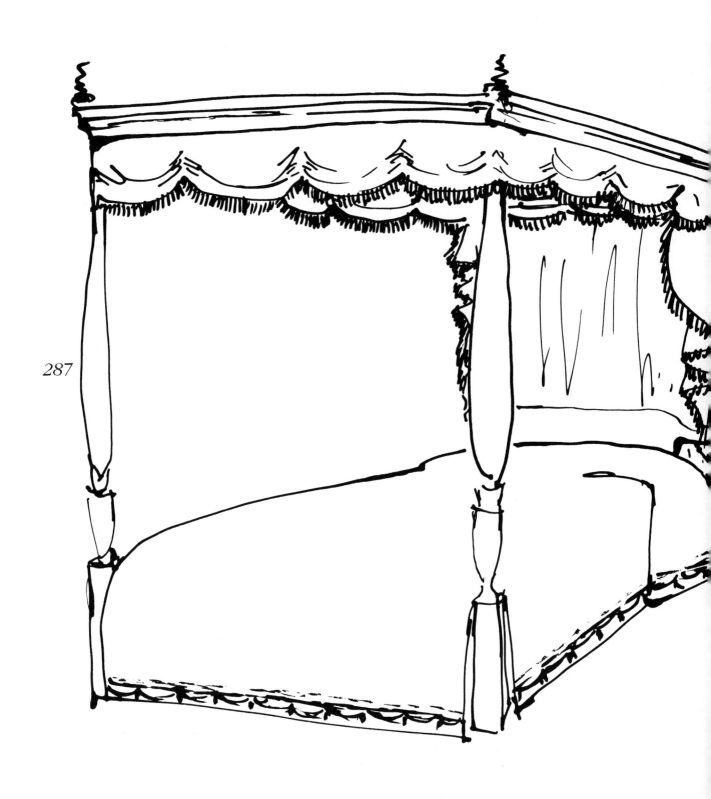

Formal Designs

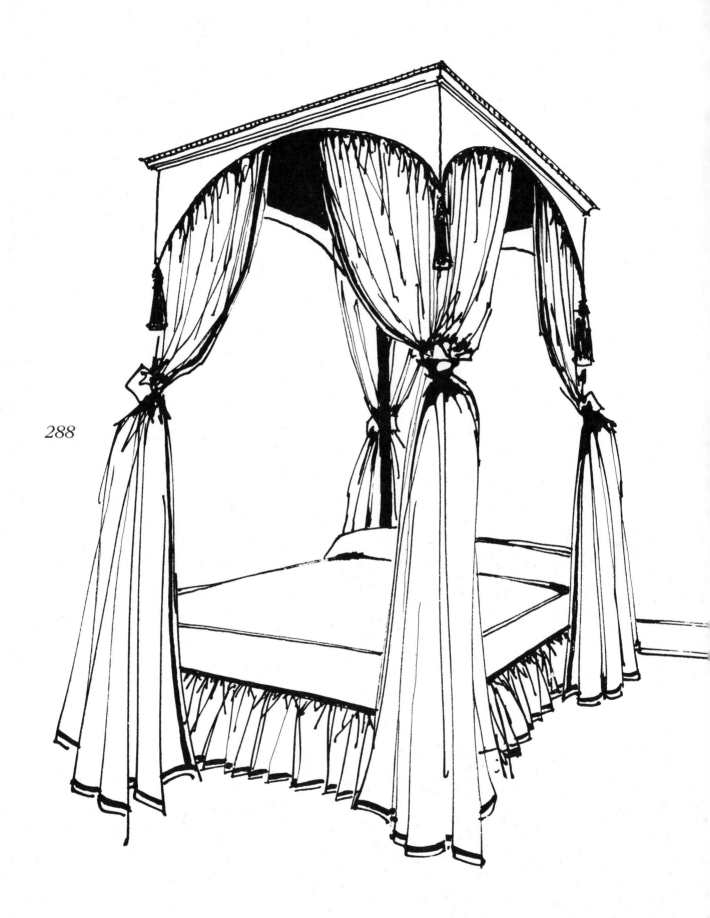

288

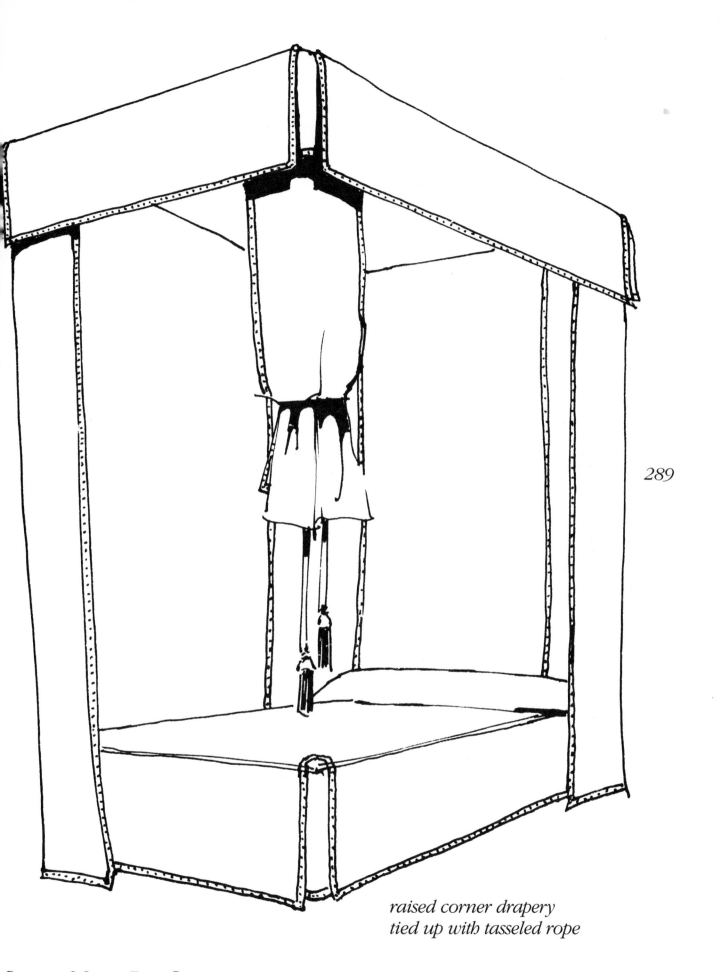

289

*raised corner drapery
tied up with tasseled rope*

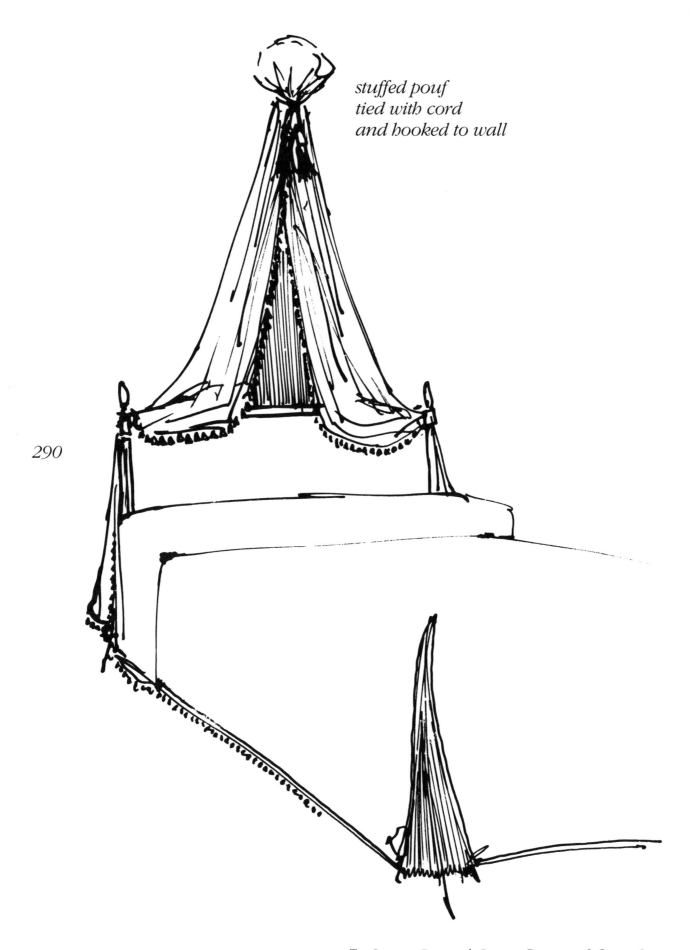

*stuffed pouf
tied with cord
and hooked to wall*

290

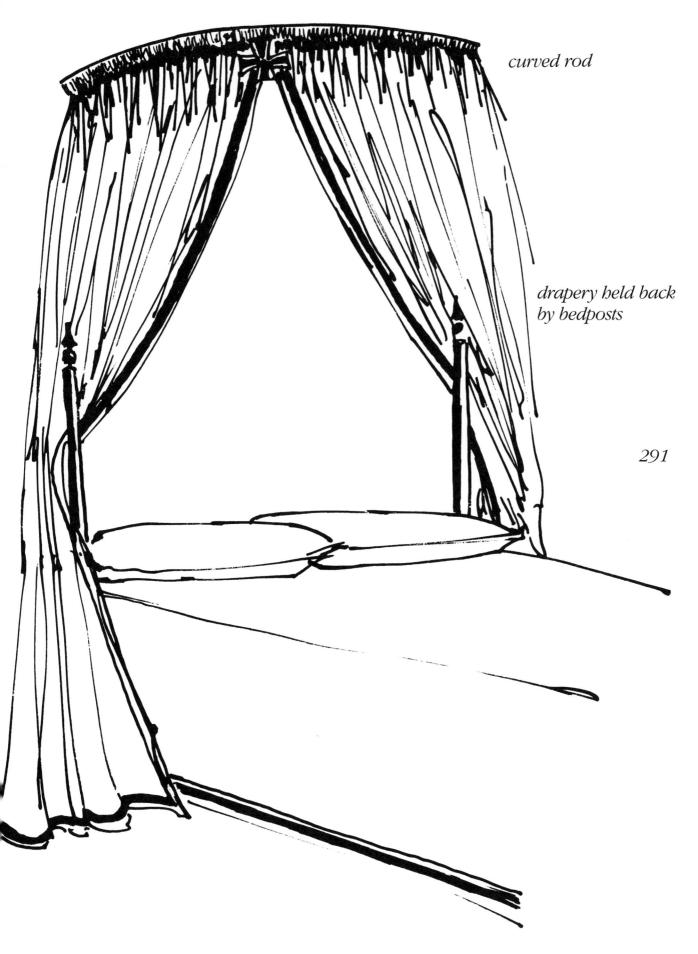

curved rod

drapery held back by bedposts

291

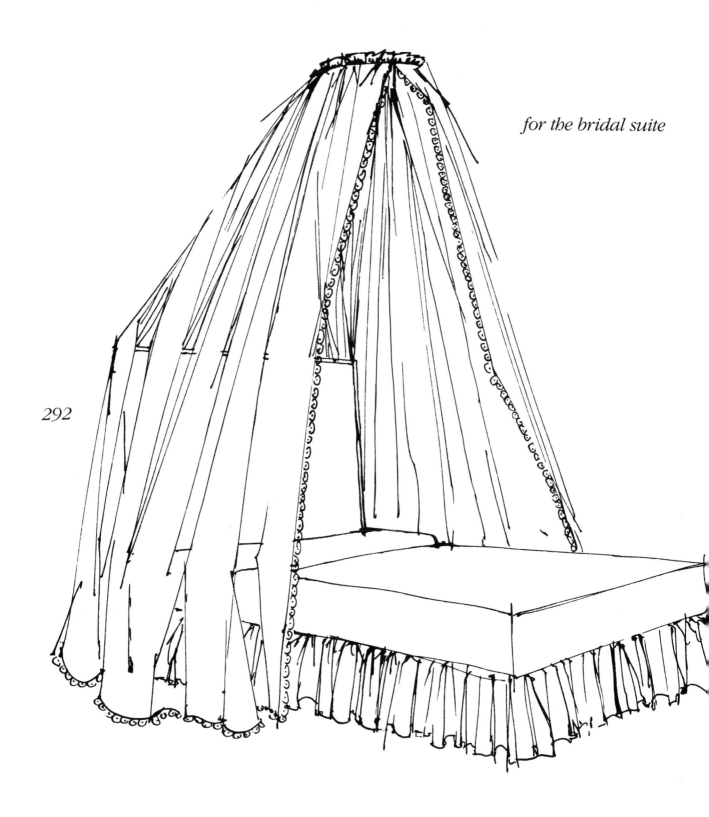

for the bridal suite

292

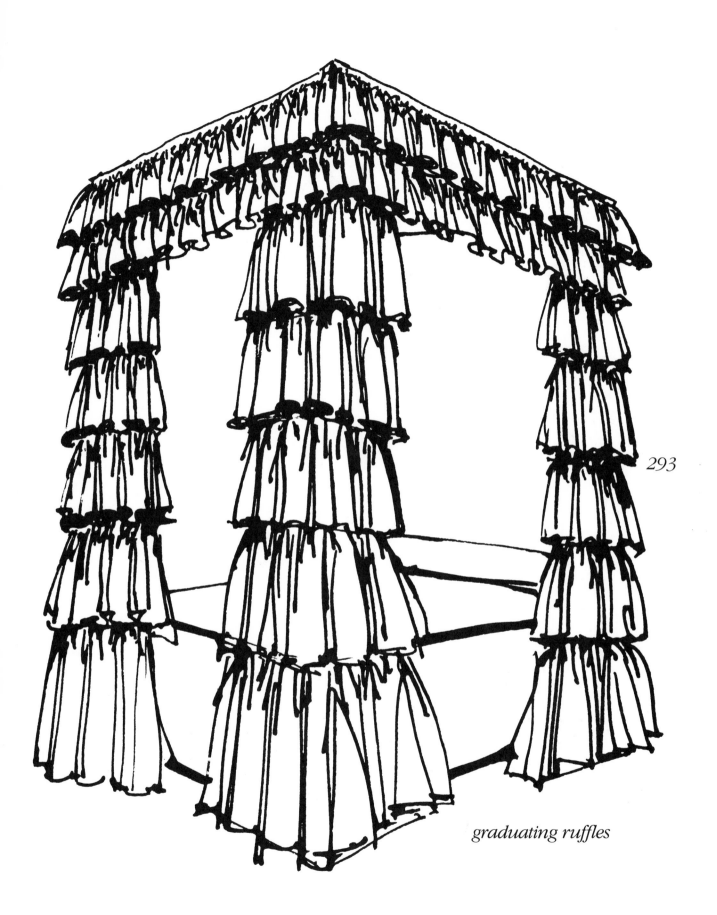

293

graduating ruffles

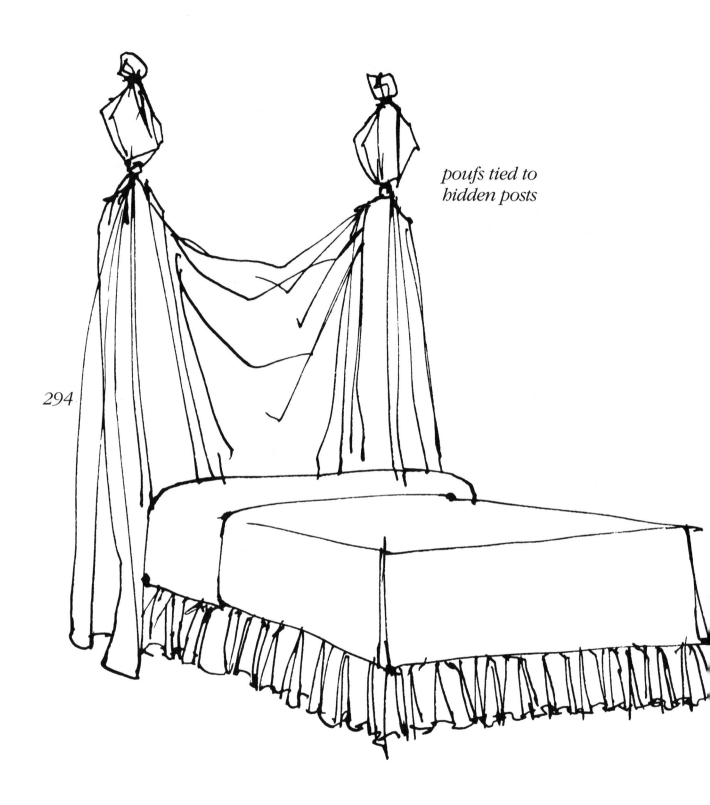

*poufs tied to
hidden posts*

294

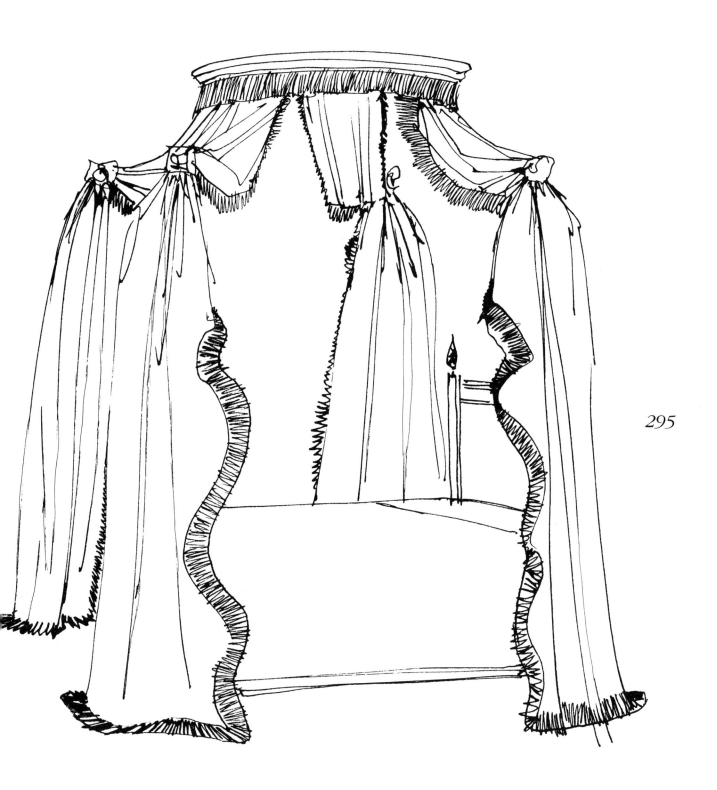

295

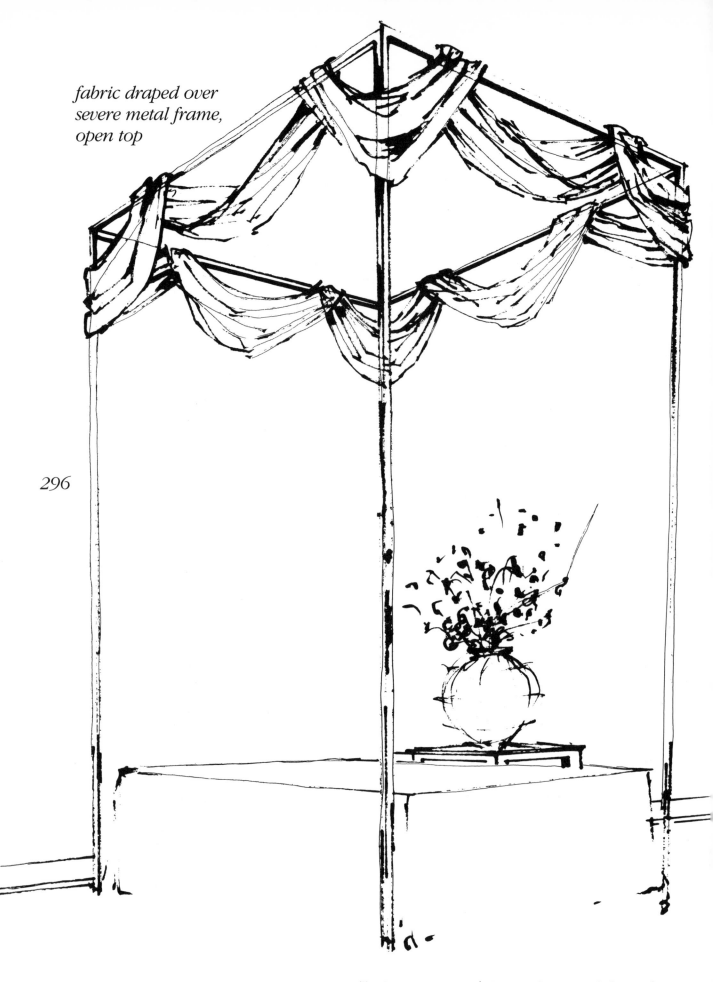

*fabric draped over
severe metal frame,
open top*

296

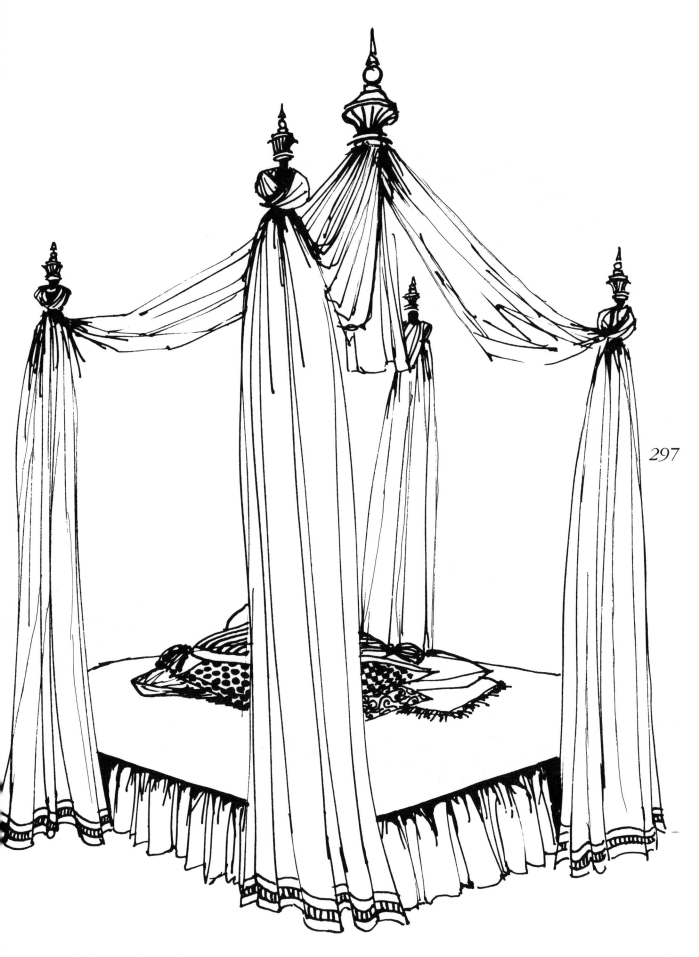

297

298

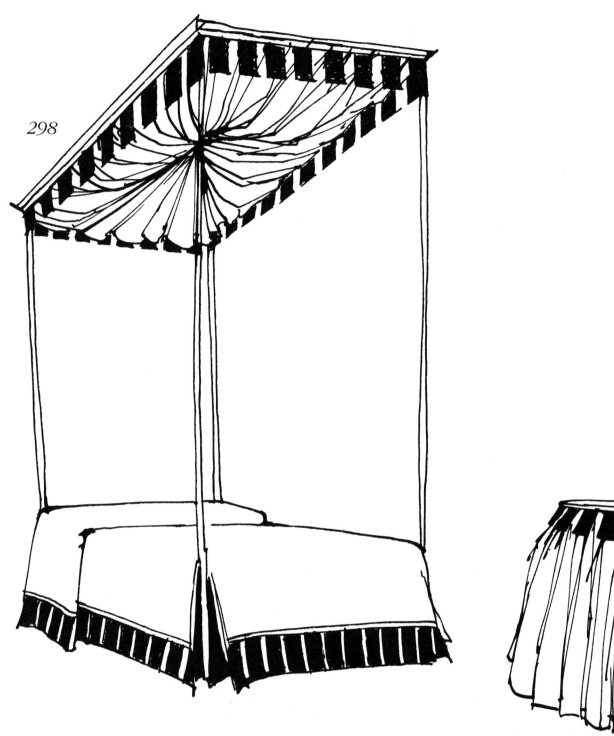

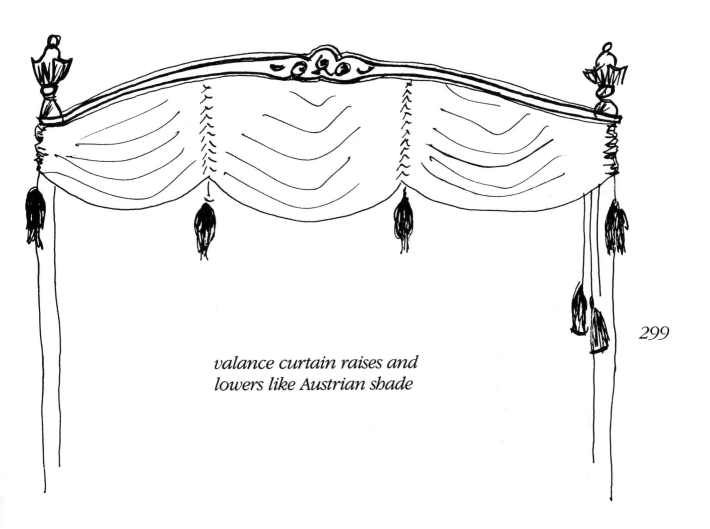

299

*valance curtain raises and
lowers like Austrian shade*

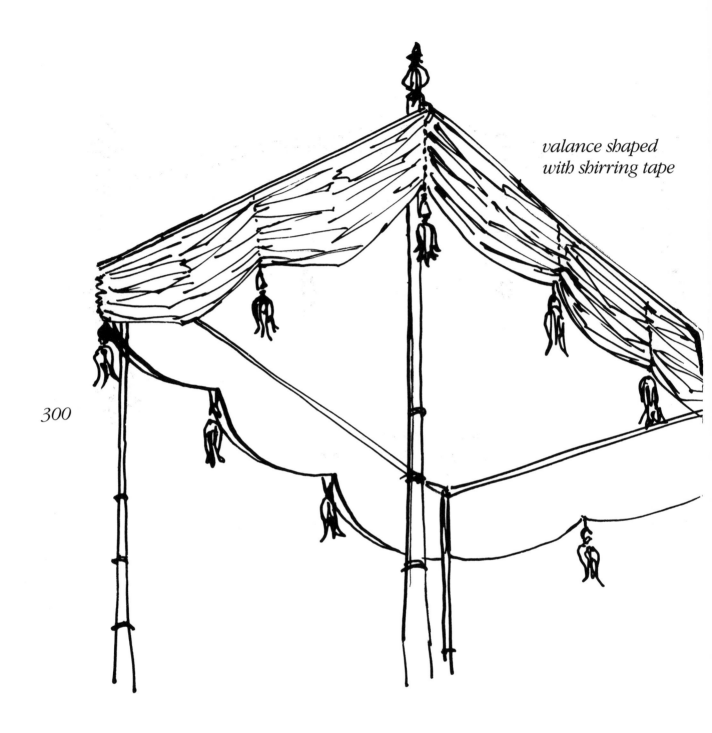

valance shaped
with shirring tape

300

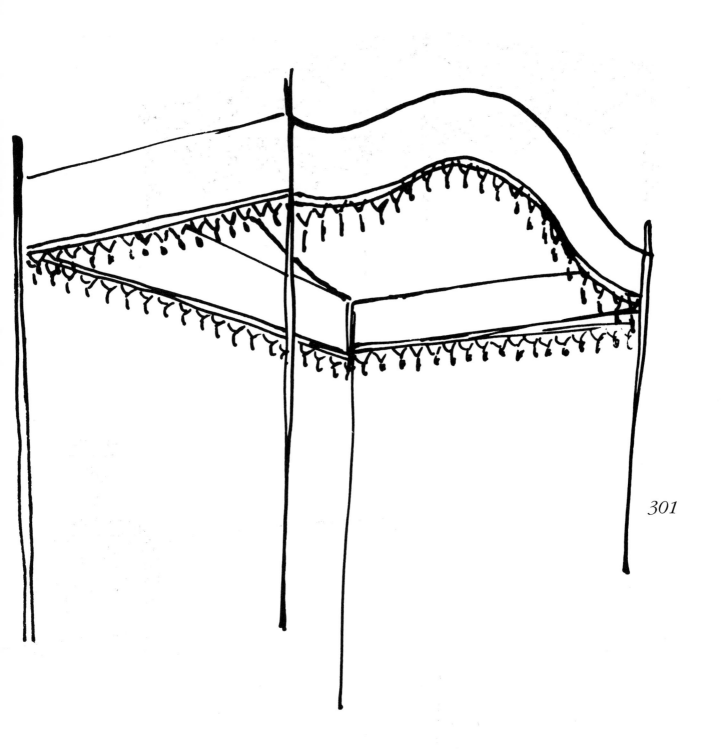

301

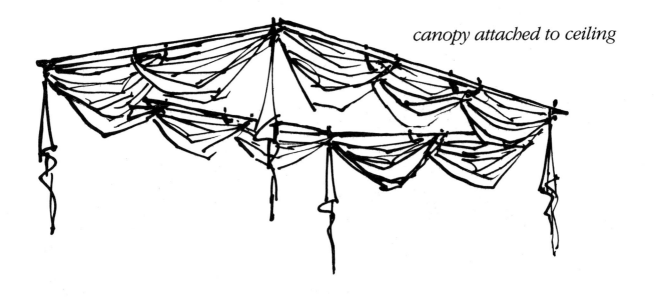

canopy attached to ceiling

302

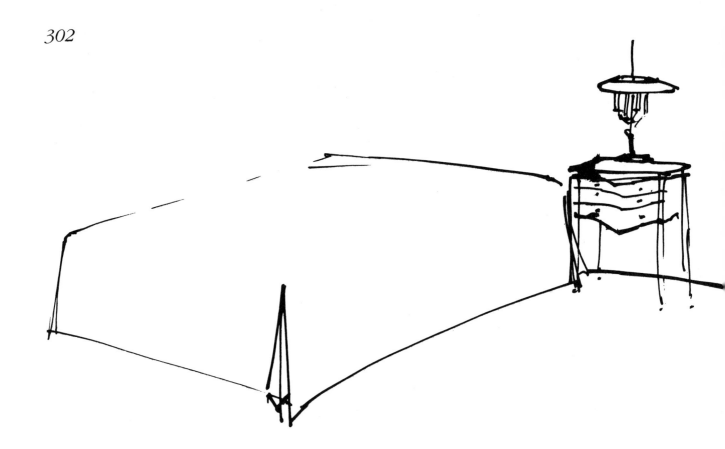

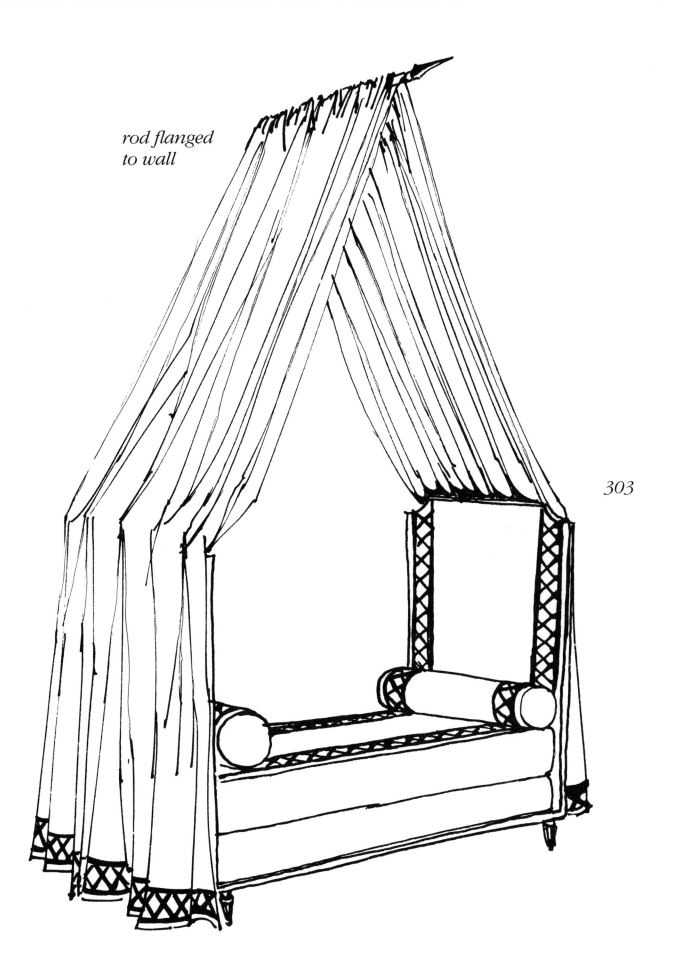

*rod flanged
to wall*

303

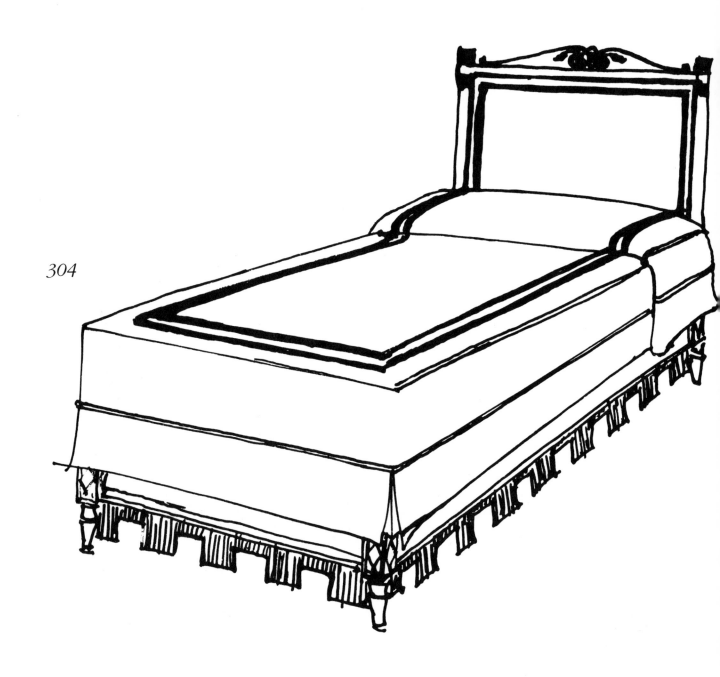

304

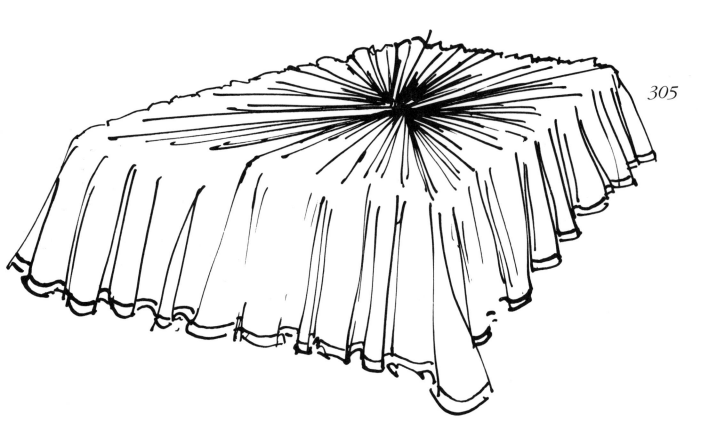

305

"Austrian" bedspread

306

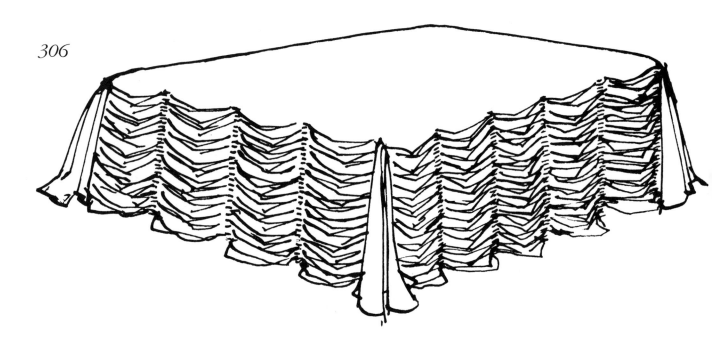

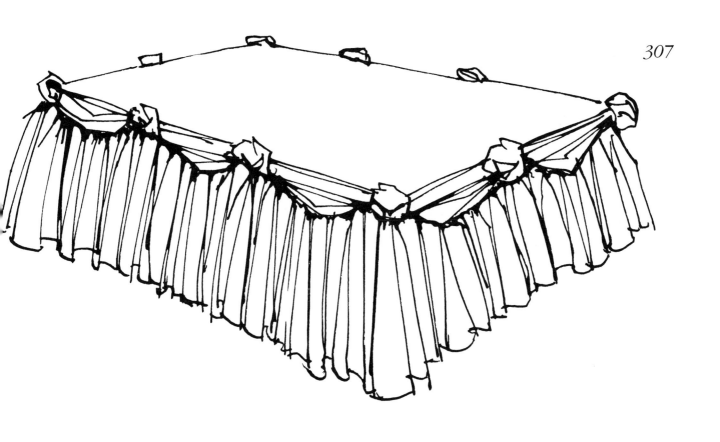

307

308

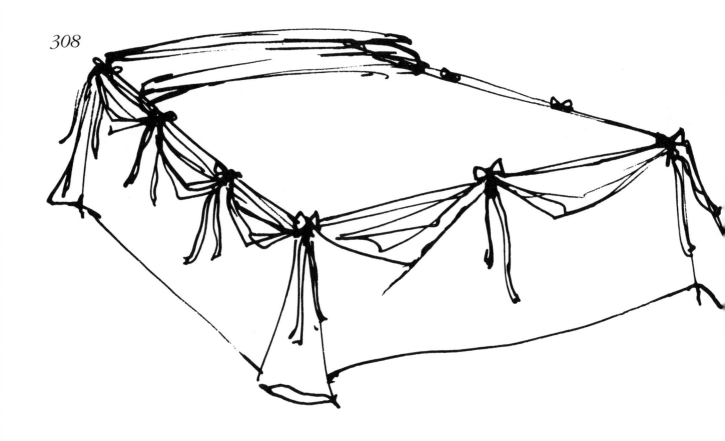

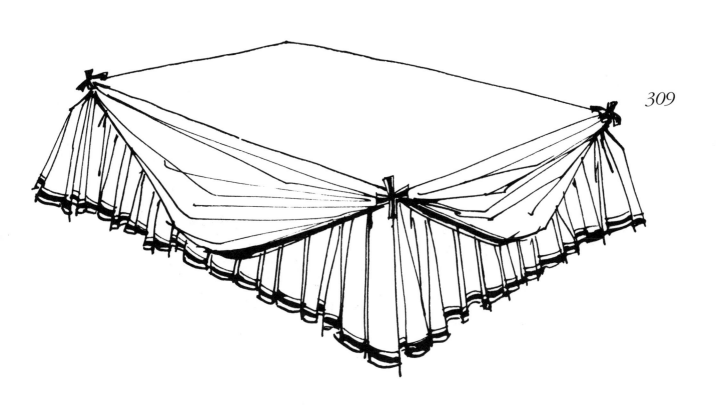

309

310

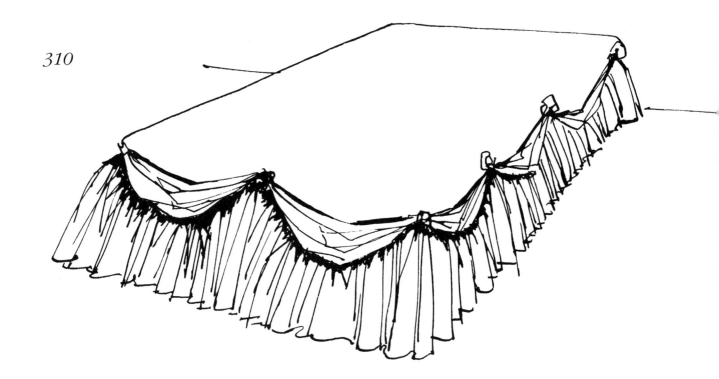

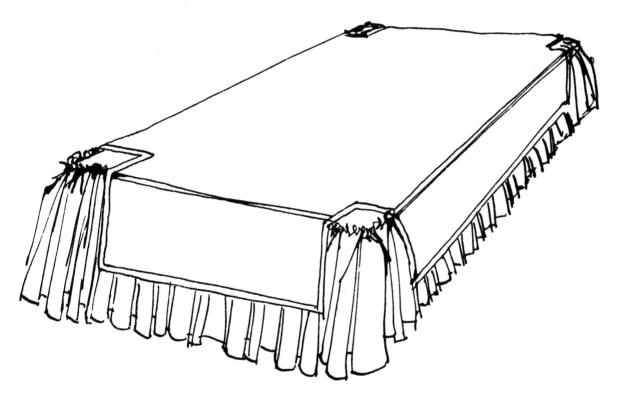

311

312

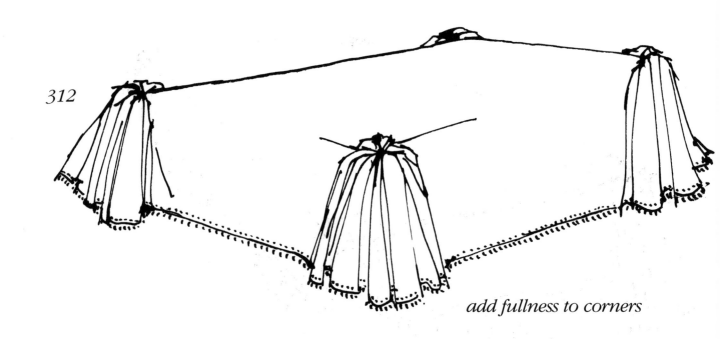

add fullness to corners

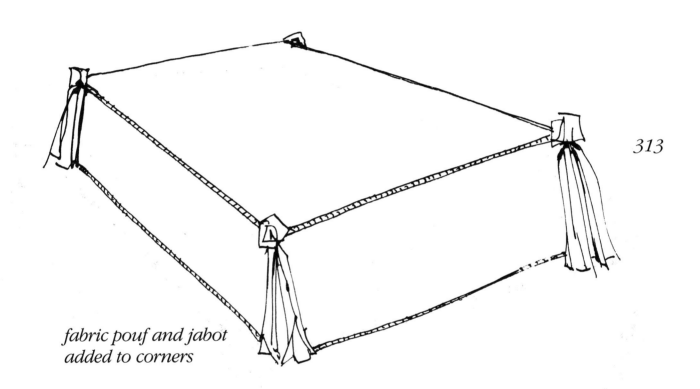

313

*fabric pouf and jabot
added to corners*

314

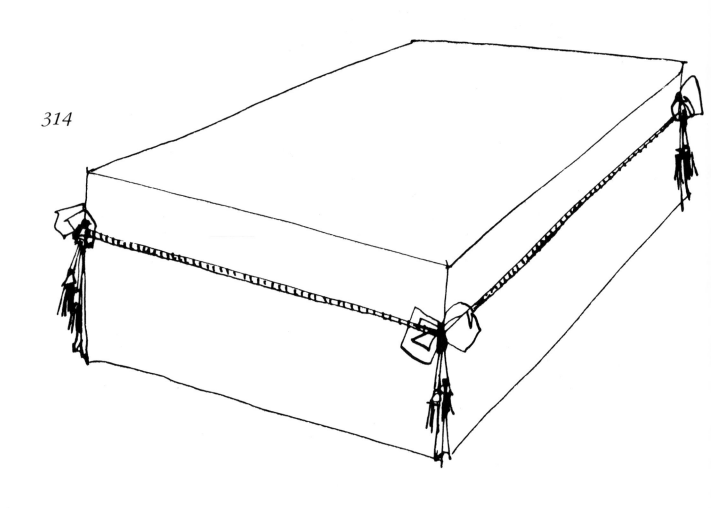

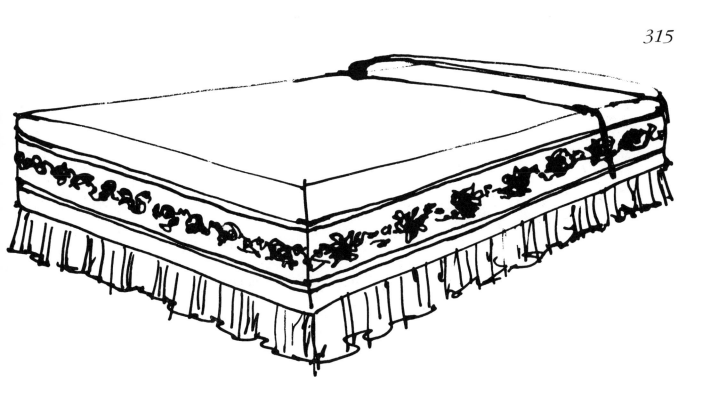

315

316

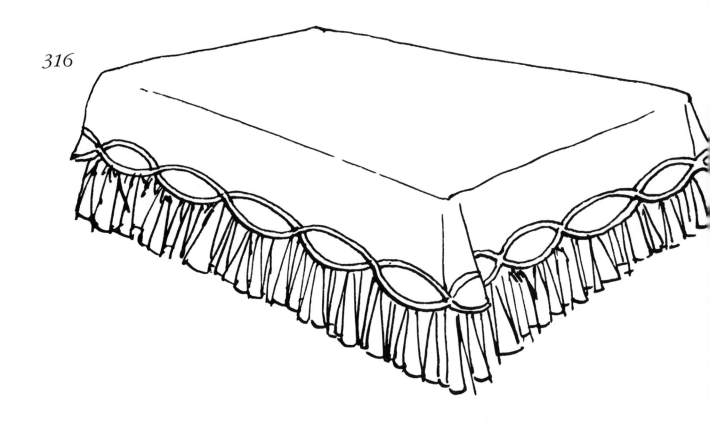

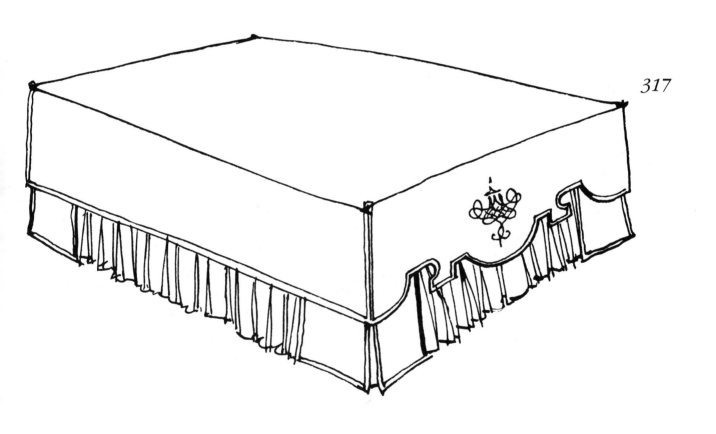

317

318

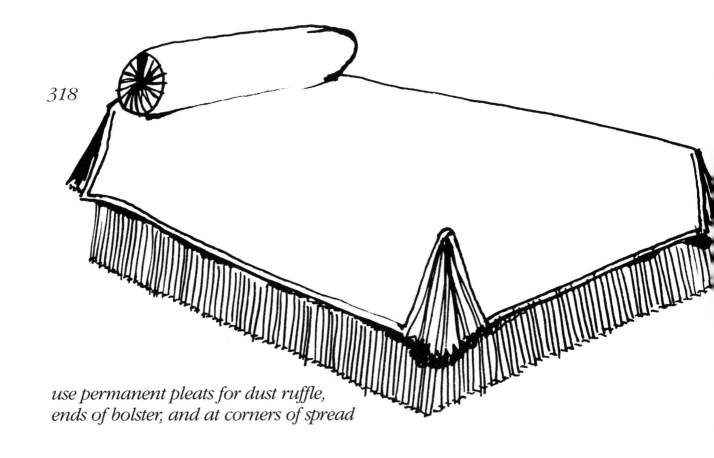

*use permanent pleats for dust ruffle,
ends of bolster, and at corners of spread*

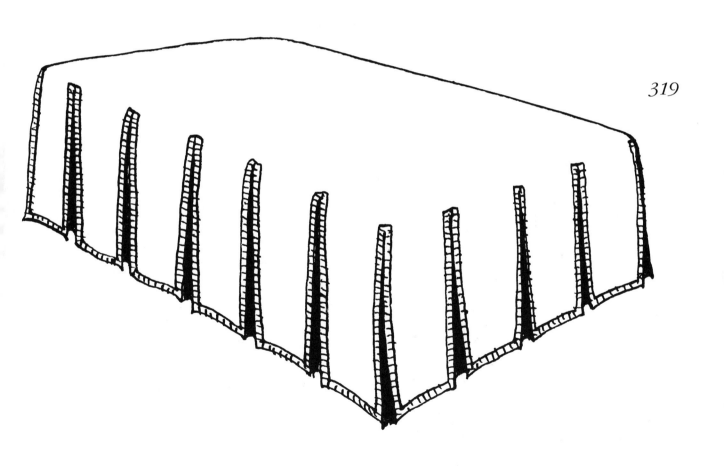

319

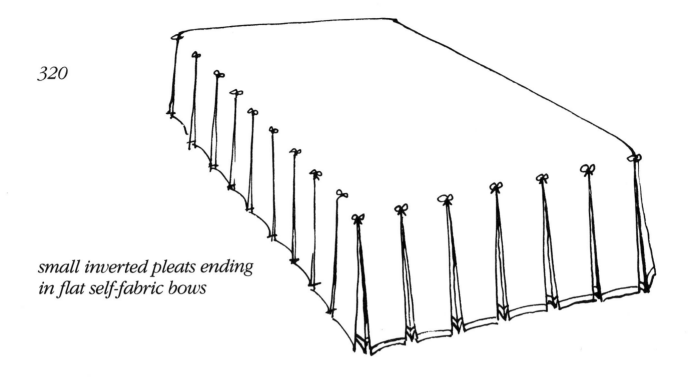

320

*small inverted pleats ending
in flat self-fabric bows*

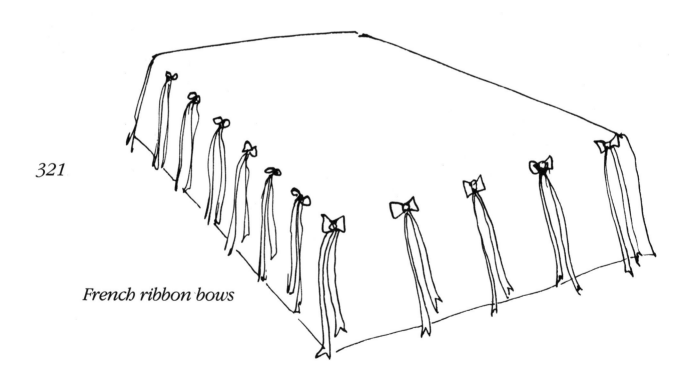

321

French ribbon bows

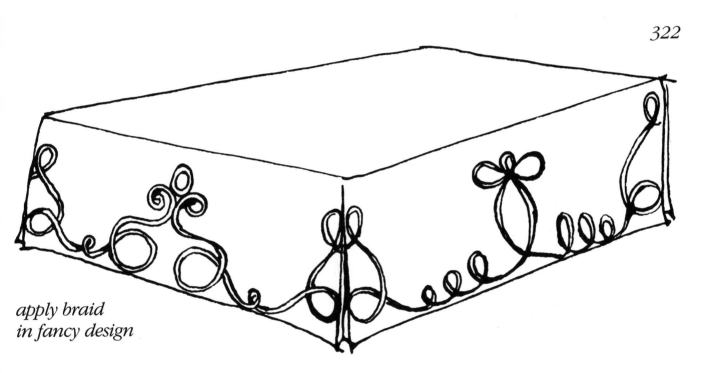

*apply braid
in fancy design*

323

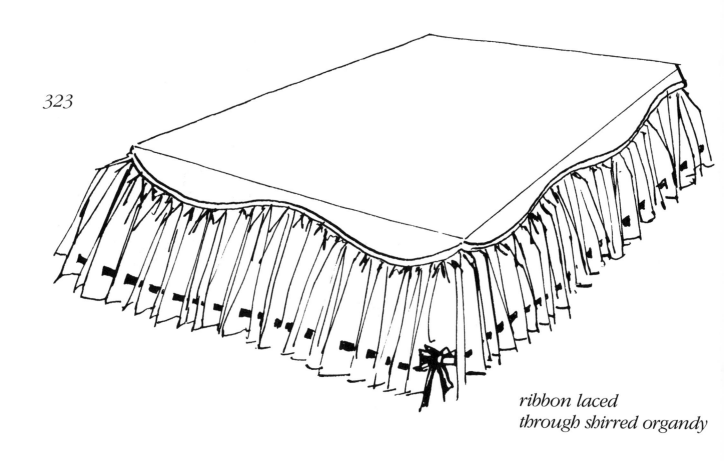

*ribbon laced
through shirred organdy*

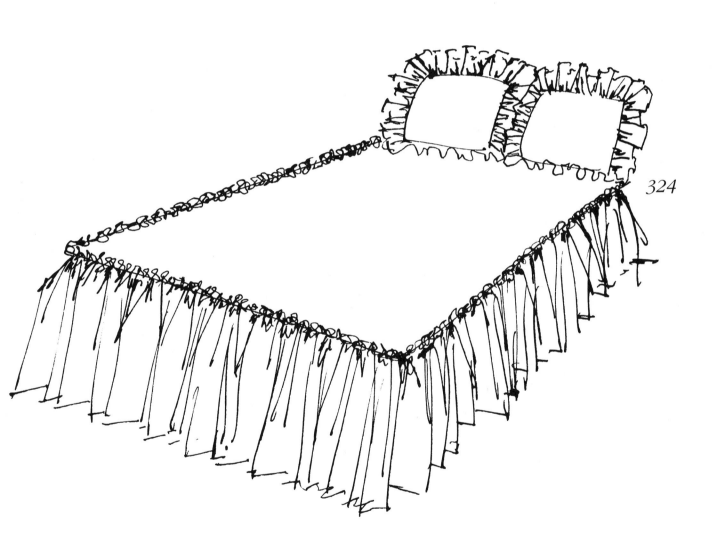

324

*use second fabric for
petal binding and skirt*

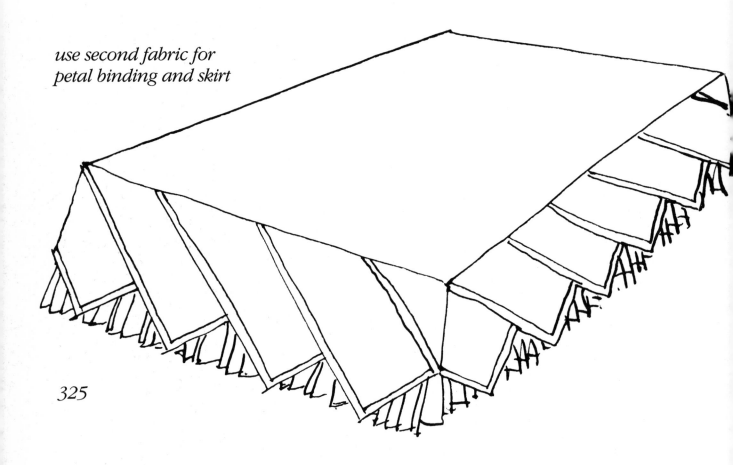

325

Casual Designs

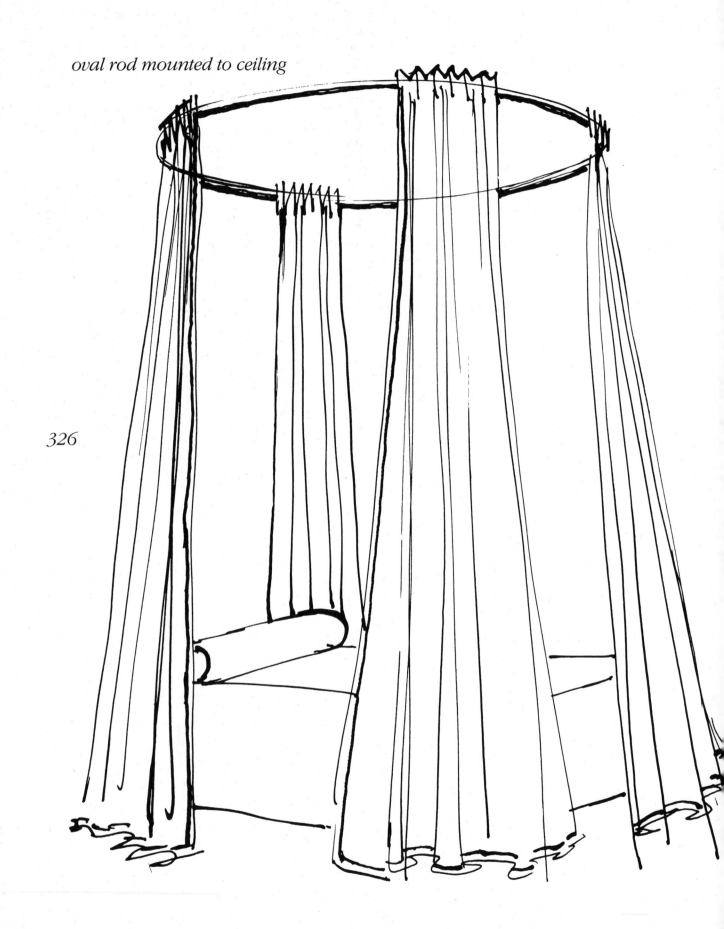

326

*wooden frame
with fabric ceiling
trimmed with braid*

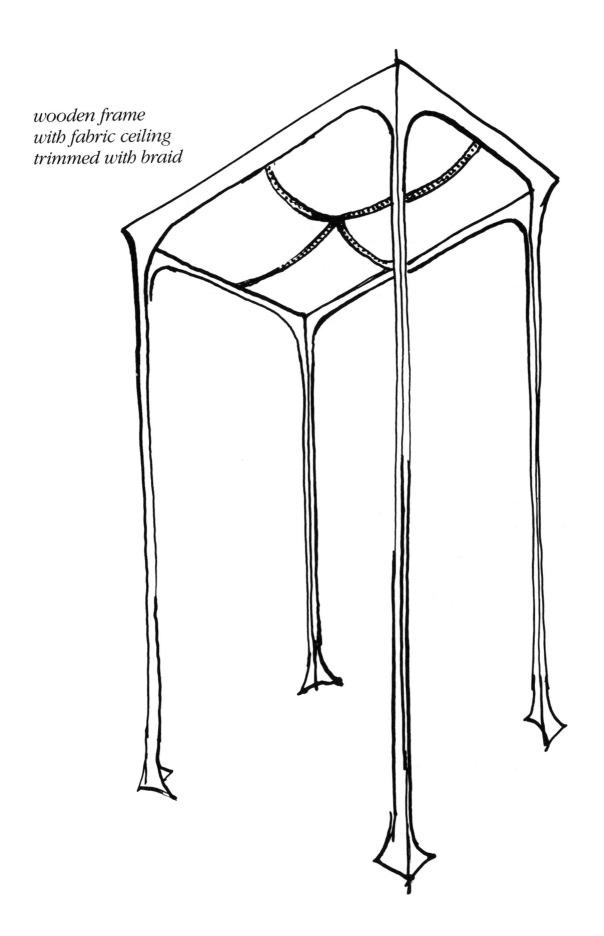

327

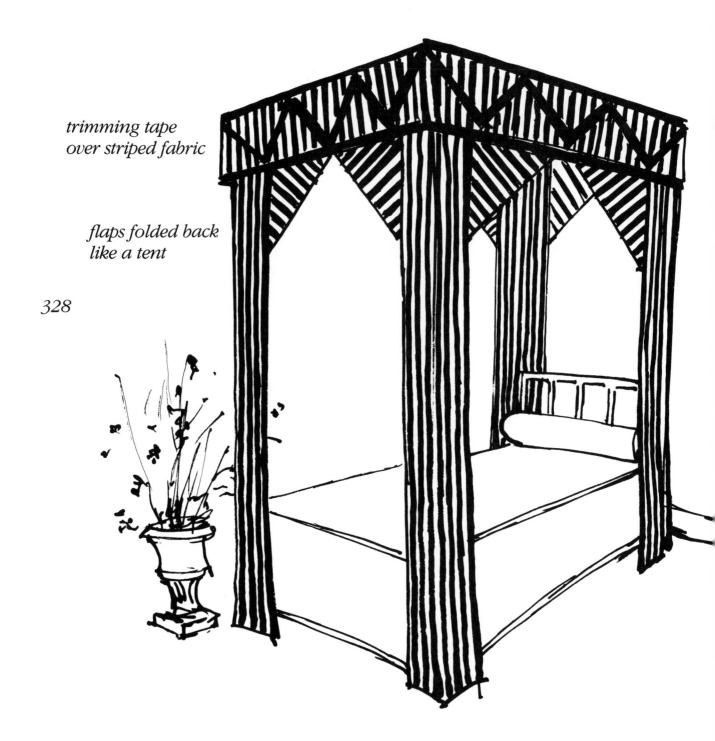

*trimming tape
over striped fabric*

*flaps folded back
like a tent*

328

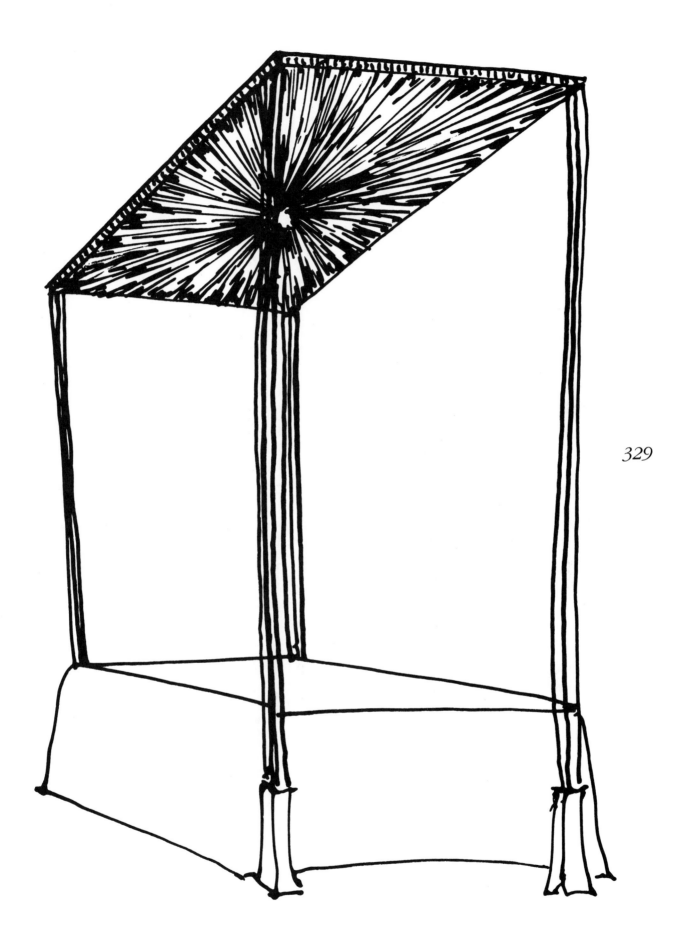

329

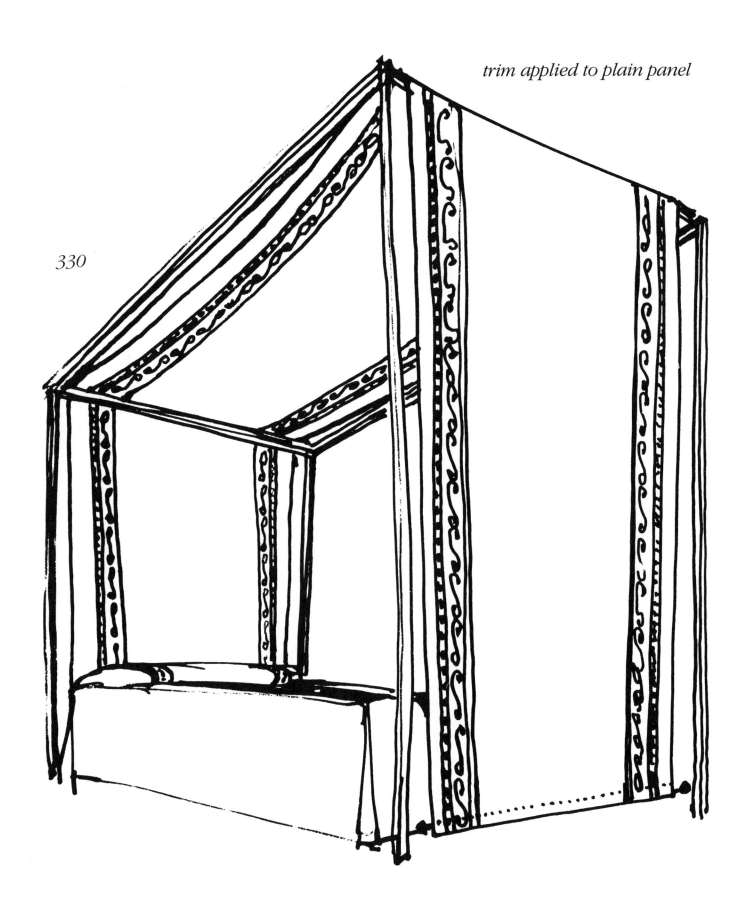

trim applied to plain panel

330

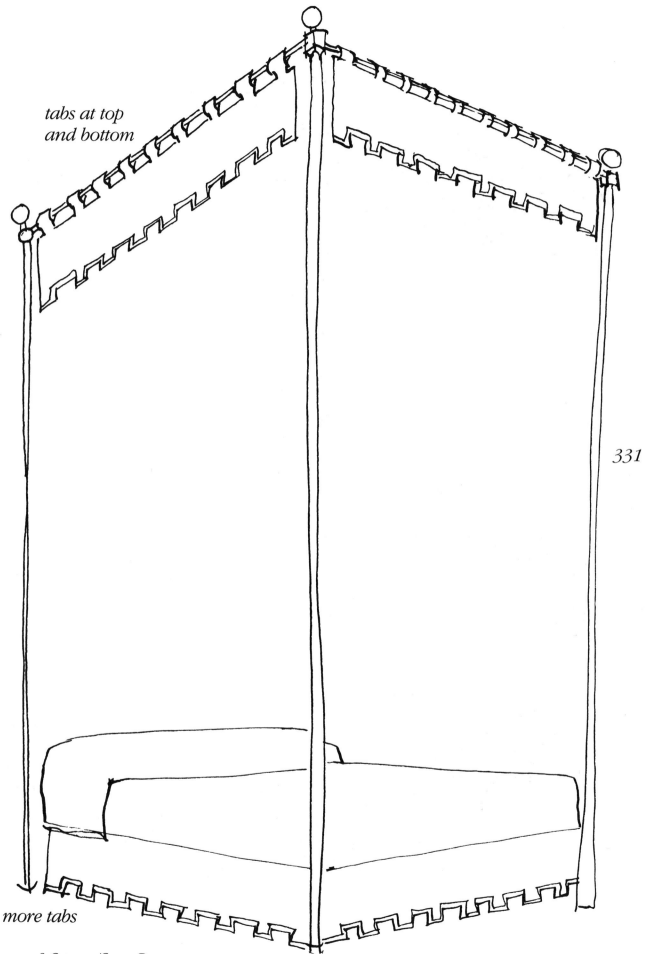

*tabs at top
and bottom*

331

more tabs

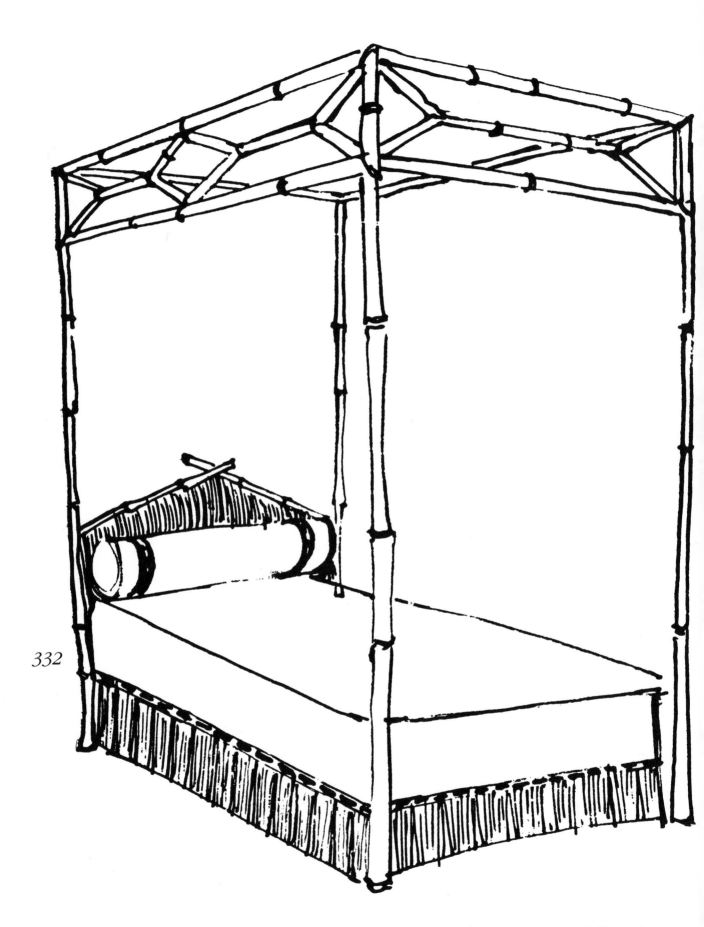

332

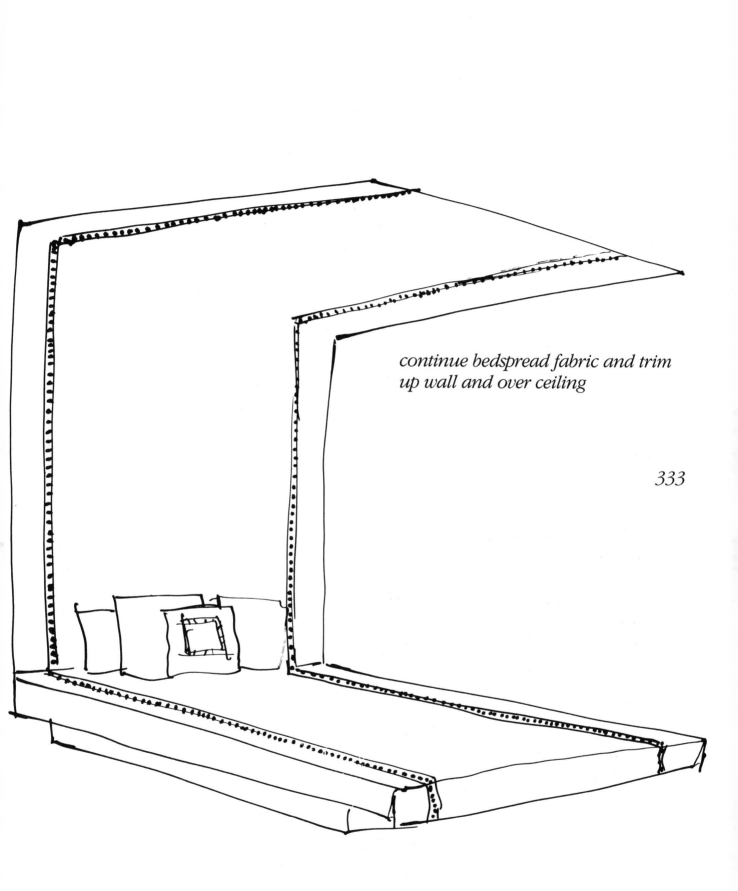

continue bedspread fabric and trim up wall and over ceiling

333

*stiffened canopy
hung by ring
from ceiling*

334

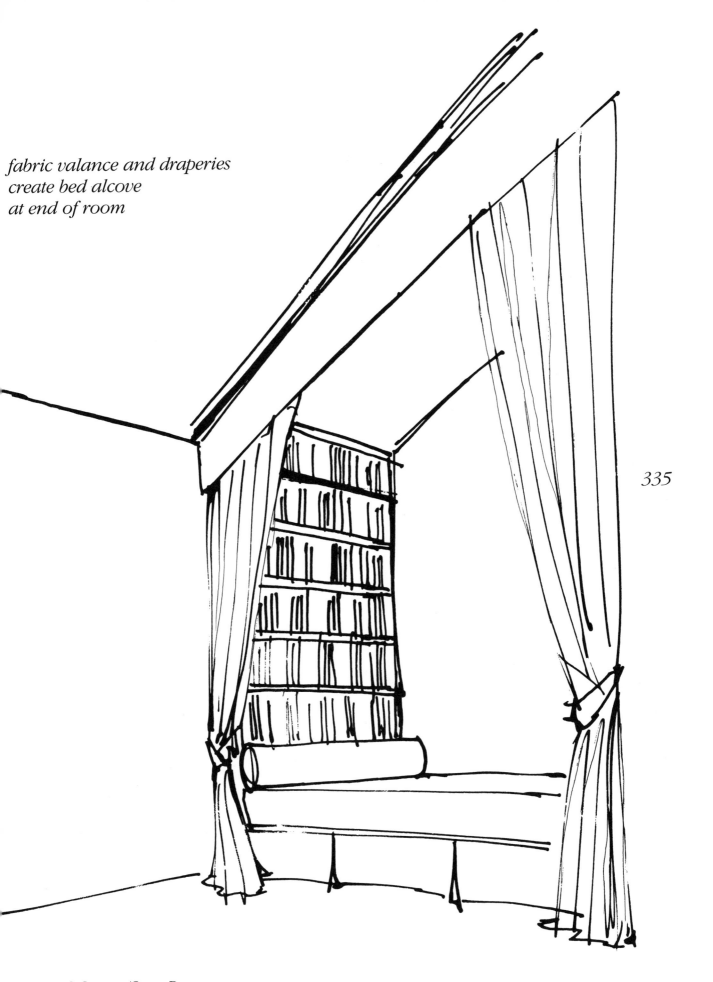

*fabric valance and draperies
create bed alcove
at end of room*

335

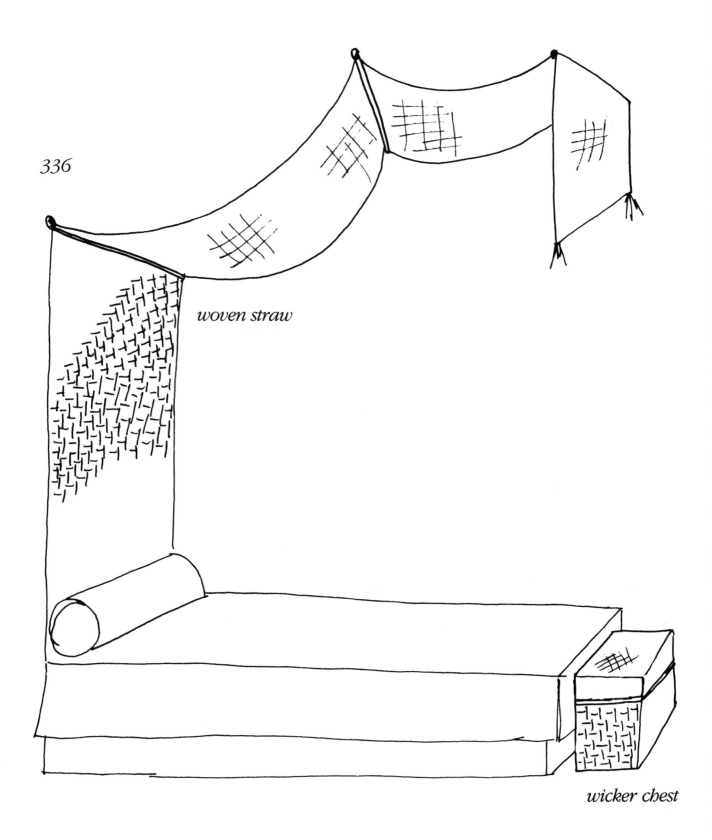

336

woven straw

wicker chest

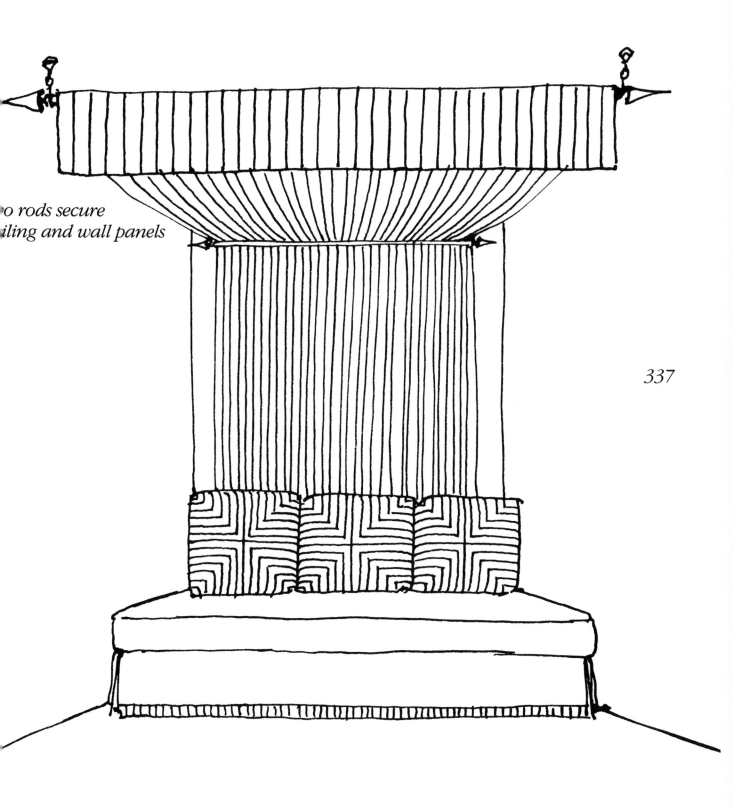

o rods secure
iling and wall panels

337

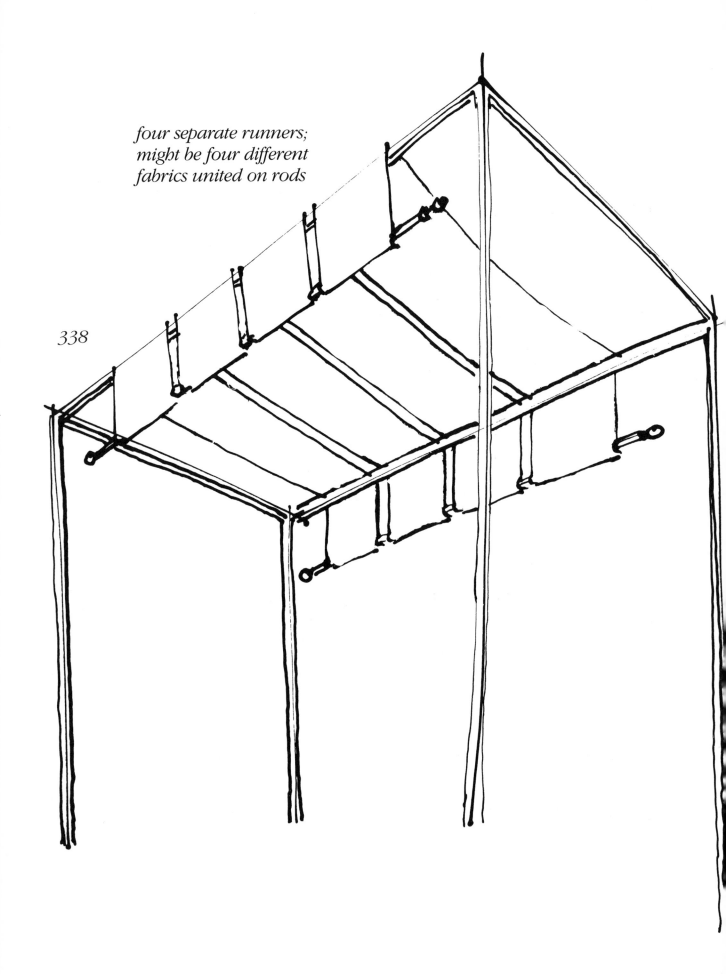

*four separate runners;
might be four different
fabrics united on rods*

338

Austrian canopy and curtains
following dormer line

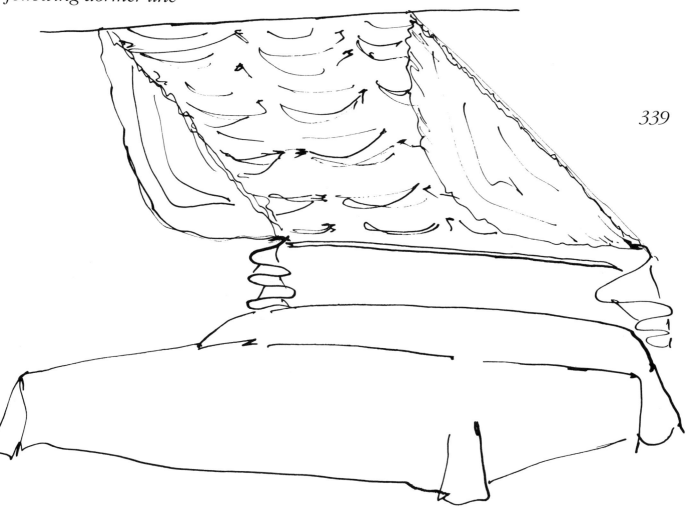

339

340

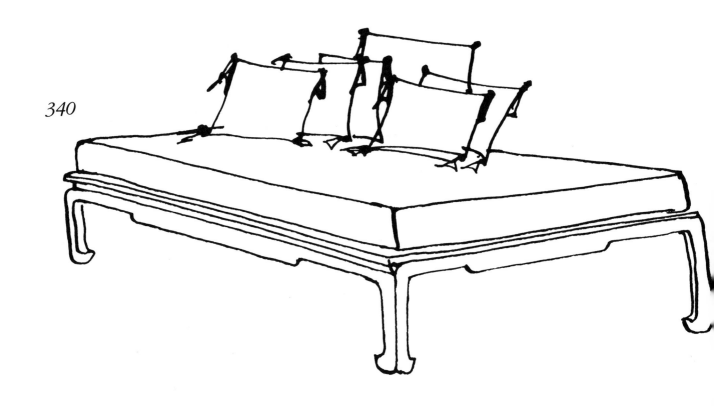

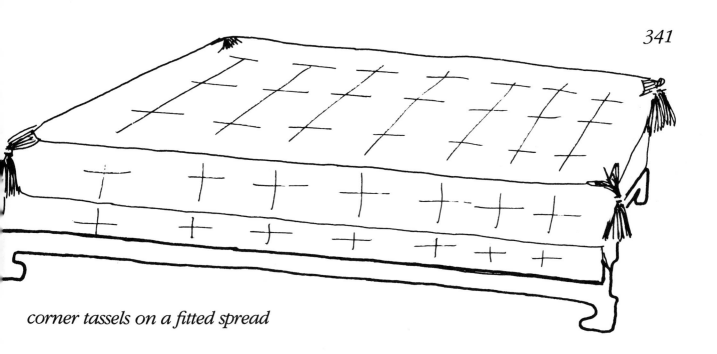

corner tassels on a fitted spread

342

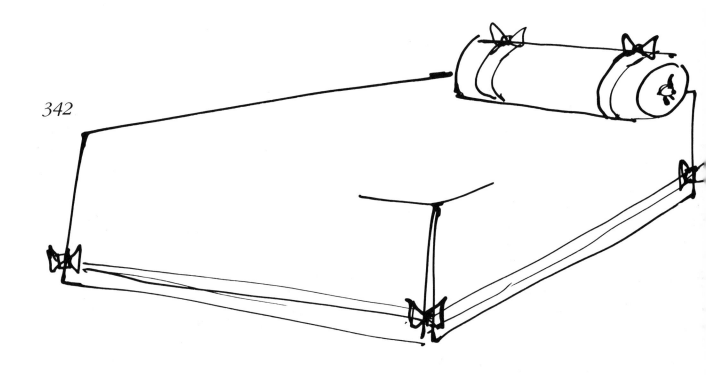

343

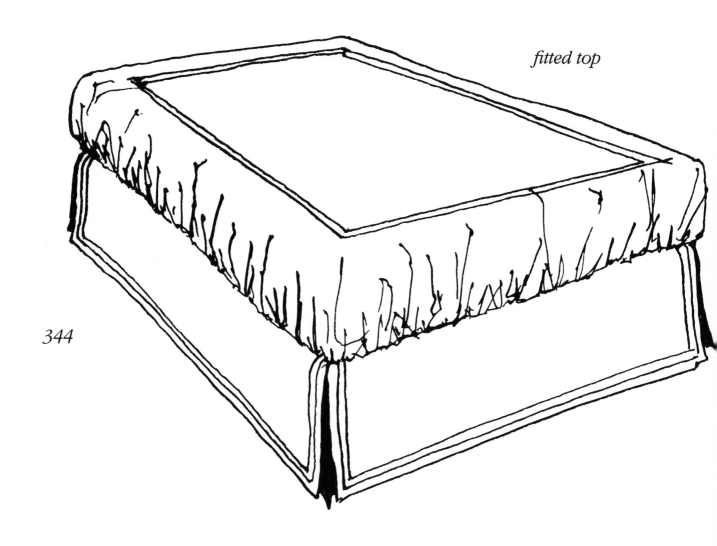

fitted top

344

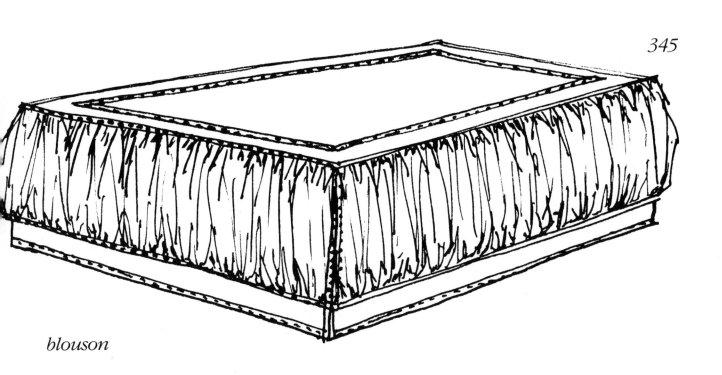

blouson

346

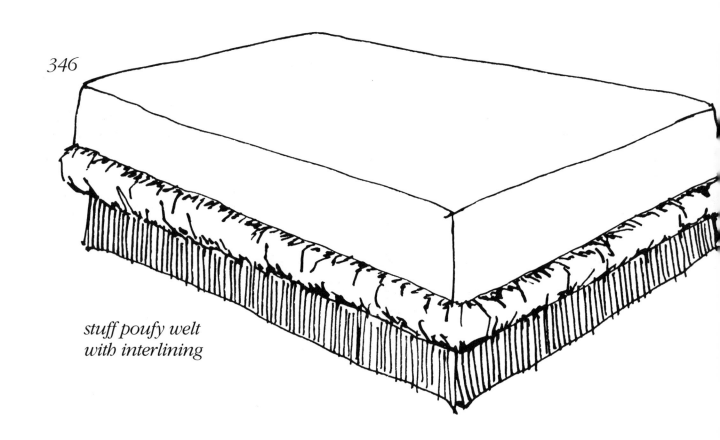

*stuff poufy welt
with interlining*

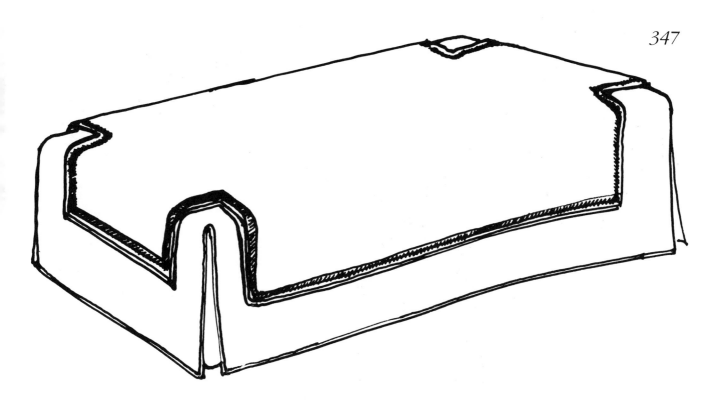

BEDSPREADS & CANOPIES/CASUAL DESIGNS

348

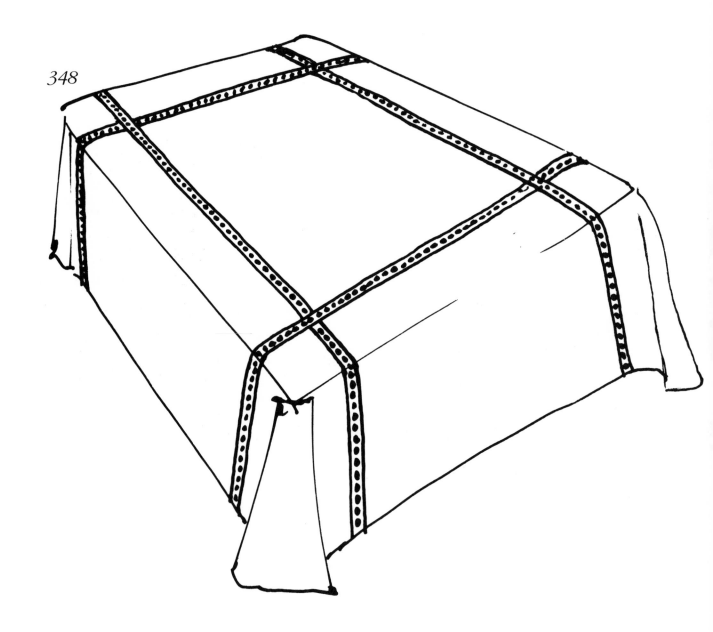

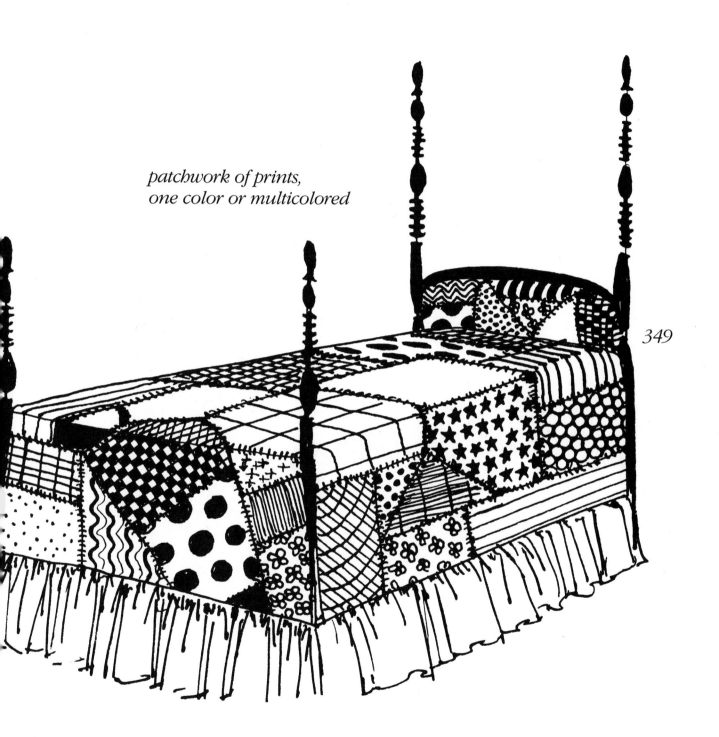

patchwork of prints,
one color or multicolored

349

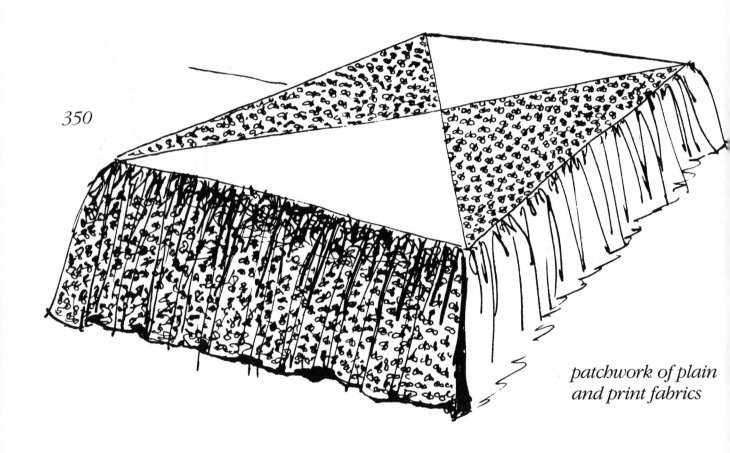

350

*patchwork of plain
and print fabrics*

Headboards
and Daybeds

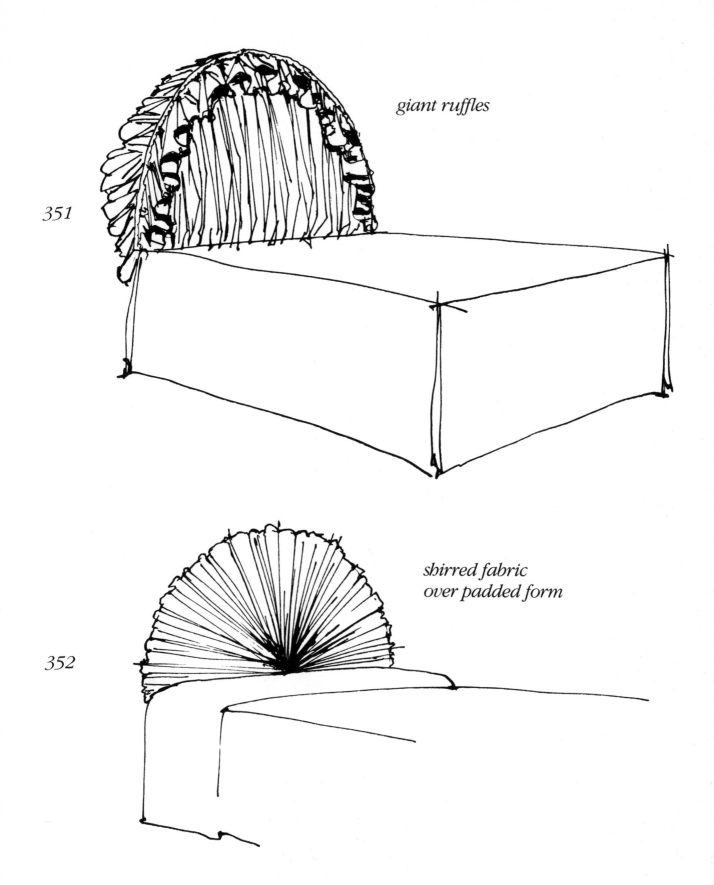

giant ruffles

351

352

*shirred fabric
over padded form*

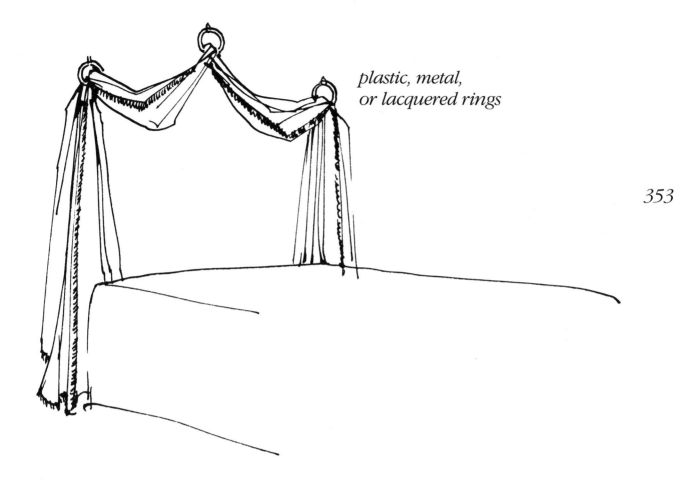

*plastic, metal,
or lacquered rings*

353

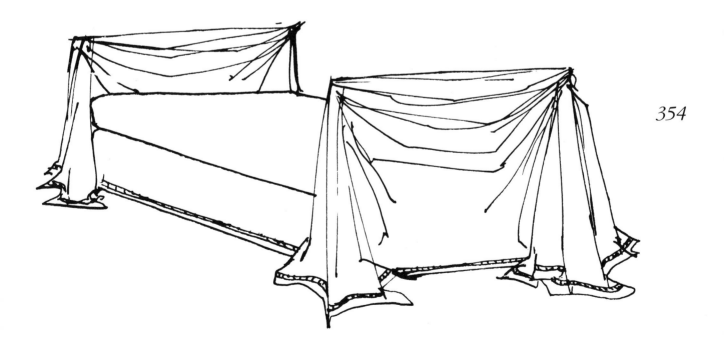

354

355

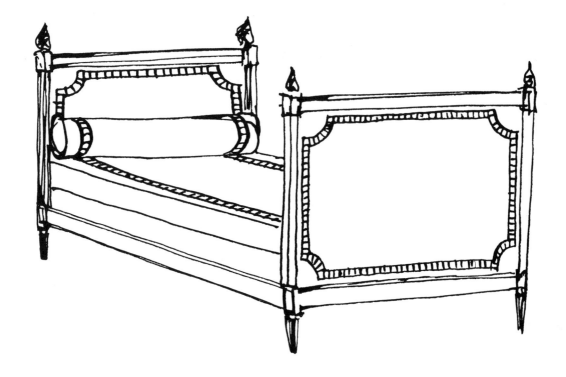

356

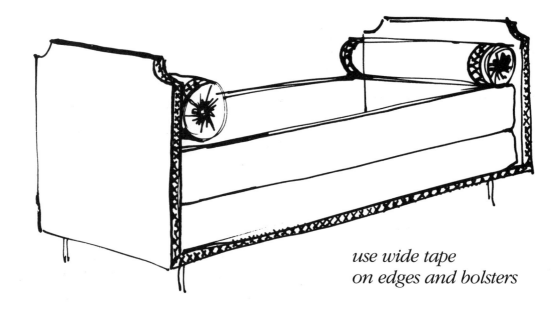

*use wide tape
on edges and bolsters*

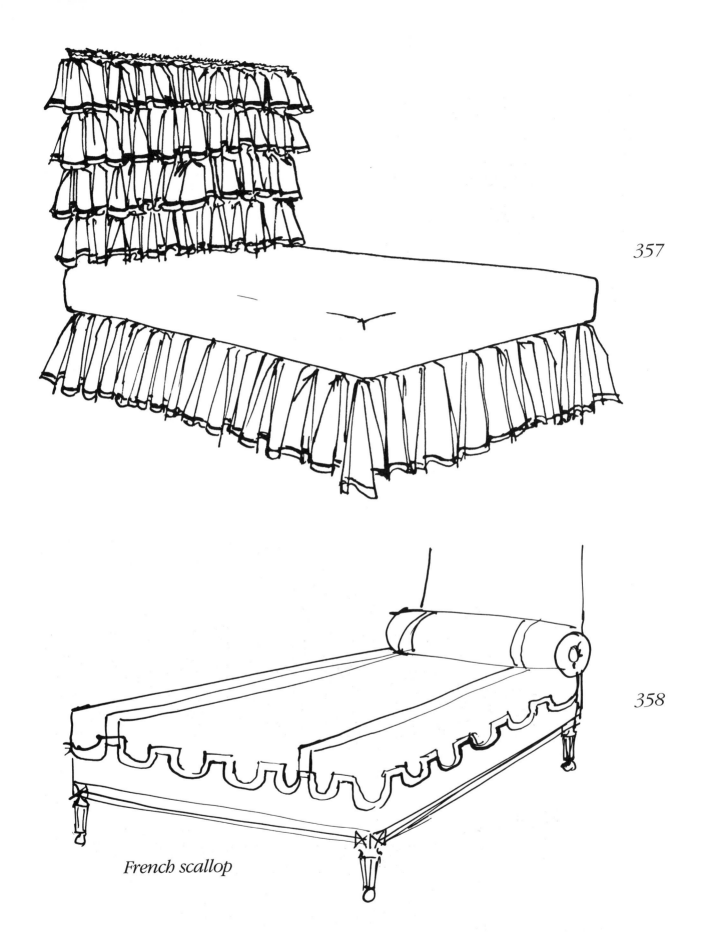

357

358

French scallop

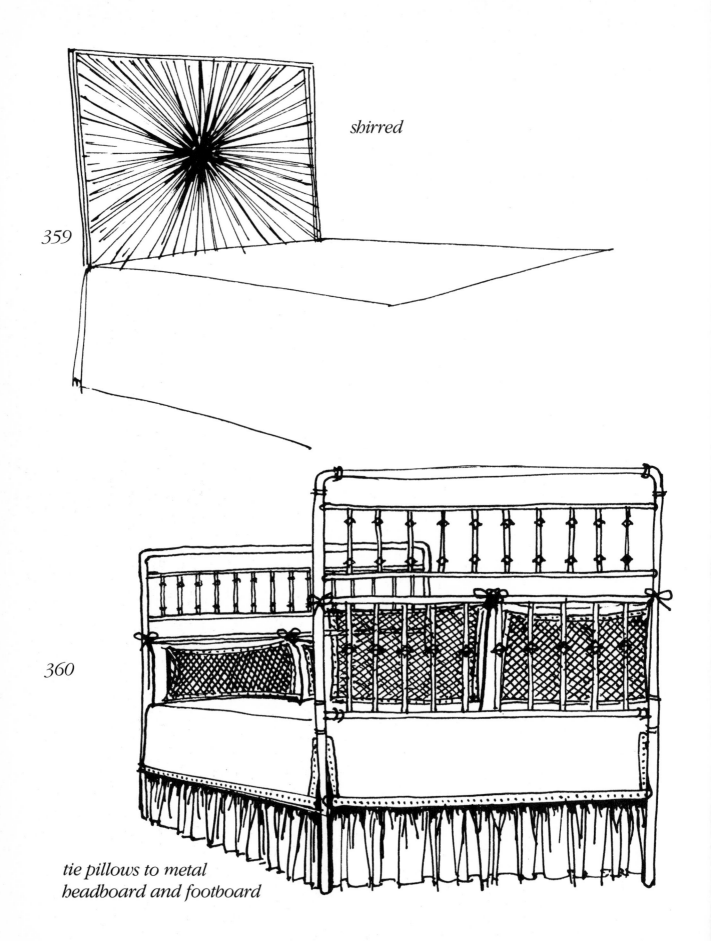

shirred

359

360

*tie pillows to metal
headboard and footboard*

Skirts

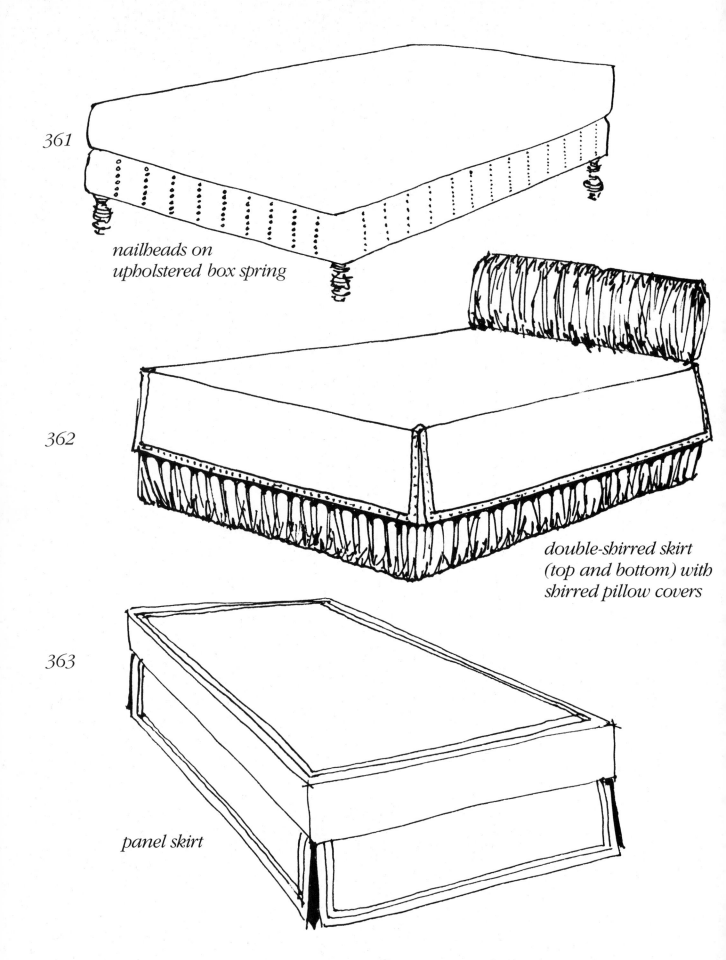

361

*nailheads on
upholstered box spring*

362

*double-shirred skirt
(top and bottom) with
shirred pillow covers*

363

panel skirt

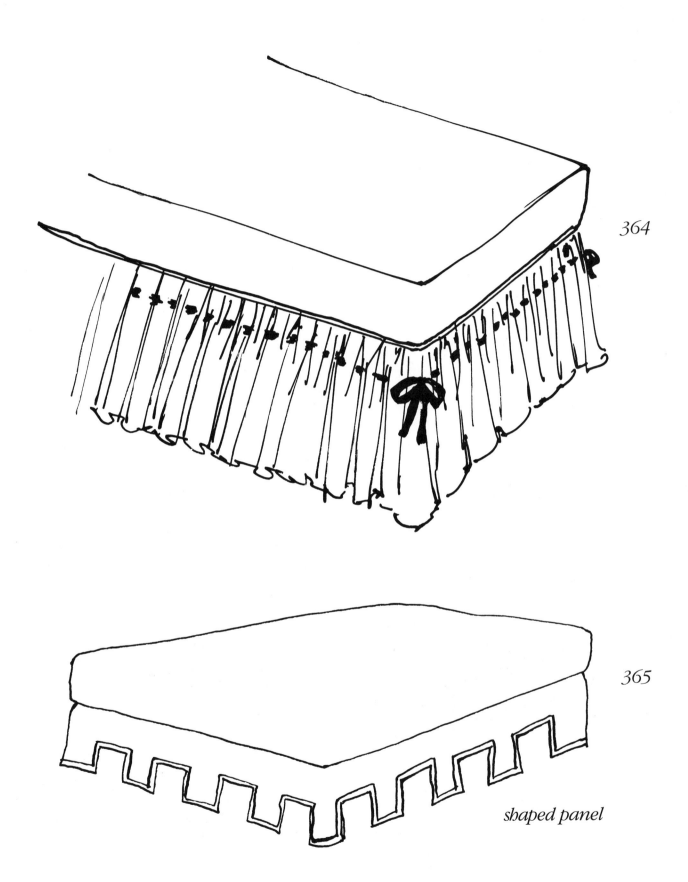

364

365

shaped panel

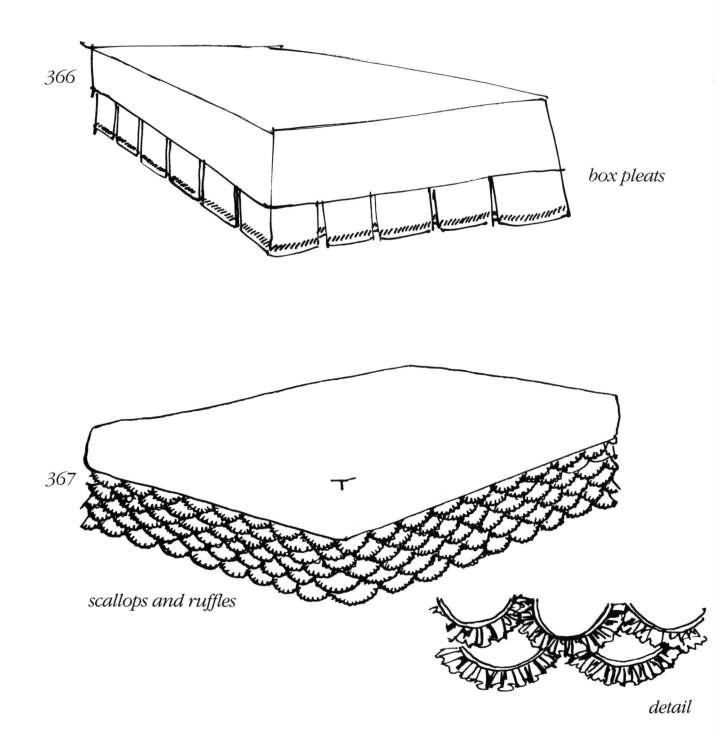

366

box pleats

367

scallops and ruffles

detail

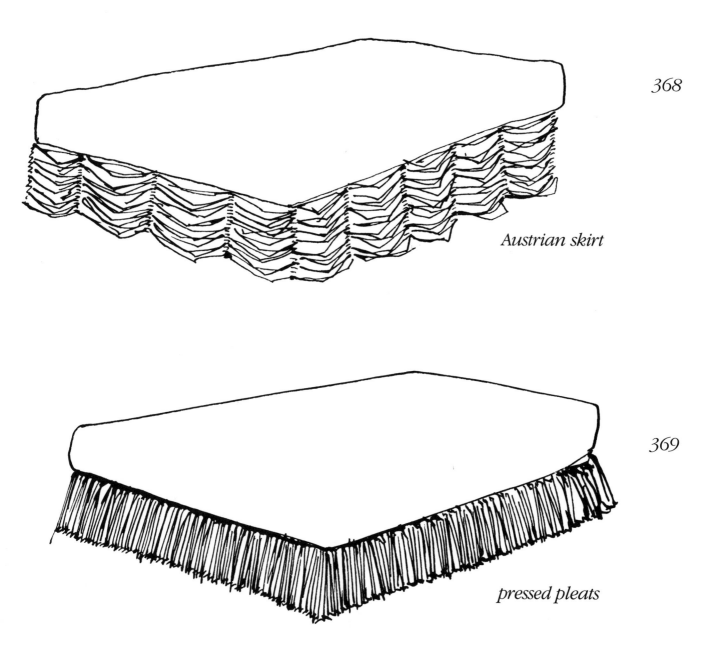

368

Austrian skirt

369

pressed pleats

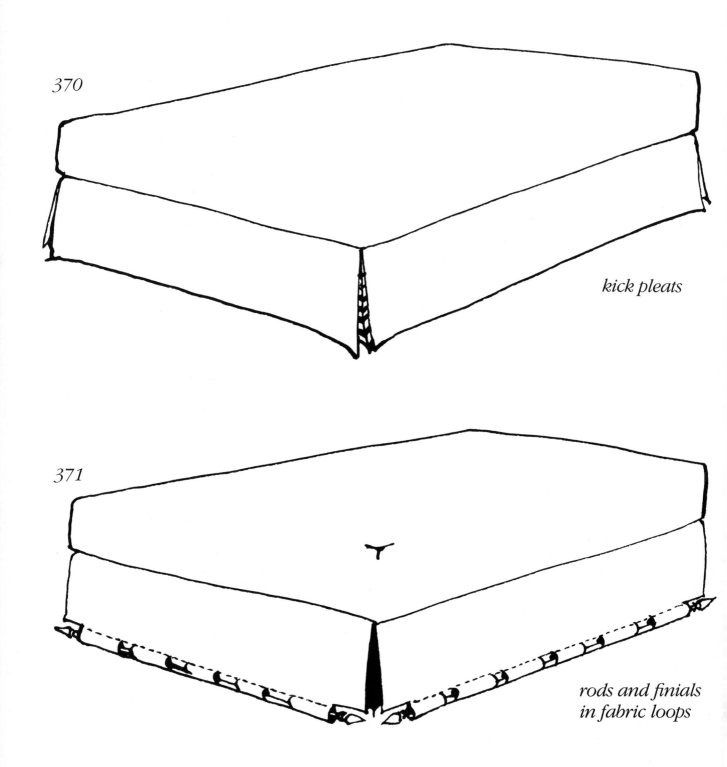

370

kick pleats

371

*rods and finials
in fabric loops*

Index

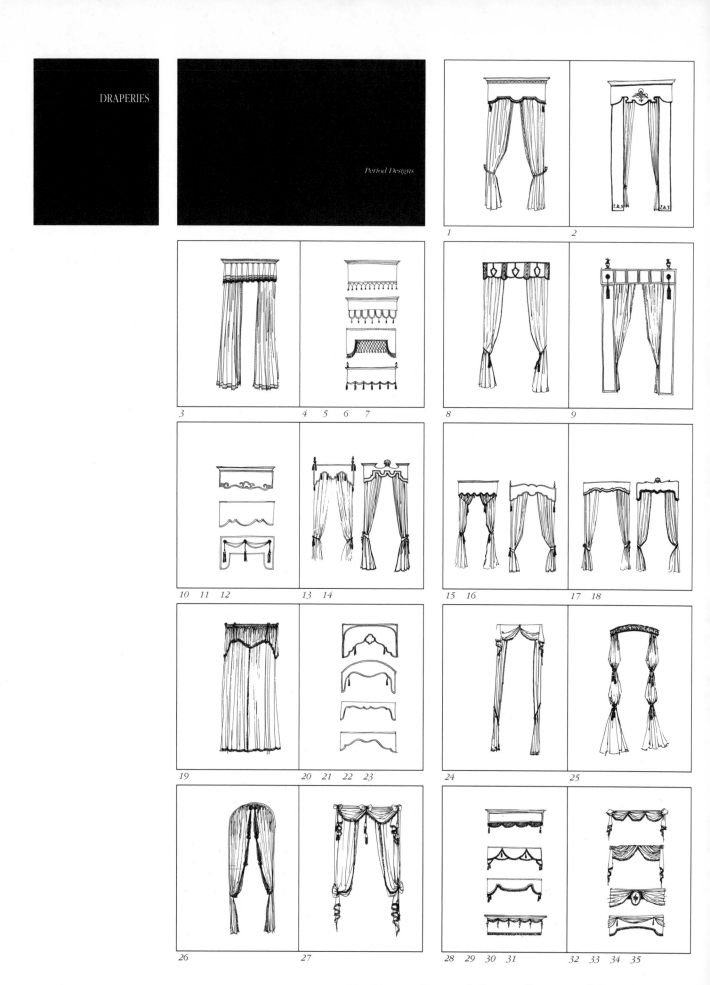

DRAPERIES

Period Designs

1
2
3
4 5 6 7
8
9
10 11 12
13 14
15 16
17 18
19
20 21 22 23
24
25
26
27
28 29 30 31
32 33 34 35

THE INTERIOR DESIGNER'S DRAPERY, BEDSPREAD & CANOPY SKETCHFILE

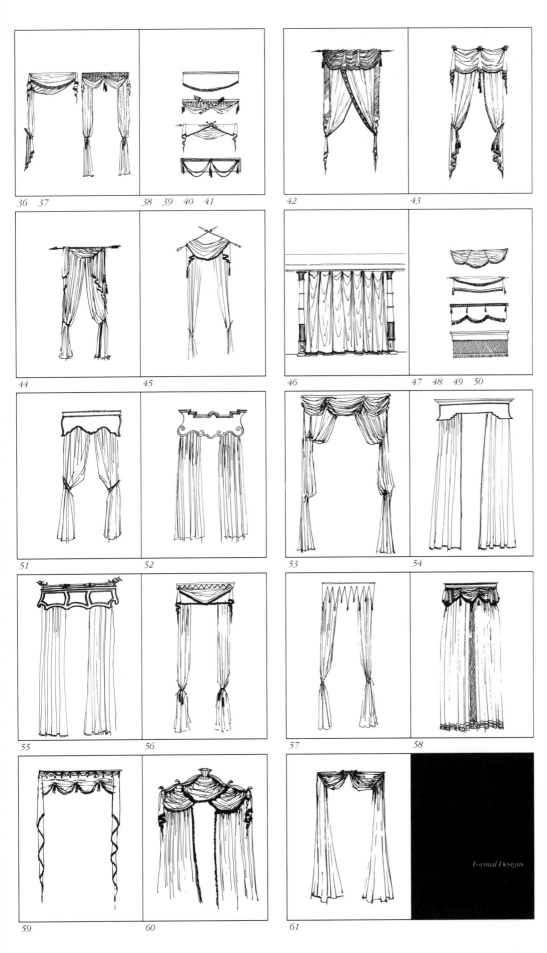

36 37 38 39 40 41 42 43

44 45 46 47 48 49 50

51 52 53 54

55 56 57 58

59 60 61 *Formal Designs*

INDEX

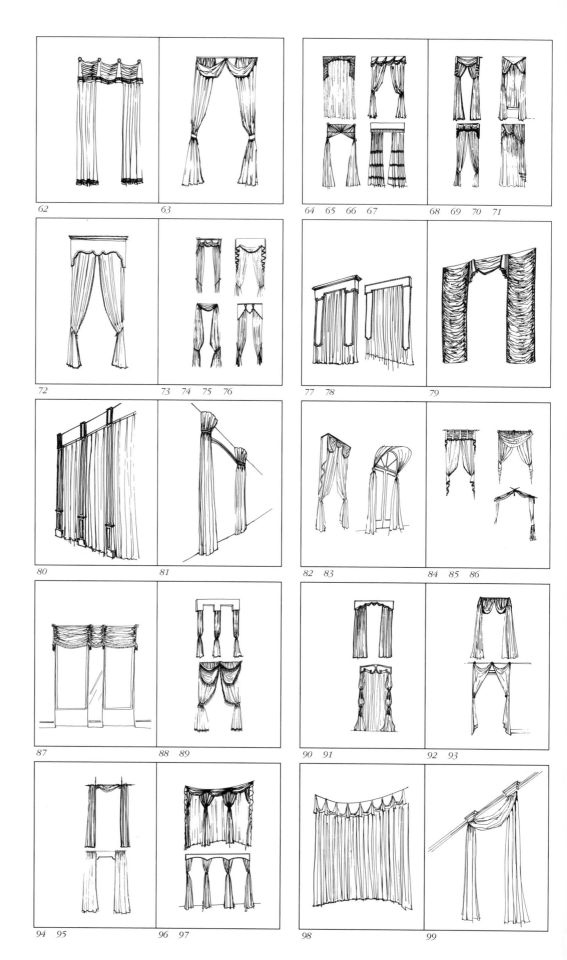

62 63 64 65 66 67 68 69 70 71

72 73 74 75 76 77 78 79

80 81 82 83 84 85 86

87 88 89 90 91 92 93

94 95 96 97 98 99

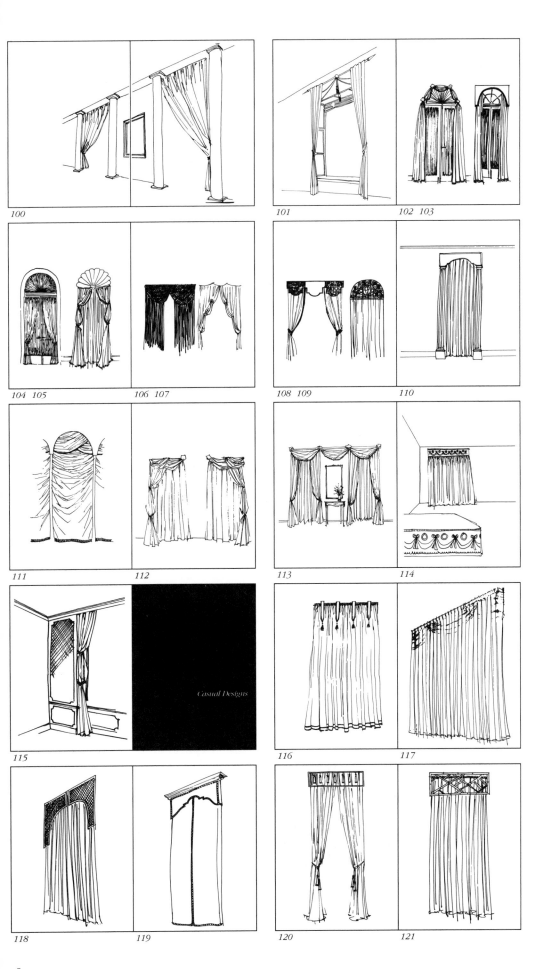

100

101 102 103

104 105 106 107

108 109 110

111 112 113 114

115 *Casual Designs* 116 117

118 119 120 121

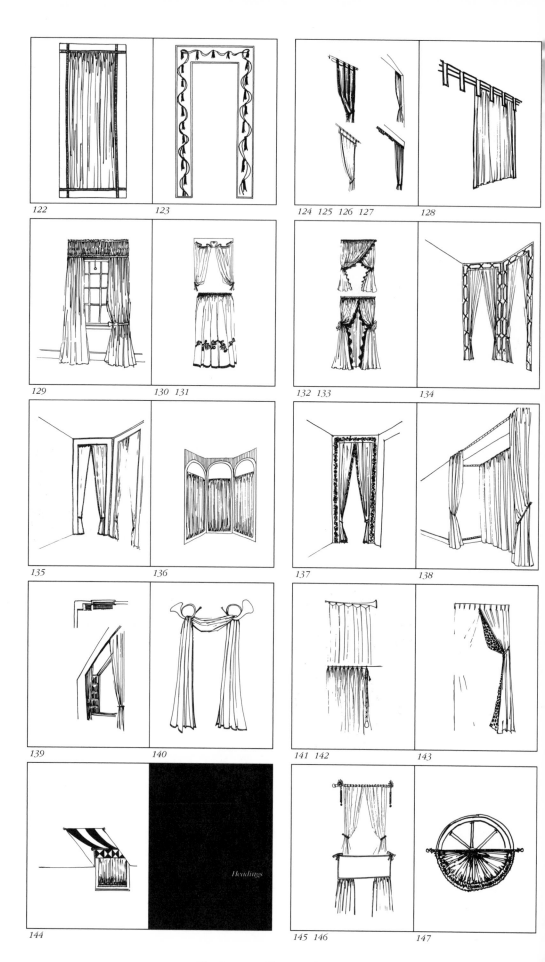

122

123

124 125 126 127

128

129

130 131

132 133

134

135

136

137

138

139

140

141 142

143

144

Headings

145 146

147

THE INTERIOR DESIGNER'S DRAPERY, BEDSPREAD & CANOPY SKETCHFILE

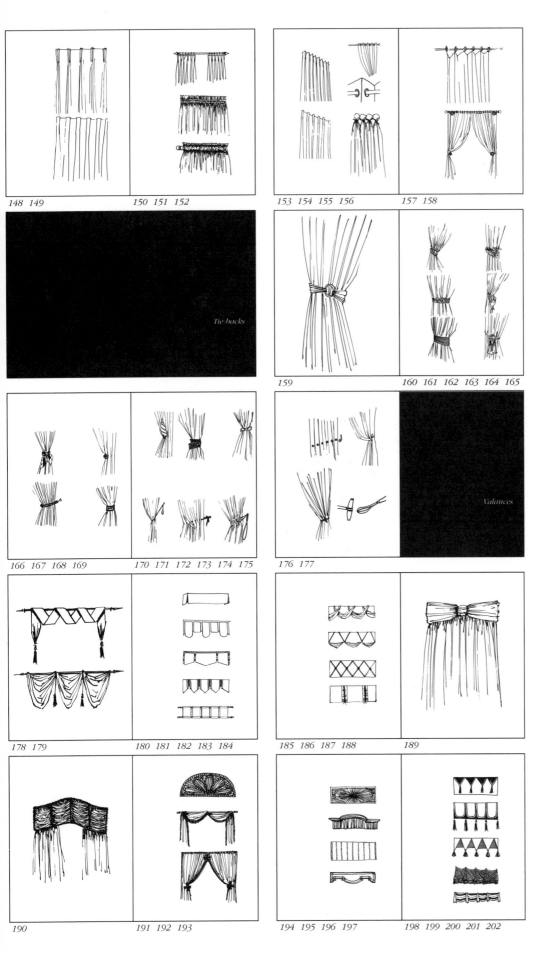

148 149

150 151 152

153 154 155 156

157 158

Tie-backs

159

160 161 162 163 164 165

166 167 168 169

170 171 172 173 174 175

176 177

Valances

178 179

180 181 182 183 184

185 186 187 188

189

190

191 192 193

194 195 196 197

198 199 200 201 202

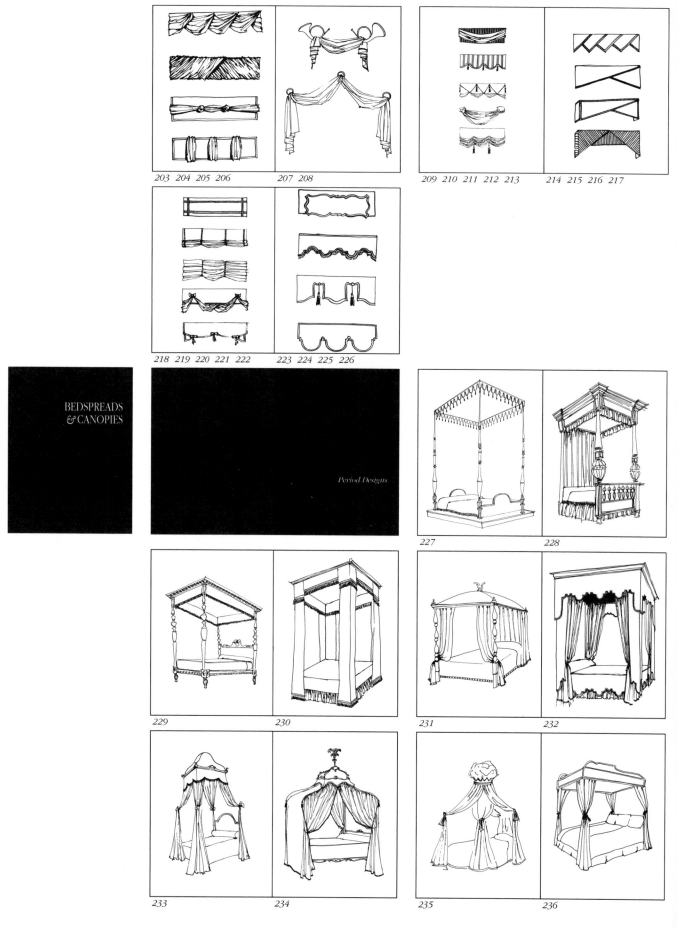

203 204 205 206　　*207 208*　　*209 210 211 212 213*　　*214 215 216 217*

218 219 220 221 222　　*223 224 225 226*

BEDSPREADS
& CANOPIES

Period Designs

227　　*228*

229　　*230*　　*231*　　*232*

233　　*234*　　*235*　　*236*

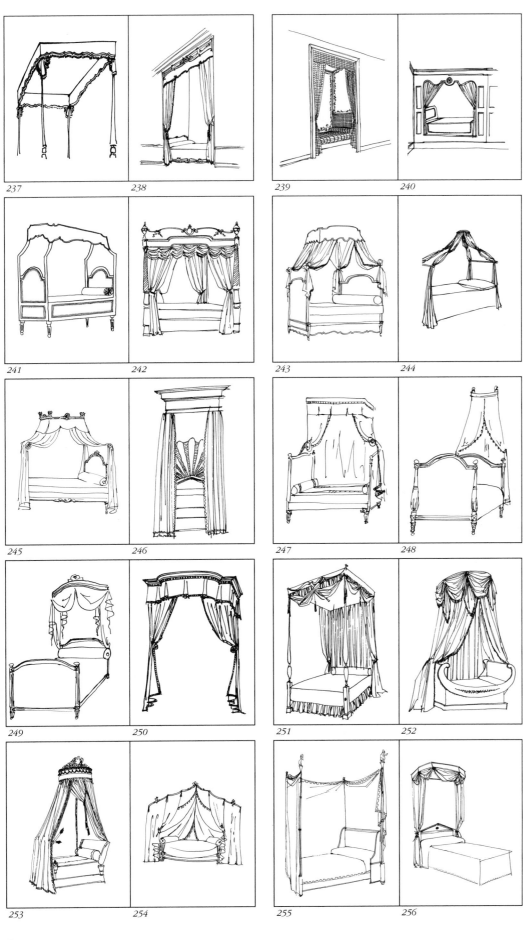

237

238

239

240

241

242

243

244

245

246

247

248

249

250

251

252

253

254

255

256

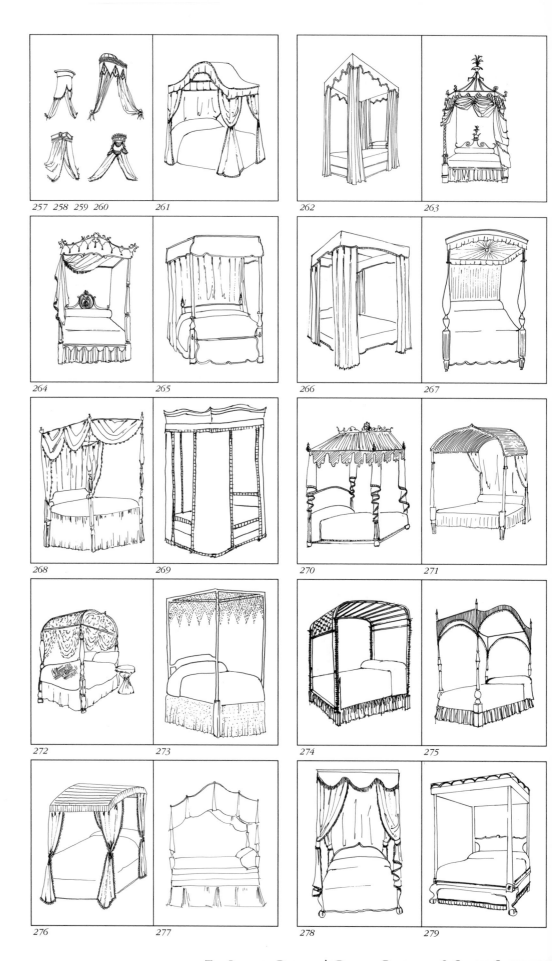

257 258 259 260 261 262 263

264 265 266 267

268 269 270 271

272 273 274 275

276 277 278 279

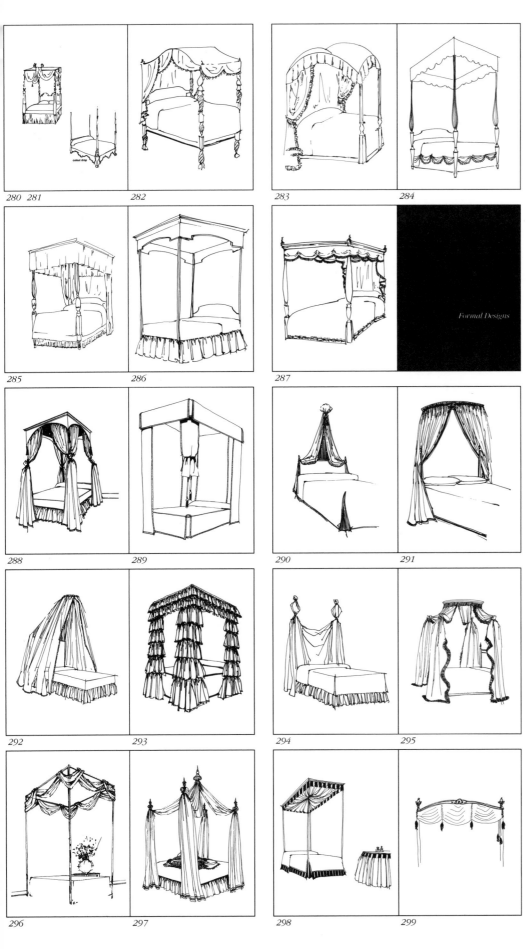

280 281 282 283 284

285 286 287

288 289 290 291

292 293 294 295

296 297 298 299

Formal Designs

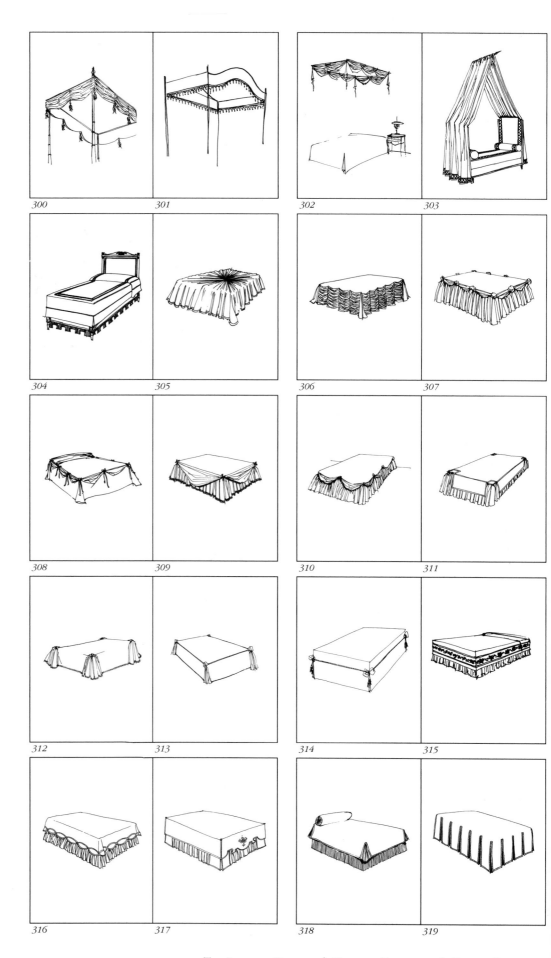

300 301 302 303

304 305 306 307

308 309 310 311

312 313 314 315

316 317 318 319

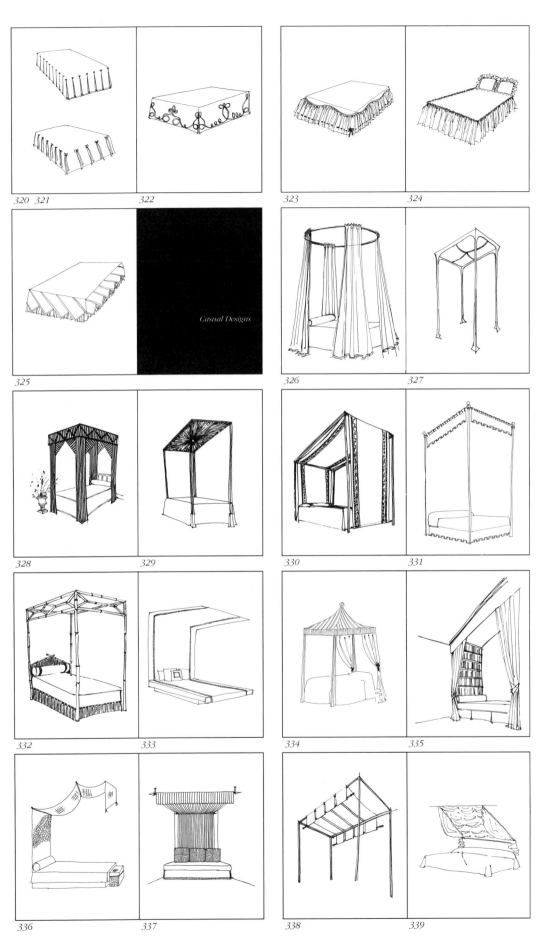

320 321 322 323 324

325 *Casual Designs* 326 327

328 329 330 331

332 333 334 335

336 337 338 339

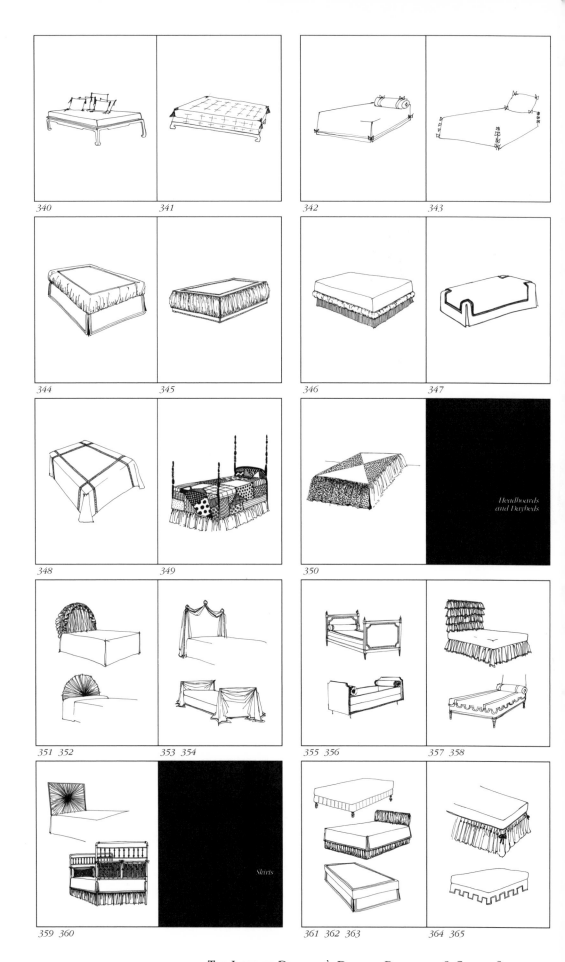

340 341 342 343

344 345 346 347

348 349 350

Headboards and Daybeds

351 352 353 354 355 356 357 358

Skirts

359 360 361 362 363 364 365

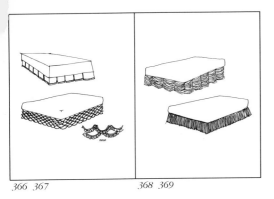

366 367 368 369

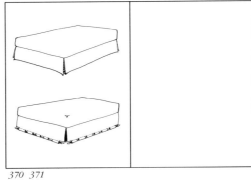

370 371